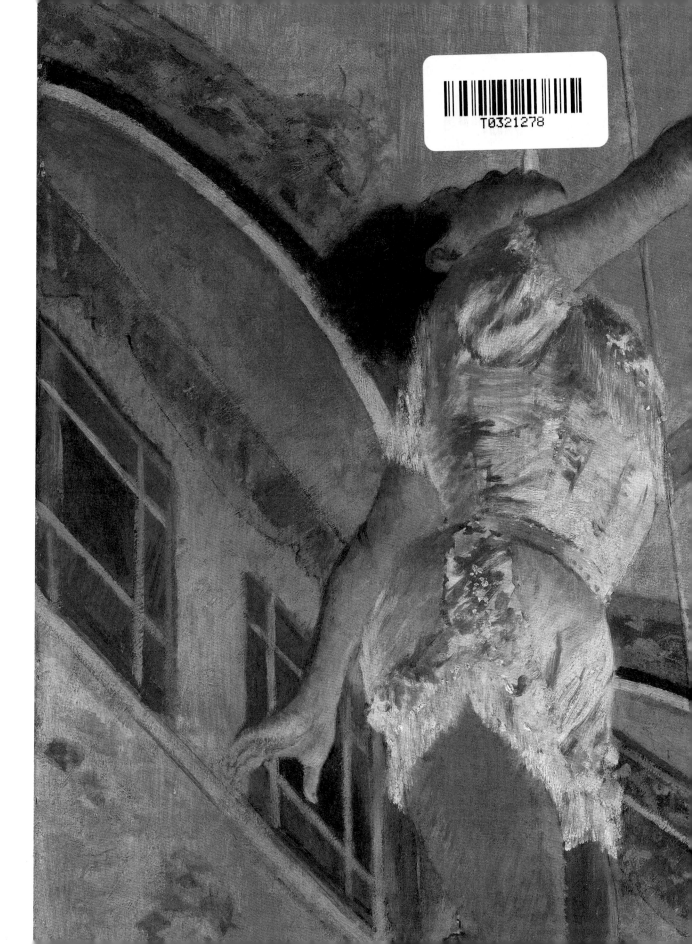

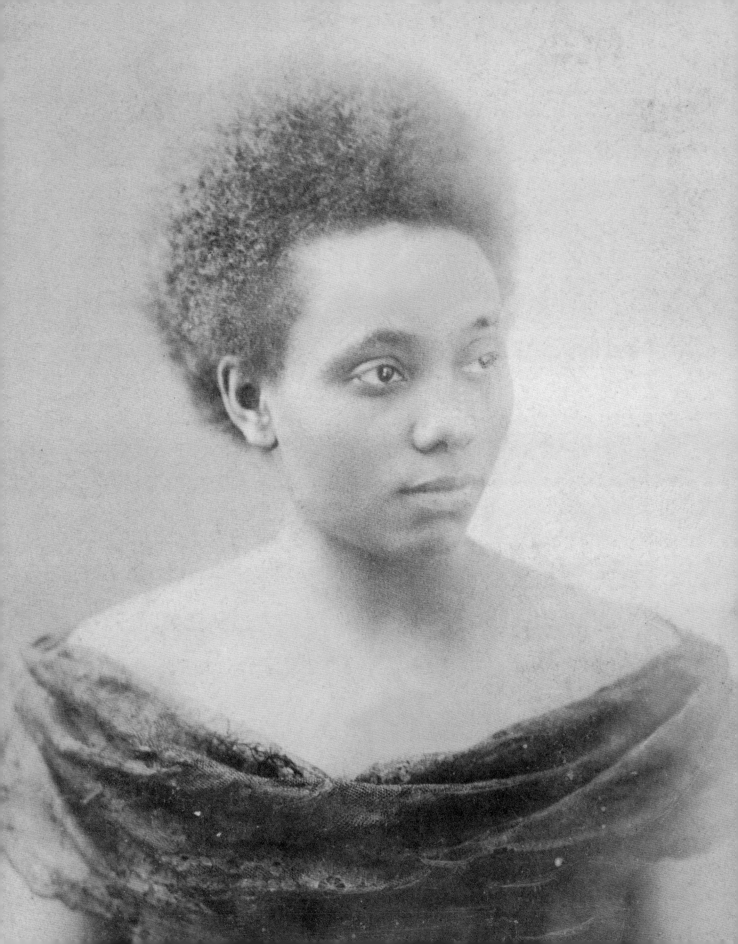

DISCOVER DEGAS & MISS LA LA

ANNE ROBBINS

with Chiara Di Stefano
and contributions by Laurie Fierstein, Darcy Grimaldo Grigsby, Denise Murrell,
Sterre Overmars, Isolde Pludermacher and Christopher Riopelle

NATIONAL GALLERY GLOBAL, LONDON
DISTRIBUTED BY YALE UNIVERSITY PRESS

Published to accompany the exhibition:

Discover Degas & Miss La La
The National Gallery, London
6 June–1 September 2024

Exhibition supported by

The Thompson Family Charitable Trust

The Sunley Room exhibition programme is
supported by the Bernard Sunley Foundation

Publication supported by

ARTscapades

This exhibition has been made possible
by the provision of insurance through
the Government Indemnity Scheme.
The National Gallery would like to thank
HM Government for providing Government
Indemnity and the Department for Digital,
Culture, Media and Sport and Arts Council
England for arranging the indemnity.

NG200
200 YEARS OF THE NATIONAL GALLERY

First published in 2024 by
National Gallery Global Limited
Trafalgar Square
London WC2N 5DN
www.shop.nationalgallery.org.uk

ISBN: 9781857097146
1053012

British Library Cataloguing-in-Publication Data
A catalogue record is available from the
British Library
Library of Congress Control Number:
2023938161

Publisher: Laura Lappin
Managing Editor: Diana Adell
Copy-editor: Jenny Wilson
Proofreader: Felicity Maunder
Picture Researcher: Suzanne Bosman
Production: Davina Cheung

Designed by Sandra Zellmer
Cover design by George Bird
Origination by DL Imaging, London
Printed in Belgium by Graphius

All works are by Hilaire-Germain-Edgar Degas
(1834–1917) unless otherwise stated.

All measurements give height before width.

Front cover and p. 1: *Miss La La at the Cirque
Fernando* (detail from cat. 40)
Back cover: *Miss La La at the Cirque Fernando*
(detail from cat. 2)
p. 2: *Anna Albertine Olga Brown* (cat. 16)
p. 6: Marcellin Desboutin, *Portrait of Edgar
Degas*, 1876. Drypoint on paper, 22.7 × 14.3 cm,
Rijksmuseum, Amsterdam
pp. 70–1: Pierre-Auguste Renoir, *Acrobats at
the Cirque Fernando (Francisca and Angelina
Wartenberg)* (detail from cat. 28)
p. 125: *Miss La La at the Cirque Fernando*
(detail from cat. 35)
p. 131: Walter Sickert, *The Trapeze*
(detail from cat. 47)
p. 135: Demolished dome of the Cirque
Medrano, Paris, 28 November 1972.

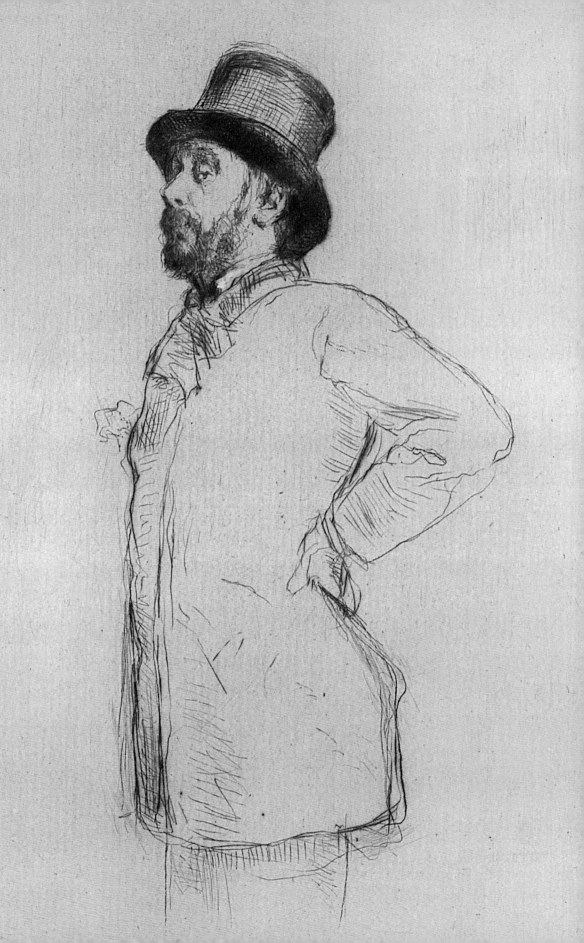

DIRECTOR'S FOREWORD

Discover Degas & Miss La La is the first exhibition to open at the National Gallery in our Bicentenary year, which began on 10 May 2024. It is not entirely coincidental, of course, that Degas's painting of *Miss La La at the Cirque Fernando*, one of the Gallery's most celebrated nineteenth-century works, was acquired almost exactly one hundred years ago against the background of the Gallery's first centenary celebrations. The work shows the acclaimed acrobat performing her signature act of rising up to the circus's roof clenching a rope between her teeth. Degas went to see her several times in January 1879 and was evidently mesmerised by the grace and strength of her performance, as well as by the pictorial possibilities that the subject offered, from the implicit modernity of the circus setting to the narrow-format picture field and the audacious foreshortening required for the scene.

Miss La La was the stage name of Anna Albertine Olga Brown, who was born in Poland (then part of Prussia) to a Black American father, an emancipated slave, and a German-Prussian mother. She performed in a circus troupe from a young age in east and central Europe, as well as in England, before taking up her year-long residency at the Cirque Fernando in Paris. Degas, who had non-white relatives in his family, was clearly fascinated by her. There has been significant academic interest in recent years in the role of Black and mixed-heritage performers, actors and models in the Parisian artistic avant-garde. This exhibition project is the beneficiary of the research in this area undertaken by Denise Murrell, Isolde Pludermacher, Laurie Fierstein and Darcy Grimaldo Grigsby, who have all contributed to this catalogue. At the National Gallery, the exhibition's co-curator, Chiara Di Stefano, and Christopher Riopelle have also contributed new information and aperçus on the life of the painting.

The exhibition was conceived by Anne Robbins when she was working with us as a curator in Trafalgar Square. She has since joined the staff at the Musée d'Orsay and I am very grateful to her for the curatorial and research skills she has brought to bear on the project. I would also like to thank all the lenders, individuals and institutions who have generously contributed to the exhibition. And for their consistent and longstanding support, stretching back more than three decades, I am very grateful to the Bernard Sunley Foundation. Finally, I would like to thank the Thompson Family Charitable Trust for their continued generosity, and ARTscapades for their support of this catalogue.

Gabriele Finaldi
Director, The National Gallery

DENISE MURRELL AND ISOLDE PLUDERMACHER

Preface

In recent years, one of the most revelatory strategies of curatorial practice has been to shift the gaze of art history, and of the viewing public, from an almost exclusive focus on the intentionality and pictorial methods of the artist to an exploration of the subjectivity of the sitter. This revisionary focus is leading to an expanded and more nuanced appreciation of the faceted meanings of significant works of art by introducing a rich new interpretive context gained from an understanding of the historical background for both artist and sitter.

Degas's Miss La La oeuvre, including several accomplished studies and the final oil painting, has until the last 20 years been among the artist's least studied bodies of work, due in part to its focus on the circus, a slightly atypical subject for an artist best known for his paintings of ballerinas, cafe scenes and the more quotidian aspects of modern Parisian life. This lack of scholarly attention was also due to the historical marginalisation of virtually all portrayals of non-white subjects by the collectors and scholars of nineteenth-century French art.

These factors are especially critical to the study of representations of African diasporan subjects (commonly referred to as 'Black' in this book, in recognition of their ancestry or partial ancestry). Historical inquiry that centres these sitters' racial heritage has contributed to a broader understanding of the fact that European nations have had an African diasporan presence within their resident populations for centuries. These populations were small minorities, but some members held influential roles within the artistic circles that developed in early modern art and are a window into the rapidly modernising societies of the West. The excavation of the histories of sitters of African ancestry – as well as their myriad societal positions, ranging from elite writers,

performers, courtiers, diplomats and politicians to the more problematic household servitude – thus becomes a basis for new art histories that more accurately reflect the actual ethnic mix of historical Europe.

Still, in the case of Degas, it is difficult to assess the extent to which Anna Albertine Olga Brown's skin colour may have been a factor in his decision to depict the acrobat in full performance. A few years earlier, apart from the silhouette of a nanny on the threshold of a house (cat. 42), he had depicted none of the Black men and women he regularly mentioned in his letters from New Orleans. The National Gallery's exhibition and catalogue offer fascinating food for thought on this complex issue.

It is within this context that *Discover Degas & Miss La La* emerges as a landmark exhibition, with its thrilling new discoveries and insights about Olga's life and work. This project comprises a transformative expansion of the foundational research on the Miss La La works, first with the essay '"Miss La La's" Teeth: Reflections on Degas and "Race"' by Marilyn Brown (*The Art Bulletin*, 2007) and then the exhibition *Degas, Miss La La, and the Cirque Fernando*, curated by Linda Wolk-Simon at the Morgan Library & Museum, New York (2013).

The National Gallery exhibition carries forward the work done in *Posing Modernity: The Black Model from Manet and Matisse to Today* at Columbia University's Wallach Art Gallery in New York (Denise Murrell, 2018) and that exhibition's extensive development as *Le modèle noir de Géricault à Matisse* at the Musée d'Orsay, Paris (Cécile Debray, Stéphane Guégan, Denise Murrell and Isolde Pludermacher, 2019).

In London, curators Anne Robbins and Chiara Di Stefano have advanced some of the modes of research and discovery that shaped the New York and Paris exhibitions. Olga's extant family has been located and for the first time a comprehensive biography has been developed by researcher Laurie Fierstein (pp. 122–3), leading to the uncovering of Olga's correct full name. The curators have collaborated with the family to bring forth photographic portraits of Olga that have never before been published. These newly discovered family portraits complete Olga's transcendence beyond racial stereotypes; they situate her within traditional narratives of middle-class respectability, marriage and motherhood – even the realm of beauty, a space routinely exclusionary of Black femininity. The fresh research carried out in preparation for the National Gallery exhibition has also allowed the identification of previously unpublished drawings by Degas related to his *Miss La La* painting (cats 30, 37).

With some difference in scope, the founding principle of *Posing Modernity/Le modèle noir* exhibitions remained identical: to highlight the lives and careers of Black individuals who had posed for artists, and who were sometimes themselves active in the arts, including Laure, the young woman who posed for the Black servant in Manet's *Olympia* (1863). In the Orsay exhibition their names and biographies appeared on dedicated labels, alongside the traditional label explaining the work on display. It was proposed, wherever possible, to create

Fig. 1
Glenn Ligon (born 1960)
Des Parisiens Noirs, 2019
13 neons, dimensions variable

a title reflecting the current state of research and, consequently, the name of the model when known.

The exhibition transformed hitherto anonymous figures into real people, with a first name, sometimes a surname, an address, a signature, a career path, the places where they lived, the traces of an encounter... Among them, the best known and documented were probably the Black personalities evolving in the performing arts and circus circles, whose presence in that sphere is notable from the beginning of the nineteenth century in France. Many of these artists came from the United States or the Caribbean, and had a family history at least partly linked to enslavement. They included Joseph, a native of Saint-Domingue (present-day Haiti), who was spotted by Géricault as a member of an acrobatic troupe in Paris, where he became one of the most famous artists' models of the century; the Havana musician Maria Martínez, admired by Théophile Gautier; the Shakespearean actor Ira Aldridge; and the virtuoso pianist 'Blind Tom'. All of them sought the opportunity to make a career in Europe through the recognition of their talent; just like Olga, who in the exhibition was accompanied by Philadelphia-born animal tamer Ledger Delmonico and Havana-born clown Rafael (alias Chocolat).

Many Black contemporary artists have paid homage to these models, asserting their enduring legacy. Glenn Ligon's 2019 installation *Des Parisiens Noirs (Some Black Parisians)*, commissioned by the Musée d'Orsay on the

occasion of the *Modèle noir* exhibition, literally brought to light the names of these models, most of whom had fallen into oblivion (fig. 1). In addition, the 2022–4 installation at New York's Metropolitan Museum of Art – around a long-term loan of the *Miss La La* study now on view in London (cat. 33) – featured a performance video made in tribute to Olga by the Black British aerialist Blaze Tarsha (commissioned by the Weston Park Museum, Sheffield, in 2018), as well as a photograph produced by the National Gallery (fig. 2). The Musée d'Orsay and Metropolitan Museum installations therefore likewise situated the history of this nineteenth-century muse, and of the artist who portrayed her, in alignment with the interests of the diverse societies of the present day.

We are delighted to see an exhibition devoted entirely to 'Miss La La' as a painting, as well as to Anna Albertine Olga Brown, in which her exceptional life and career are further explored, and we hope that many more exhibitions will be dedicated to the Black models who are fitfully emerging from the shadows into which they have been relegated for too long.

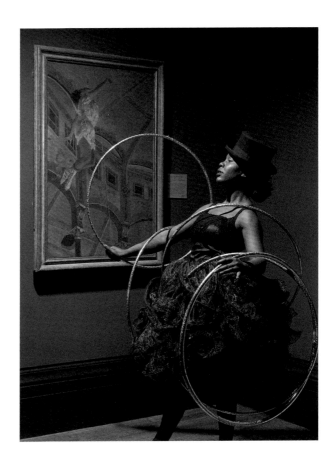

Fig. 2
Blaze Tarsha at the National
Gallery, London, 2018

ANNE ROBBINS

Paris, 1879:
Degas and Miss La La

A few minutes away from London's Trafalgar Square, in the National Gallery's Wohl Room, hangs a painting like no other. It depicts a circus acrobat in the middle of performing an 'iron-jaw' act. With folded legs and tightly stretched arms, a woman is being hoisted to the rafters of a circus by a rope attached to a bit clenched between her teeth (cat. 40). The taut cable is visible to her right – a straight line bisecting the image – but the picture does not show the pulley affixed to the roof, nor her stage partners on the ground, pulling the rope. Instead, we look up at her: a mixed-heritage young woman, her cloud of hair combed backwards, who wears a tight, shimmering outfit adorned with gold detailing, as well as matching booties. Despite the vertiginous height to which she is lifted, and the violence of her mouth contraption, she moves with exceptional poise and grace, seemingly unaware of the danger of her feat. We catch our breath as she ascends towards the rafters (or descends from them), against the circus's ornate architecture, in the building's warm, artificial glow. While conveying a sense of her slow, rotating movement, the painting captures her at the very moment when her pose and gestures mirror the diagonal lines of the cast-iron ceiling trusses.

The painting, signed at lower left on one of the metal beams, is a work by French painter Hilaire-Germain-Edgar Degas (1834–1917), who completed it in the first months of 1879. Then aged almost 45, his career had already spanned 20 years, progressing primarily in the mid- and late 1860s at the Paris Salon – where he showed history scenes and acutely observed portraits, before turning to subjects drawn from modern life. Standing out for their unusual motifs and composition, these pictures of racecourses, ballerinas and cafe scenes featured in the independent, artist-managed Impressionist

Cat. 40
*Miss La La at the Cirque
Fernando*, 1879
Oil on canvas, 117.2 × 77.5 cm
The National Gallery, London

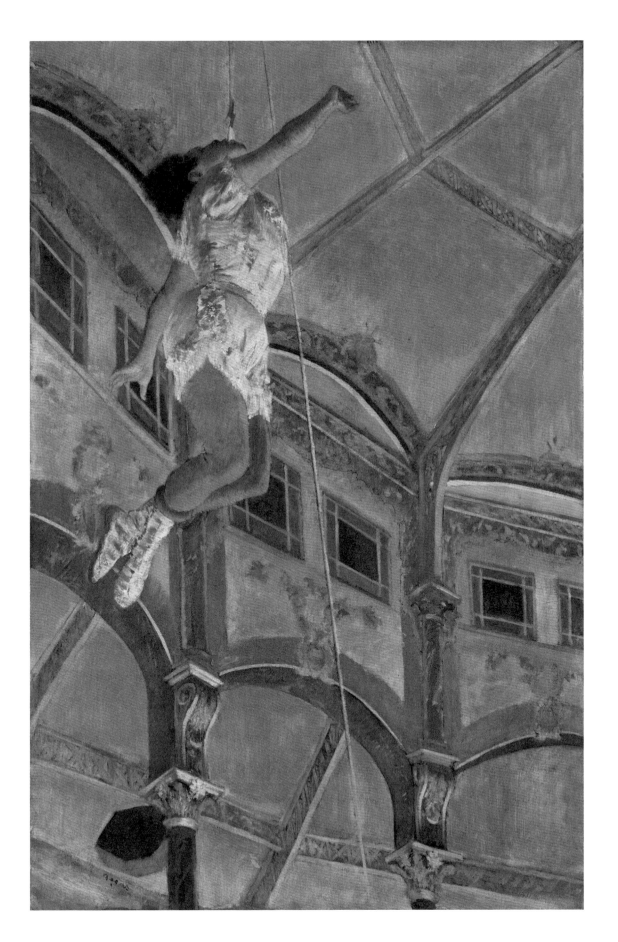

exhibitions that Degas helped organise from 1874 onwards,[1] or were sent to commercial galleries in England.[2] There, but primarily in Paris, critics, dealers and collectors were showing growing interest in his work.

Upon completion of his painting, which we now know as *Miss La La at the Cirque Fernando*, Degas sent it to the Fourth Impressionist Exhibition in April 1879, under the title *Miss Lola, au Cirque Fernando*, providing essential clues about the person and the place it depicts. Among the eight remaining drawings and pastels made by Degas in preparation for this work – in addition to about ten sketches in notebooks, and an oil and pastel study (cat. 33) – four are dated to different, almost consecutive days in January 1879, and bear Miss La La's name (with nearly correct spelling) inscribed by the artist.

The circus acrobat and aerialist Miss La La, or Anna Albertine Olga Brown (1858–1945), was performing at the Cirque Fernando in Paris on those dates, in an extraordinary act which would soon literally shoot her to fame, and which Degas came to watch. For about a decade, he had started to explore in his work the theme of women performers, dancers and singers, on stage or at rehearsal, in countless, highly personal and unusual variations. Yet in *Miss La La at the Cirque Fernando*, his skill for formal invention reaches new, unprecedented heights. The painting, which focused Degas's attention for at least a few months, is preceded by a whole body of work, forming a 'rare instance of specific documentation in Degas's work'.[3]

On account of its status as a one-off in Degas's oeuvre, not to mention its uncommon subject matter and viewpoint, the painting has long disconcerted viewers, ever since it entered the National Gallery's collection almost a hundred years ago, as one of the purchases made from the Courtauld Fund for the British nation.[4] While soon featured in two exhibitions celebrating these new acquisitions made from the Fund,[5] and, a few decades later, in a show gathering works from all eight Impressionist exhibitions,[6] the painting was perplexingly absent from the major international 1988–9 Degas retrospective held in Paris, Ottawa and New York.[7] Likewise, throughout *The Artist's Eye* exhibition series organised by the National Gallery from the 1970s to 1990 (each featuring works from the Gallery's collection, selected by a contemporary artist), it failed to make it into a single show, though these often included works by Degas.[8]

Only from the turn of this century have exhibitions and studies started to 're-discover' *Miss La La at the Cirque Fernando*, analysing it from a variety of perspectives: the world of the circus;[9] the story of its making;[10] the history of Black models.[11] In the wake of Professor Marilyn Brown's essential study of the painting, examining it in the light of Degas's relationship to race, two ground-breaking exhibitions looked at the work from the point of view of its sitter and her ethnicity. *Posing Modernity/Le modèle noir* situated Degas's painting in the context of Black subjects in avant-garde art in nineteenth-century Paris (see pp. 9–10).[12] By doing so, it forever changed the way in which we engage with representations of Black models.

The present exhibition, focusing solely on Degas's *Miss La La at the Cirque Fernando*,[13] attempts to interlace these novel approaches, weaving them with new research done specifically for this project, as well as the study of recently discovered material relating to Olga/Miss La La and Degas's painting, presented here for the first time. Three previously untraced or unknown drawings by Degas of Miss La La or her stage partner Theophilia Szterker (1862–1888) – the latter precisely dated[14] – join the body of preparatory works relating to Degas's project.[15] One of these, a large sheet showing Miss La La in her rope-and-pulley act, her profile delineated no fewer than three times, was last reproduced in the catalogue of the artist's final posthumous sale in 1919 (cat. 35).[16] The two other drawings, newly discovered, have never been published (cats 30, 37). In addition, we see Olga looking straight ahead in a group of family photographs, uncovered by researcher and biographer Laurie Fierstein (cats 15–20). This project thus provides a vital reassessment of Miss La La's life and career, the main elements of which had previously only been known through a physiologist's account dating back to 1910.[17]

Miss La La's Paris Debut

In 1879 Miss La La was, like Degas, already halfway into her career; she had been performing publicly for about 10 years. With a German-Prussian mother and an African American emancipated enslaved father, she was binational. West Pomerania, the part of Poland where she was born, had been Prussian since 1720 and would remain under German control until Poland gained its independence in 1918, and finally again post-war in 1945 – just a few months after Olga's death. Starting in 1869, having joined a small local circus troupe (comprising four acrobats only), she mostly toured within the confines of the German Imperial Reich and the Austro-Hungarian Empire – with the exception of a few engagements in England between 1875 and 1876 (see p. 122). Her company, then going by the name 'Miss La La and The Kaira Troupe',[18] arrived in Paris in December 1878, contracted by the Cirque Fernando for a whole year, for a show of acrobatic and iron-jaw acts.

Located on the southern edge of Montmartre, on a plot formed by the boulevard de Rochechouart, the rue des Martyrs and the rue Lallier, the Cirque Fernando was a relative latecomer in the rich landscape of Paris circuses – by the 1880s the capital counted seven permanent circuses[19] – but it was no less fashionable. First set up in the summer of 1873 as part of the annual 'Fête de Montmartre', by 1875 a makeshift circus tent (with only five artists and ten horses) was being replaced by a permanent home built just a few yards from where the temporary structure had first been erected (fig. 3, observed from its back, at the intersection between avenue Trudaine and rue Lallier), and the circus was being energetically managed by Ferdinand Constantin Beert (1835–1902), called Fernando, a Belgian circus entrepreneur. His stepson and artistic director Louis 'Fernando' (1851–1917) curated varied programmes, mostly novelty acts, best suited to the circus's relatively modest scale.[20] Its ring, a traditional 13 metres wide, was topped by two circles, the higher one supported

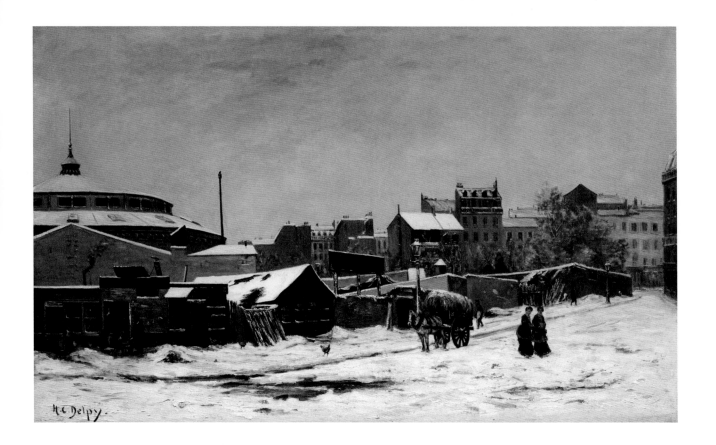

by 16 cast-iron columns that raised the roof to a height of over 20 metres; the ceiling was painted a warm peach-pink colour. It could hold over 2,000 spectators, who enjoyed various levels of comfort depending on the category of their ticket, according to price: from padded seats to simple benches with a 'butt stop' for seated visitors (fig. 4). The steep gradient ensured good acoustics and visibility; by daytime abundant light flooded through the windows, and by night gas chandeliers provided a warm, intimate atmosphere.[21]

In 1878 the Paris Universal Exhibition had brought the entire world to the French capital[22] and increased the public's expectation of seeing, in the many '*spectacles*' the city had to offer, foreign performers and troupes from abroad. That winter, now performing under the name 'Miss La La and The Kaira Troupe', the circus act formed part of an attractive programme that premiered at the Cirque Fernando on 10 December, alongside clown Boum-Boum[23] and a variety of other acts. One newspaper report praised the 'Térésa brothers, so comical and so intrepid in their exercises ... the graceful Miss Auguste Ducos; finally ... the famous Miss Lala, known as the Cannon Woman, who is admired by everyone in general, and by dentists in particular, for the power of her jaw'.[24] Success was immediate and 'stunning';[25] reviewers soon singled out Miss La La and her fellow 'Kaira troupe' partners, whose acrobatic group performance saw Olga progress from holding a little boy ('le petit Kara' [*sic*],

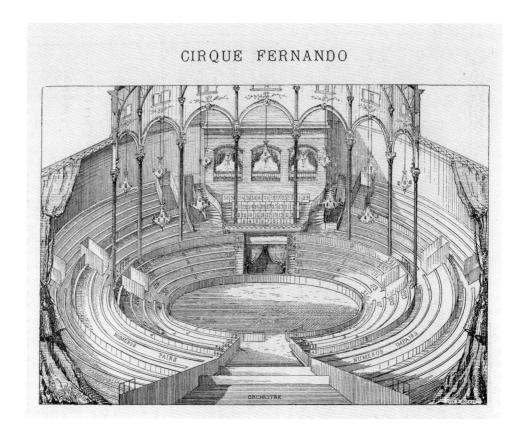

CIRQUE FERNANDO

Fig. 3
Hippolyte-Camille Delpy
(1842–1910)
*La rue des Martyrs, Paris in the
Snow*, 1876
Oil on canvas, 76.2 × 127 cm
Private collection

Fig. 4
Yves and Barret (engravers;
active around 1870–90)
*Plan of the Cirque Fernando,
with ticket prices*, undated
Engraving, 23.6 × 28.2 cm
Musée Carnavalet, Paris

thought to be Theodor Jüttner), to a woman (Theophilia Szterker), to a man (Franz Pospischil) by the strength of her jaw, culminating in suspending a cannon barrel, which weighed over 300 kilograms and was then packed with gunpowder and lit, with Olga still hanging on by her teeth.

Spectators were astonished, not to mention those living nearby: 'A few days ago, two cannon shots rang out in the Montmartre district. Emotions ran high. It was believed to be a gas explosion, and the neighbours of the Cirque Fernando went to get information from the doorkeeper … It was [in fact] the rehearsal of the incredible exercises of Miss Lala, who will certainly be the success of the theatrical season this winter …'.[26]

With its martial symbolism, the cannon may also have caused a different sort of 'frisson', one tainted with memories of the French defeat in the recent Franco-Prussian war (1870). Yet audiences, seemingly unaware of the troupe's Prussian identity – which was left out of the Cirque Fernando's marketing campaign – seemed undeterred.[27] In the following days and weeks, the troupe's star act became the talk of the town, increasingly centred on Miss La La herself. In the press, Olga eclipsed her fellow partners and became the headline for the show, acclaimed for her 'cannon exercise and ascent to the ceiling. This exercise, completely new and invented by Miss Lala, is the *nec plus ultra* of everything that has been seen to date.'[28]

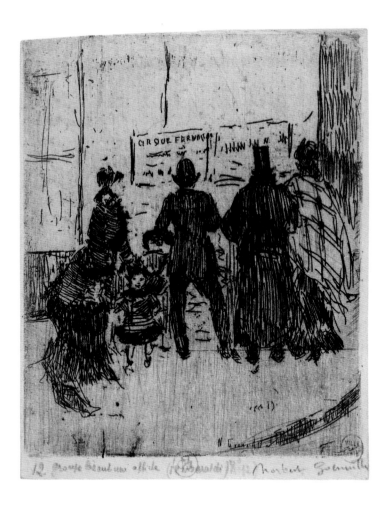

Miss La La's ever-growing reputation is reflected in the number and the tone of the newspaper articles praising her, both in France and abroad, extolling, for example, 'the dizzying success of the *négresse* Miss Lala, the Cannon Woman';[29] 'the Black Venus';[30] the 'Venus of the Tropics' who is 'all the rage at the Cirque Fernando'.[31] These French reviews ignore her foreignness, highlighting instead her otherness in racial terms. By emphasising her 'exotic allure'[32] in strongly racist terms, journalists relied on crude stereotypes, also to be found in the posters advertising the troupe's performance, and designed for maximum 'sensation'. With the extraordinary proliferation of posters in Paris since the middle of the nineteenth century – animating the city's uniform streets (fig. 5)[33] – entertainment venues were vying for exposure and publicity. The Cirque Fernando had no qualms about advertising Miss La La's alterity as a non-white performer, making a spectacle of her mixed-heritage identity.

It is not known how non-white circus artists, or other performers, felt about being depicted in these often brutally caricatural ways, both in text and image; nor what Miss La La made of featuring no fewer than five times on the poster advertising her act at the Cirque Fernando in the winter of 1878–9 (cat. 6),

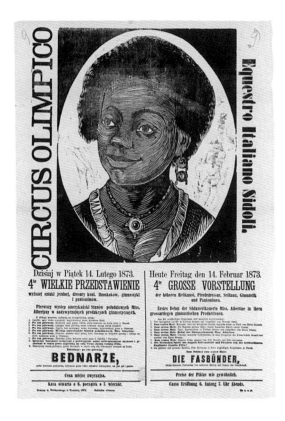

Fig. 5
Norbert Gœneutte (1854–1894)
*Group looking at a Cirque
Fernando Poster*, 1875
Etching, published in *Paris
à l'eau-forte*, 13 × 10.7 cm
Musée Carnavalet, Paris

Fig. 6
Anastazy Rusinowski (printer);
Volta (engraver)
*Circus Olimpico Equestro
Italiano Sidoli*, 1873
Wood engraving on paper,
63 × 45 cm
Jagiellońska Biblioteka,
Uniwersytet Jagielloński, Kraków

with the cannon prominently in the centre, her rope ascension to the right, and her ring partners reduced to tiny props. As a performing artist, albeit only 20 years old, she would have been used to seeing her image schematised and exoticised in posters (fig. 6)[34] or business photographs (cats 1–5). Olga may not have heard of Degas when he approached her to sit for him, but she was no doubt already very familiar with the exercise of posing 'in costume', in the setting of a studio – whether a photographer's or otherwise; a review dated 24 December 1878 informs us that 'Miss Lala and Miss Kaira are envied models for the painters of the neighbourhood'.[35] Miss La La's name, at that point, was undoubtedly more famous than Degas's.

Degas at the Cirque Fernando

With his studio only a stone's throw from the Cirque Fernando,[36] Degas had been attending the venue since at least 1876, with his fellow painters Edouard Manet, Pierre Puvis de Chavannes and Henri Gervex.[37] He and his artist friends may have benefitted from free access to rehearsals (see p. 88).[38] A regular at the circus, Degas would sketch there the clown Gougou (Arsène Loyal; cat. 29), rotund and cheerful, or another, unnamed clown, known only through a monotype – a lanky young man with dark, textured hair and gangly legs, possibly fallen on the sand floor (fig. 7). The ring's edge is evoked in the background by a curved line, also emphasised in a small lithograph, executed

by Degas at probably the same time, showing dogs and their trainer performing or rehearsing at Fernando's (cat. 27).

Degas watched Miss La La perform probably around mid-January, making rapid pencil sketches and notations in a small notebook pulled in and out of his pocket; several of these drawings are in reverse, indicating that he was working hastily, using his sketchbook occasionally upside down.[39] The journalist and theatre director Gabriel Astruc (who knew Degas in the 1880s) later recounted where the artist placed himself in the auditorium: 'In the last row ... right at the top, Degas sat, with notebook and charcoal pencil in hand, drawing ... Miss Lala, a woman who, suspended by her teeth, descended in this perilous position from the height of the rafters down to the ground.'[40] The cramped interior of the Cirque Fernando, not to mention the 'wicked light shed by [its] Quinquet oil lamps',[41] projecting some 'caricatural shadows', makes it improbable that Degas (whose eyesight was declining) would have been able to work 'on site' on any larger support, or in any other medium, let alone on a large oil painting.[42]

The largest drawings and pastels currently known of Miss La La[43] were in all likelihood executed by the artist in his studio at rue Fontaine,[44] where he asked the acrobat to come and pose.[45] In a letter to his friend, the writer Edmond de Goncourt (1822–1896), Degas invited him to attend a forthcoming sitting scheduled two days later, on a Saturday morning: 'From 10.30 to half-past noon, I will have my *négresse* and her partner ... Best wishes. E. Degas. Thursday evening.'[46] The painter may have approached Miss La La in the foyer of the Cirque Fernando, where performers and artists could socialise,[47] or the meeting could have been arranged through Rodolphe Rosinsky (1839–1896),

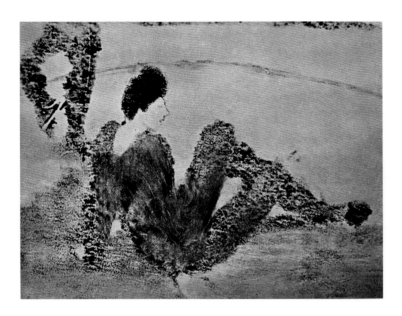

Fig. 7
The Clown, about 1877–8
Monotype, black ink on white
paper, 12 × 16.7 cm
Private collection

her manager.[48] A former acrobat, with the same geographical origins as Olga,[49] the Paris-based Rosinsky was described in March 1879 as 'her Sole Agent' – a sign of her growing status as an 'accomplished businesswoman'[50] – and the organiser of her upcoming tour to England from mid-February of that year; he would later be hailed as 'one of Paris's most important impresarios and artistic agents'.[51] Rosinsky may have been the 'manager' who accompanied Olga to Degas's studio some time in January 1879; a visit recalled by the sculptor Paul Paulin (1852–1937), a friend of Degas's, in such great detail that one wonders whether he himself may have been present as well: 'at the time when Degas made the painting of Miss La La hanging by her teeth, we had dinner together and spent the evening at the Cirque Fernando … He had the artist pose in his studio and the manager held the end of the rope that passed through a pulley on the ceiling of the room at 19bis rue Fontaine. He worked long enough and suggested that the acrobat rest because she was still hanging by her jaw and Degas was amazed by the fact that after the barman [*sic*] asked Miss La La [in English] "Are you tired?" she replied to him with a grunt that meant: a little but I can carry on posing'.[52]

Rosinsky might also be the 'barman' referred to in that letter, as well as Miss La La's 'camarade' mentioned in the note that Degas sent to Goncourt – although this person (despite being described as masculine in Degas's note: '*son* camarade') has usually been interpreted as being Miss La La's stage partner, Theophilia Szterker, also known as Kaira. Indeed, not just Olga, but Theophilia as well sat for Degas as part of these joint sessions – at least the one on 24 January 1879,[53] as evidenced by two drawings of her, on one of which the artist inscribed that date and the name 'Theofila Paira' (cat. 30).[54] Degas sketches her pressing her hands on a trapeze bar, as if to haul herself up. Paulin's full description gives us a sense of the number and complexity of props involved in these sessions, in order to recreate in Degas's studio Miss La La's pose hanging from a rope. Although she denied it, this would have been highly strenuous for Olga who, during that winter season, was in the ring with the entire troupe every evening at 8.30pm.[55] She soon focused the entire attention of the artist, who does not seem to have pursued Theophilia's pose any further, making Olga instead the sole motif of his painting.

As the 'inventor' of her rope-and-pulley feat,[56] Olga was 'a significant and active agent and participant in the production of the picture'.[57] The choice of depicting her in this act – as opposed to the cannon feat – also required a more manageable amount of accessories, and allowed Degas to explore effects of asymmetry, in stark contrast with the 'heraldic' composition seen on the circus poster of François Appel (1821–1882), organised around the cannon.[58]

Among the large drawings and pastels done by Degas in preparation for the painting, four are dated to 19, 21, 24 and 25 January 1879 (fig. 8, cat. 32, fig. 9 and cat. 36), informing us of the days when at least some of these studio sittings may have taken place. Degas's use of the possessive pronoun ('*ma négresse*') when describing Miss La La in his note to Goncourt implies a certain degree

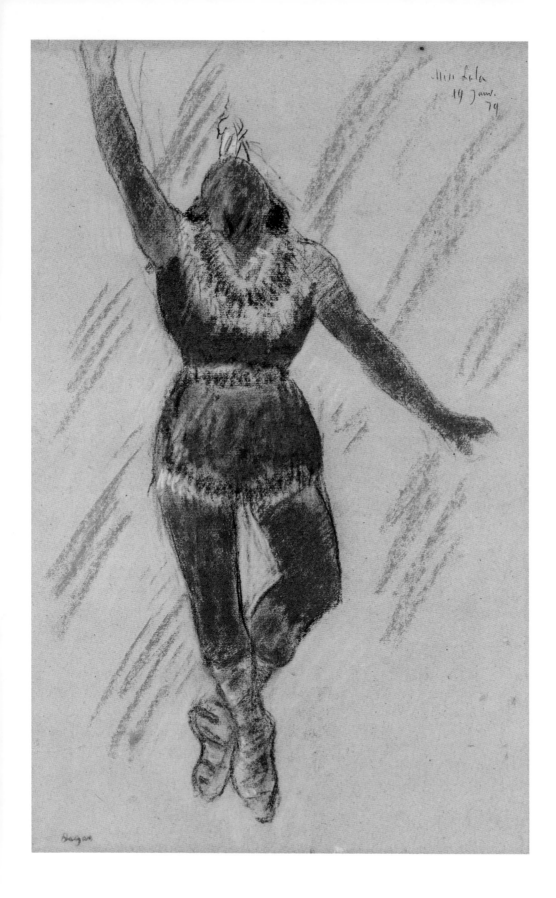

Fig. 8
*Study for Miss La La at the
Cirque Fernando*, 1879
Pastel on paper, 48.6 × 31.8 cm
Speed Art Museum,
Louisville, Kentucky, Bequest
of Mrs Blakemore Wheeler,
Conservation funded by Mr and
Mrs William O. Alden Jr., 2004,
1964.31.10

Fig. 9
*Miss La La at the Cirque
Fernando*, 1879
Pastel on paper, 61 × 47.6 cm
Tate, London, Presented
by Samuel Courtauld 1933

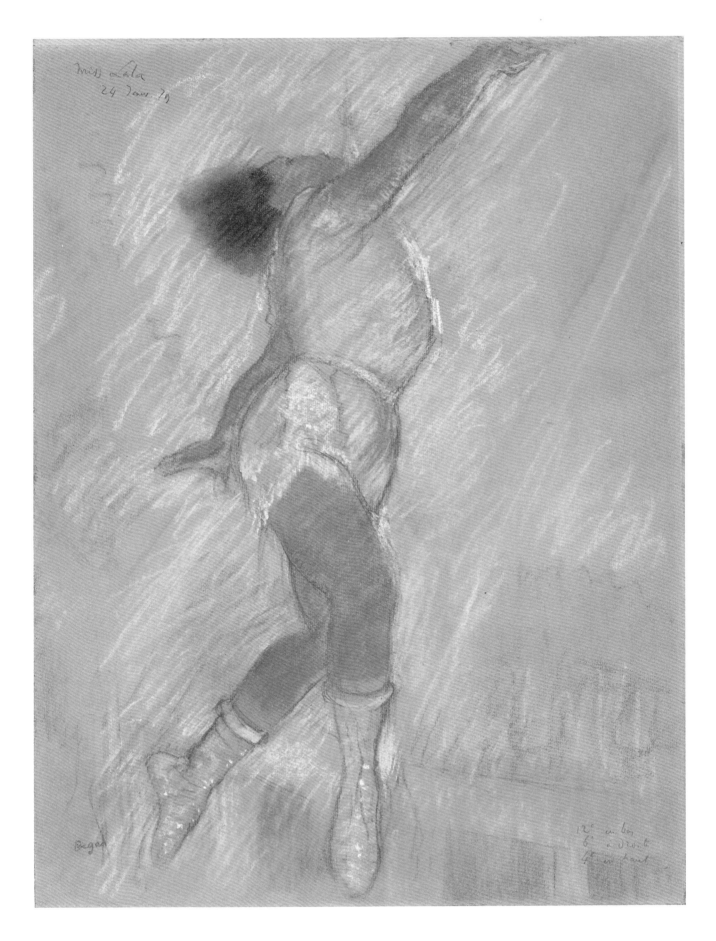

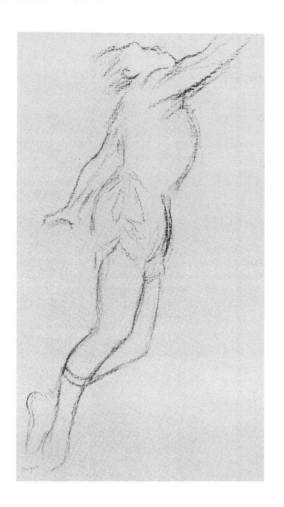

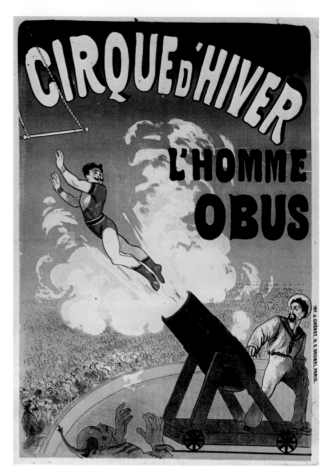

of familiarity between the artist and the acrobat, suggesting that he and Olga already knew each other, and that the forthcoming sitting in the studio was a repeat exercise.[59] Degas's date indications enable us to retrace precisely the elaboration of his project, starting with the large pastel showing Miss La La wearing a striking red fringed costume (fig. 8) – identical to the one seen in the Appel poster. With its frontal, slightly stiff depiction, this pastel may have been based on Appel's printed image, which was possibly the very first representation of Olga that Degas came across that winter.

One of Degas's initial drawings (now untraced; fig. 10), may have been inspired by a different poster – not of Miss La La, but announcing an earlier, unrelated acrobatic performance of an 'homme obus' at the Cirque Fernando in 1876 (fig. 11). She appears, like the 'Cannon Man' on Jules Chéret's poster, weightless and arrow-like, as if propelled from below; and on the diagonal, rather than suspended from above. Did Degas work from posters, then switch from them to making life drawings of Olga? This practice of basing paintings on commercial posters would later be adopted by Georges Seurat when painting his masterwork *Le Cirque*.[60] These two early Degas studies (figs 8, 10) show him

Fig. 10
Study for Miss La La at the Cirque Fernando, 1879
Charcoal on paper, 48 × 28.5 cm
Private collection

Fig. 11
Jules Chéret (1836–1932)
Cirque d'Hiver. L'Homme obus, 1876
Colour lithograph, 122 × 90 cm
Bibliothèque nationale de France, Paris

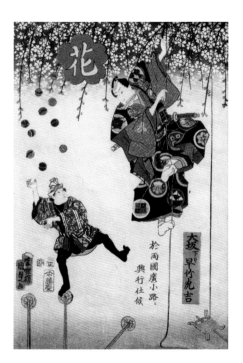

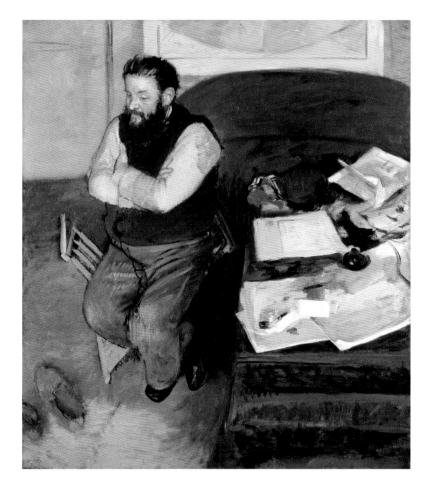

exploring formal ideas possibly before he even met, or watched, Miss La La at the circus. In her final pose, perfectly vertical, the acrobat looks to the right, seen in a three-quarter view; she is positioned asymmetrically at the top left of the canvas, with an arresting *di sotto in sù* effect, viewed 'from below to above'.[61] The composition also attests to Degas's intense interest in Japanese prints (fig. 12), which he fervently admired and would later collect in large numbers.[62]

Leafing through Degas's notebooks, filled with sketches done at the Cirque Fernando, gives a hint of what was on his mind in these months. Next to random notes jotted down on the earliest of these carnets, Degas states his intention to concentrate on drawing or painting figures from a new perspective: 'after having made portraits seen from above, I will do some seen from below'.[63] This was a project he brilliantly achieved in *Miss La La at the Cirque Fernando*, which it is instructive to compare with his portrait of Diego Martelli, this time observed from above, on which he worked at about the same time (fig. 13).[64]

On the pages of another notebook, where he also sketched Miss La La (cat. 31), are pencil drafts for the announcement of the other endeavour

occupying him at the time: the Fourth Impressionist Exhibition, an event he was in the midst of planning. In those weeks, Degas was busy looking for a venue for the show, scurrying to get his artist friends to enrol (or not to withdraw), and scrambling to get a selection of works to display. A letter to his friend Félix Bracquemond (1833–1914) reveals that he had already 'drawn up the list of his submissions';[65] indeed, such a list appears on the pages of his notebook, recapitulating the pictures to be sent to that show, including '8. Miss Lala'.[66] Probably still in the making at that point, the painting was thus firmly intended, from the outset, as an 'article d'exposition', i.e., in his own words, a work to be shown publicly. This throws light on Degas's decisions as he conceived and progressed in his Miss La La 'project'.

Degas and his Artistic Milieu

The first three Impressionist exhibitions had had mixed success at best, yet Degas, unlike some of his friends (Pierre-Auguste Renoir, that year, as well as the previous and following years; Claude Monet, the next), would never revert to the Paris Salon, where he sent works for the last time in 1870. Since the death of his father five years earlier, the artist had fallen on hard times; thanks to the efforts of proactive dealers, the market for his pictures was burgeoning, but he also relied on the Impressionist exhibitions as a crucial platform to test his ideas, impose his vision and increase his sales. There was, for him, a lot at stake, hence the time and attention he invested in the making of his 'articles', not least Miss La La at the Cirque Fernando, with a sophisticated studio set-up and live model sessions. For all its formal audacity, the picture was painstakingly prepared, following steps characteristic of academic art: sketches, studies from life, compositional sketching, drawings squared for transfer on canvas – a thoroughgoing process that was far from experimental.

The urge to make an impact may also have determined the subject of his picture. With a painting on the theme of the circus, Degas was giving himself the best possible odds, as circuses were enjoying unprecedented popularity in Paris at the beginning of the Third Republic. This was reflected in the literature of the time, with works including Jules Claretie's novel Le train 17 (1877), probably set at the Cirque Fernando, and Edmond de Goncourt's Les Frères Zemganno, a novel of circus life published a few weeks after Degas completed his painting in 1879 (see p. 36). Circus subjects also permeated the walls of the Paris Salon, where works on this theme had, since the late 1860s, been favourites, such as the Prussian painter Paul Meyerheim's La Parade devant le cirque (Salon of 1867),[67] or the American Frederick Arthur Bridgman's Un cirque en province (Salon of 1870) (fig. 14).[68] For the French artist Maurice Blum (1832–1909), circus scenes were becoming a 'niche': at the 1874 Salon, he showed Une répétition au cirque Fernando,[69] and the following year Artistes de cirque (cat. 26),[70] both set at the Cirque Fernando. Indeed, Blum took such pride in the former that he included it in a painting showing the interior of his studio, being admired (and possibly purchased) by a visitor (fig. 15).

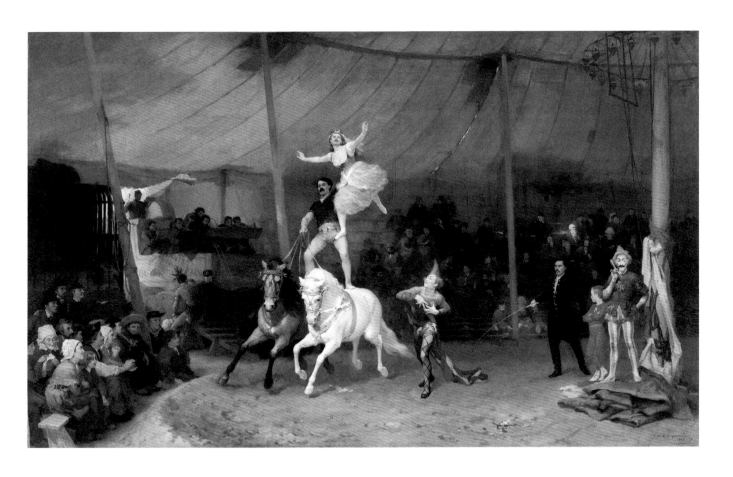

Fig. 14
Frederick Arthur Bridgman
(1847–1928)
*Un cirque en province (The
American Circus in France)*,
1869–70
Oil on canvas, 75.5 × 123.8 cm
Private collection

Fig. 15
Maurice Blum (1832–1909)
In the Artist's Studio, 1885
Oil on panel, 55.5 × 45 cm
Private collection

Miss La La at the Cirque Fernando may not have been the first (nor the last) circus-themed artwork to feature in an Impressionist exhibition,[71] but with his arresting, highly accomplished picture of a fashionable venue, Degas was making his mark. Starring Miss La La in one of her most famous acts, the painting was also, for Parisian viewers, immediately relatable to a '*spectacle*' they may have seen and enjoyed (it was, that winter, an unmissable event: 'As for Miss Lala, she is the attraction of the day; to admit that you have not seen her is to lose your reputation as a Parisian').[72] By naming the sitter and the painting's title, in print in the catalogue of the Fourth Impressionist Exhibition, was Degas capitalising on *her* success? Miss La La's celebrity would certainly have helped in getting the picture noticed. A well-informed journalist writing on the eve of the opening of the exhibition, 'committing some indiscretions about the pictures to be sent by these artists', mentions 'Miss Lala (*la femme-canon*)' as one of the highlights to be expected that year, next to 'portraits and pastels'.[73]

Impressionists and Black Sitters

Olga was highly identifiable in the exhibition, not only as a renowned aerialist, but also as a woman of colour. Degas's painting was not the first depiction

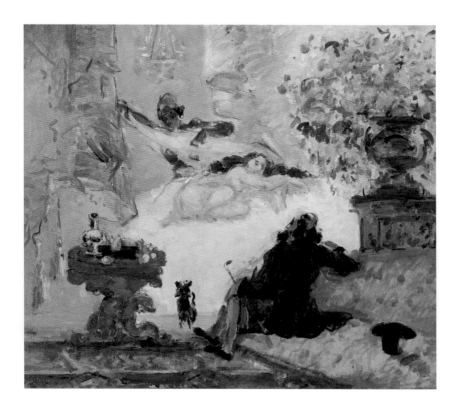

Fig. 16
Paul Cezanne (1839–1906)
A Modern Olympia. Sketch,
1873–4
Oil on canvas, 46.2 × 55.5 cm
Musée d'Orsay, Paris

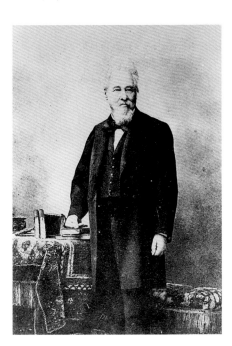

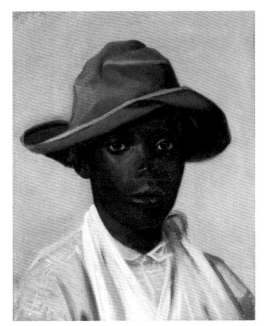

Fig. 17
Unknown
Norbert Rillieux (1806–1894)
Photograph
Louisiana State Museum,
New Orleans

Fig. 18
Camille Pissarro (1830–1903)
Portrait of a Boy, 1852–5
Oil on canvas, 37 × 30 cm
Ordrupgaard, Copenhagen

of a non-white person to appear on the walls of an Impressionist exhibition; indeed, it had been preceded by Paul Cezanne's work, *A Modern Olympia. Sketch* (fig. 16), included in the first of these group shows, and by Degas's own *Courtyard of a House (New Orleans, Sketch)*, in the second (cat. 42). But unlike these works, *Miss La La at the Cirque Fernando* – a finished painting – made its sitter instantly recognisable, not just by virtue of its title. Olga's features, in lost profile, are barely visible, but her identity is clearly stated. While Black sitters had started to become a key component of modernity since Manet's *Olympia* (1863, featuring the artist's model Laure next to the red-haired Victorine), they remained paradoxically a rare occurrence in avant-garde exhibitions. Cezanne's crude, probably imaginary brothel scene (explicitly deriving from Manet's painting) shows a Black servant lifting a veil on a prostitute; Degas's *Courtyard of a House* depicts, on the steps of his relatives' home in New Orleans, a Black nanny looking after his nephews and nieces – a scene directly observed by the artist during his 1872–3 trip to Louisiana (see p. 48).

Since Degas himself had non-white relatives on the maternal side of his family – the mixed-heritage Norbert Rillieux (1806–1894; fig. 17) was a first cousin of his mother, Marie Célestine Musson (1815–1847) – observing and interacting with Olga may well have brought particular associations and reminiscences, not least memories of his stay in New Orleans. Given their family backgrounds, two other artists participating in the Impressionist exhibitions could conceivably also have shown images of Black sitters – Camille Pissarro (1830–1903) and the marquise de Rambures (1844–1924),[74] both originating from the West Indies – yet, they do not seem to have done so.

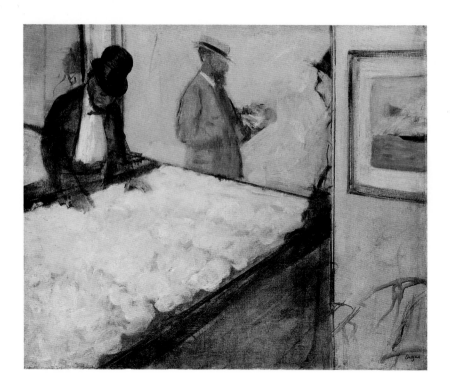

Born on the island of St Thomas, and raised there until his 12th birthday – a pupil in an all-Black primary school[75] – before moving to Venezuela and painting its inhabitants (fig. 18), Pissarro never seems to have depicted Black sitters again while in France, and sent to the Impressionist exhibitions (to all eight of which he contributed) only his most recent productions, almost all scenes from rural life in France. The marquise de Rambures, born in Guadeloupe and thus Creole like Pissarro's and Degas's mothers, left the island as a child, and her personal circumstances do not appear to have permeated the 10 pictures she sent, under the pseudonym Jacques-François, to the Impressionist exhibitions.[76] Degas, born and raised in Paris, but with specific ties to the 'Black world' he had experienced first-hand in Louisiana (fig. 19) – one of the reviewers of the 1879 exhibition even described him as '*ce Néo-Orléanais*'[77] – remained the only Impressionist to ever send to these group shows a picture with a named, identifiable Black sitter as its sole subject.

Reception and Afterlife of a Masterpiece

Miss La La at the Cirque Fernando would prove the most ambitious, highly finished work that Degas sent that year (the remarkable portrait of Diego Martelli, about as large, likely never joined the show), or indeed to any of the seven Impressionist exhibitions in which he participated.[78] On 9 April 1879, 'all the walls of Paris were covered with superb posters, where this title [*Artistes Indépendants*] shone in immense letters',[79] and the painting was being trumpeted about in the press.[80] Yet the following day, when the exhibition

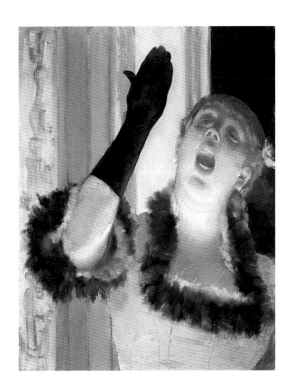

Fig. 20
Singer with a Glove, about 1878
Pastel on canvas, 53.2 × 41 cm
Harvard Art Museums/Fogg
Museum, Bequest from the
Collection of Maurice Wertheim,
Class of 1906, 1951.68

opened its doors in an apartment on the avenue de l'Opéra, the picture
was not there; in fact, the majority of Degas's works listed in the catalogue
were missing. 'Do not believe ... that Degas has sent his 27 or 30 numbers',
complained Gustave Caillebotte (1848–1894), his fellow Impressionist. 'This
morning, there were eight paintings by him' – a repeat occurrence for Degas,
and a trait his friend found deeply irritating: 'He is very annoying, but one has
to admit that he has a lot of talent. There are some astonishing things.'[81] The
late arrivals slowly trickled in,[82] with *Miss La La* finally joining the exhibition
by 27 April,[83] among a richly varied selection of new works: portraits, radical
scenes from modern life (fig. 20) and numerous fans (there may even have
been a project for a wall decoration).[84]

One can only speculate as to why Degas postponed sending his
masterwork. The painting was probably already complete by then; Olga had
long left Paris for London (her winter performances at the Cirque Fernando,
extended by four days by popular demand, stopped on 9 February),[85] and
Degas's correspondence indicates that he had moved on to other projects.[86]
Was he delaying the painting's 'disclosure' to ensure greater attention?
Whatever the strategy, it backfired. The picture attracted very few reviews:
principally the ironical remarks by art critic Armand Silvestre (1837–1901) on
Degas's incongruous topic, with some words of praise for its drawing, which he
judged to be 'of exquisite truth and accuracy'.[87] Another reviewer lauded, more
generally, Degas's use of 'glowing incandescent reds, coppery radiations, and
twilit half-tones'.[88] The comments by writer Joris-Karl Huysmans (1848–1907),

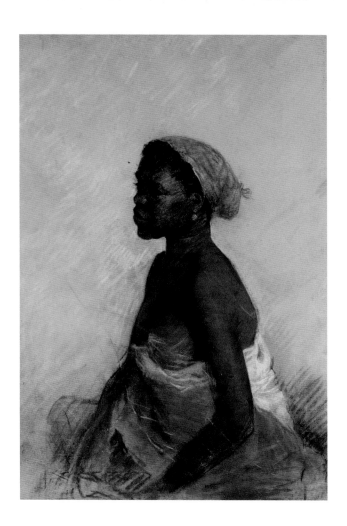

Fig. 21
Giuseppe De Nittis (1846–1884)
Black Woman, Female Figure,
1883
Pastel on canvas, 89 × 63 cm
Museo Civico, Castello

Fig. 22
Durand-Ruel gallery label on
stretcher of Degas's *Miss La La
at the Cirque Fernando*, with
inscription 'Degas/L'acrobate'
and the gallery's stock number
'10347'

written the following year, but clearly recalling Degas's *Miss La La*, remain the most astute, if also brief, extolling his 'skilful and yet simple painting, focusing on the most complicated and the most audacious poses of the body ... on the most unexpected effects of perspective, daring, in order to give the exact sensation of the eye that follows Miss Lola [*sic*] ... to make the circus roof lean wholly to one side!'[89]

During that spring in Paris, two other paintings with the Cirque Fernando as their subject were also on view, and attracted possibly more attention than Degas's: at the Salon, *Les Chiens savants* by the indefatigable Maurice Blum (cat. 25), and at the Galerie de La Vie Moderne, Renoir's delightful *Acrobats* (cat. 28), depicting two young circus girls in the ring, gathering oranges, wearing the same outfit as Miss La La in Degas's painting.[90] In a major break with his Impressionist friends, that year Renoir had favoured the Salon to show his work, as well as this new exhibition venue – attached to the magazine *La Vie Moderne* – which in June 1879 gave him a solo exhibition, largely of pastels, but including this remarkable work: 'two small girls in pink tights, bordered with a strip of silk

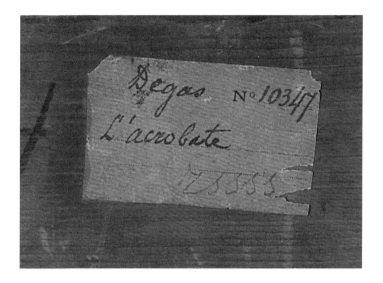

fringed in gold … The gestures could not be more accurate, the physiognomies more true, the harmony of tones more clear. We are not facing a picture, we are facing a reality.'[91]

After its two short weeks' public exposure in 1879, *Miss La La at the Cirque Fernando* remained behind closed doors in Degas's studio, gathering dust for almost a quarter of a century, only seen by occasional visitors. One can surmise that Paris-based Giuseppe De Nittis, a close friend of the artist, may have seen it, or more evidently some of Degas's Miss La La pastels; De Nittis's handling of the medium in one of his own depictions of a Black woman strongly echoes Degas's technique and colour harmonies (fig. 21).

In 1902 Degas left his painting on consignment at the Durand-Ruel gallery, where it was recorded as 'L'acrobate' (fig. 22), causing the momentary erasure of its title and, consequently, of the sitter's identity.[92] It carried that generic title as far as Berlin, where it was sent to an exhibition in 1903,[93] before being labelled 'Miss Zaza at the Cirque Fernando' in the vast Impressionist exhibition that Durand-Ruel mounted in 1905 at London's Grafton Galleries. A reviewer distorted her name further into 'Miss Zozo at the Cirque Fernando'.[94] By then, in London (despite her remarkable success there in the spring of 1879) and elsewhere, the acrobat's name was largely forgotten.

Olga had retired from the ring in 1891, and went on to settle in Brussels with her family (see p. 74). She would not have been able to see Degas's painting of her at the 1879 exhibition (she was touring England at the time), and would have been unaware of it travelling to Berlin, London and Toronto, where it remained for almost two decades (see p. 60). By the time the painting entered the National Gallery in 1925,[95] Degas had been dead for eight years and Olga, now

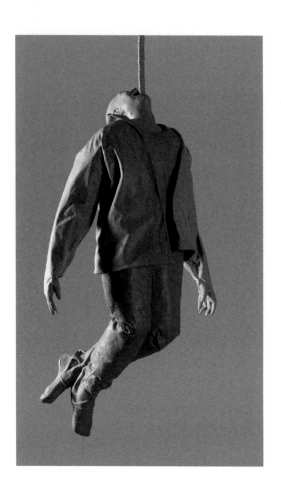

Fig. 23
Juan Muñoz (1953–2001)
Hanging Figure (After Degas),
1997
Resin, pigments, paint and
electric motor, 150 × 72 × 56 cm
(resin figure); 152 × 73 × 35 cm
(electric motor)
Musée de Grenoble

widowed, would soon become a grandmother. Degas had kept with him all
the preparatory drawings; his passing meant that these resurfaced at his
posthumous sales, putting them back in the public's eye, and reminding them
of the artworks' – and Olga's – astonishing grace and power. In Britain, Samuel
Courtauld (1876–1947), having funded the purchase of the painting for the
National Collection, bought the next year – for his own private collection – one
of the most accomplished preparatory pastels (fig. 9). He presented it in 1933
to the recently renamed Tate Gallery (previously National Gallery, Millbank),
where it joined the painting in the museum's Modern Foreign Art Galleries.[96]
These works inspired in British painters of the period a number of stunning
circus-themed artworks, drawing on the same compositional formulae as Degas's
painting, and conveying a similar atmosphere of thrill, fear and excitement.

One of Degas's obituaries, evoking *Miss La La at the Cirque Fernando* and
the circumstances of its creation, stated that 'the artist had actually seen the
clownesse being hoisted slowly towards the top of the circus, suspended by
her teeth, heavy, a little bent, her hands flapping like fins, like a big silly fish
that the hook is reeling in'.[97] This description brings to mind Spanish sculptor
Juan Muñoz's *Hanging Figure (After Degas)*, one of the most extraordinary and

harrowing responses to *Miss La La at the Cirque Fernando* made in the past 30 years – an installation reminiscent of torment and torture (fig. 23).

Works by Degas, 'which represent, with such striking truthfulness, the people he takes from the contemporary world', as Zola wrote,[98] continue to resonate profoundly today, in a variety of ways[99] – not least in the enigmatic paintings of Lynette Yiadom-Boakye, often featuring ballerinas and gymnasts. In her triptych *Liberation Compass* (fig. 24), a young female acrobat stands on (or by) a large circle that looks like a circus ring. She looks away, her face in lost profile – like Olga after her performance, feet back on firm ground, taking 'the compliments that are heaped upon her in the way of hearty plaudits with becoming reserve, and bow[ing] her acknowledgments in style'.[100]

Fig. 24
Lynette Yiadom-Boakye
(born 1977)
Liberation Compass, 2018
Oil on linen, triptych, 200 × 130 cm
(78.7 × 51.1 cm each)
Corvi-Mora, London, LYB18-31

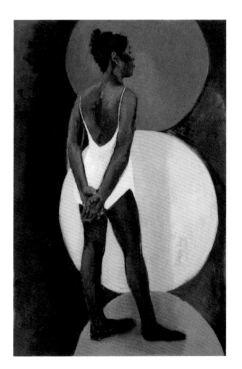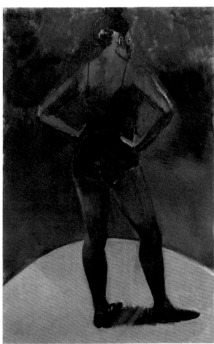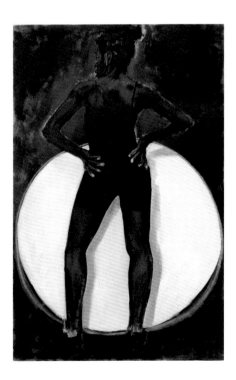

CHIARA DI STEFANO

The Artist, the Writer and the Aerialist

In the very first weeks of 1879, Degas arranged for aerialist Miss La La – whom he had seen perform at the Cirque Fernando – to come and pose in his studio. Having set the date, he invited his friend, the writer Edmond de Goncourt, to join them. Miss La La (Anna Albertine Olga Brown) and her 'partner' – Degas assured Goncourt – 'would be at [his] disposal'.[1] At the time Goncourt was working on *Les Frères Zemganno*, a circus novel he would publish a few months later. The story focuses on two acrobats, Nello and Gianni Zemganno – literary transpositions of Edmond and his brother Jules – and their quest for aesthetic innovation in trapeze acts. Degas would later praise the book lavishly. In his early biography of the artist, Georges Rivière states that he 'spoke of it to all his friends'.[2] Goncourt and Degas's concurrent interest in aerialists was in fact shared by many of their contemporaries: *Les Frères Zemganno* and *Miss La La* were far from being the only works of the time set in a circus (see p. 26).

In the second half of the nineteenth century, the infatuation for the circus was at its peak. An astonishing number of texts focusing on clowns and acrobats were published in a few years – from novels to short stories, memoirs to essays. 1879 alone saw the publication of Catulle Mendès's *La Vie et la mort d'un clown* and Richard Lesclide's *Mémoires et pantomimes des frères Hanlon Lees*, among many others. Joris-Karl Huysmans's essay 'Les Folies-Bergère en 1879', published the following year in his *Croquis parisiens*, extensively mentioned the aerialists Hanlon-Lees, major celebrities of the day.[3] Indeed, even the French word for aerialist ('trapéziste') is attested for the first time in 1879 (in *Les Frères Zemganno*, p. 53). Moreover, several writers saw trapeze acts as metaphors for artistic talent. Among them were Théophile Gautier and Jules Barbey d'Aurevilly – two authors Degas cited or mentioned in his notebooks.[4]

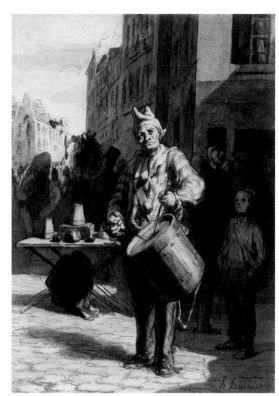

Fig. 25
Antonio Mancini (1852–1930)
Il Saltimbanco, 1879
Oil on canvas, 203.8 × 110.8 cm
Philadelphia Museum of Art,
Vance N. Jordan Collection,
2004, 2004-108-4

Fig. 26
Honoré Daumier (1808–1879)
Clown playing a Drum, about
1865–7
Pen and black and grey ink, grey
wash, watercolour, touches of
gouache, and conté crayon, over
black chalk underdrawing, on
paper, 35.4 × 25.6 cm
British Museum, London,
1968,0210.30

Circus painting, although considered a minor genre, had also been flourishing since as far back as the 1860s. The Cirque Fernando, in particular, was an exceptionally popular theme for artists. Painters and illustrators as varied as Antonio Mancini (*Il Saltimbanco*, 1879, fig. 25), Honoré Daumier (*Clown playing a Drum*, about 1865–7, fig. 26) and Gustave Doré (*Les Saltimbanques* (*L'Enfant blessé*), 1874), as well as Maurice Blum (cat. 25) and Pierre-Auguste Renoir (cat. 28), explored the subject extensively (see also p. 88).[5] Daumier, in particular, an artist highly esteemed by Degas (who, by the end of his life, owned one painting, five drawings and 750 lithographs by him), had depicted several sideshow scenes, and in 1836 illustrated the first French 'roman de saltimbanques'.[6] Circus acrobats were also a favoured motif in Japanese woodblock prints, which Degas collected and deeply admired.[7]

In the same years, poster art rose to unprecedented fame, becoming an integral part of the visual environment of everyday life, at least in cities. Commenting on the Salon of 1879, Huysmans stated that the paintings on show certainly did 'not measure up to the commercial posters on view on street walls and boulevard kiosks, these small pictures representing the corners of Parisian existence, the vaults of the ballet, the English pantomimists, the interiors of the hippodromes and circuses'.[8] Only 10 years later, the lithographer Jules Chéret (1836–1932), creator of astonishing posters, would receive a gold medal at the Paris Universal Exhibition.[9]

In a period when boundaries between writers and artists were blurry, the shared passion for literature, circus and art brought together some of the most prominent figures of the time. However, before becoming an elite whim, the fascination for the circus was first and foremost a mass cultural phenomenon. Some acrobats and clowns were internationally famous, and aerialists such as Miss La La and Leona Dare were among the most acclaimed celebrities of the age.

As *Miss La La* is the only painting by Degas set in a circus, this location did not initially attract the amount of contextual studies devoted, for instance, to the Ballet de l'Opéra, which formed the subject of so many of Degas's works.[10] However, from the 1920s, several authors – early biographers and eminent scholars alike – mentioned Degas's passion for the circus, drawing a parallel between Olga's acrobatic stunt and his own artistic *tour de force*.[11] Thanks to these studies, and drawing on recent research, it is possible to reconsider *Miss La La* by placing it in the context of the broad circus imagery of the era, reconstructing, if not Degas's initial intentions, then at least the way in which his contemporaries may have approached and understood his painting. What did it mean to portray an acrobat in 1879 Paris? How were aerialists depicted in art and literature, and what connotations did they carry for late nineteenth-century viewers?

The Clown, the Equestrienne and the Aerialist

The Cirque Fernando (renamed Medrano in 1897) was a favourite haunt of artists, and Degas was an *habitué*. The painter Henri Gervex (who would later return there with him and Jean-Louis Forain[12]) recalled how, in 1876, he encountered Degas at the circus, alongside Manet and Puvis de Chavannes.[13] According to the critic Gustave Coquiot, Degas visited the Cirque Fernando 'countless times'.[14] In his monograph on the artist, Coquiot describes the venue in the most evocative terms, extolling 'the special smell of the circus – made of everything, the smell of horse dung, the spectators' breath, the pommade spread on every hair ... the smell of lady acrobats'.[15] When the Cirque Fernando opened its doors in the mid-1870s, it was Paris's fourth permanent circus; other venues would rapidly follow. In fierce competition against each other, these venues renewed and diversified their programme regularly. But despite the wide range of performances, the shows were always organised around three key acts: the clown, the circus rider and the acrobat. As central figures of bohemian life, living in the margins of society, their personas came to embody specific topoi and types in nineteenth-century culture, serving as mirrors of their times.

The image of the clown as the poet's (artist's) double is probably the best-known. Heir to the medieval buffoon, the modern clown – who was often also a skilled acrobat – took inspiration from the Italian *Commedia dell'arte* and was initially depicted as Pulcinella or Harlequin. Over time, the clown's specific identity overlapped with that of the *saltimbanque* (itinerant performer), nourishing the Romantic theme of the pariah. An *exilé* and an outcast, condemned to public exposure but ultimately rejected by society, the clown became a favourite metaphor for the artist/writer himself.[16] For nineteenth-century, predominantly

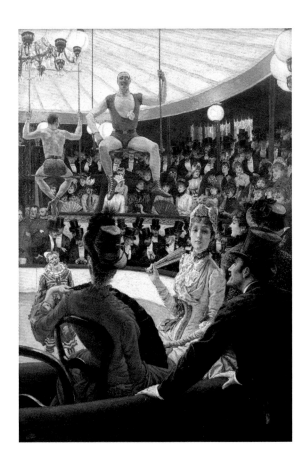

Fig. 27
Jacques Joseph (James) Tissot
(1836–1902)
*Women of Paris: the Circus
Lover*, 1885
Oil on canvas, 147.3 × 101.6 cm
Museum of Fine Arts, Boston,
Juliana Cheney Edwards
Collection, 58.45

male, writers and thinkers, this identification was reinforced by the clowns' gender, since, with few exceptions, most of them were men.

Conversely, in the last quarter of the century, the most successful circus riders and aerialists were women – a reflection of the general movement of sexualisation and eroticisation of leisure that accompanied mass consumption under the Third Republic.[17] During Degas's lifetime, in particular, women acrobats rose to unprecedented fame. Actresses and riders such as Adah Isaacs Menken (1835–1868) and aerialists such as Leona Dare (1854/5–1922) colonised the collective imagery, becoming emblems of radical otherness (see pp. 40–1).

With surprising consistency across sources, the equestrienne and the female aerialist were widely regarded as variations on the 'femme fatale': alluring yet dangerous, attractive yet castrating.[18] Occasionally a site of casual prostitution, in nineteenth-century France the circus was above all a voyeuristic space. There, both men and women could enjoy the view of athletic bodies in revealing attire. This inspired a mix of desire and anxiety, prompting a variety of creative responses from artists, including James Tissot's *Women of Paris: the Circus Lover* (fig. 27), painted in 1885. Tissot's work, set in the Cirque Molier,[19] evokes a passage from an 1878 poem titled 'Sept Journées au Cirque Fernando', published in the magazine *L'Orchestre*:

The grand bourgeoise struts on the balcony,
smiling at the gymnast she admires on the ceiling
Her husband examines her
A puffed-up man with no emotion
And on Thursday the lady bows to her choice.[20]

Despite some exceptions, most eroticised accounts of circus acts refer to lady performers. Spectacles featuring female acrobats were 'coded for erotic display [according to] the traditional conjugation of male gaze and female "to-be-looked-at-ness"'.[21] A whole generation of French writers fantasised about female performers, whose bodies were displayed in unusually close-fitting costumes. And while an adolescent Flaubert dreamed of a tightrope walker's 'thighs squeezed in her pink trousers ... her big gemstones necklace hitting her breast', Jules Vallès, writing in 1864, associated the enduring memory of a lady acrobat with 'the living statue of voluptuousness'.[22]

In the visual culture of the era, the sexualisation of female circus artists was reinforced and disseminated through at least two channels: fashionable studio photographs of performers (collectible *cartes de visite* were a 'currency for erotic fantasy'[23]) and graphic art (cats 1–14).[24] Chéret's posters, in particular, were considered highly provocative by the standards of the time, prompting both vehement attacks by Catholic authors and lurid responses by decadent writers.[25]

Unlike the aristocratic *haute école* rider, respectably dressed and performing classic dressage tricks, the *voltige* rider – vaulting bareback – often personified the object of desire in this eroticised context in quite a literal way. One of the *voltige* rider's most common performances featured a love triangle between herself, the clown and the ringmaster. Torn between these two aspiring lovers, she would ride in circles performing acrobatic stunts, invariably refusing both suitors.[26] While the clown (with whom the spectator could easily identify) elicited sympathy, the equestrienne was seen as radically 'other'. The greatest equestrienne celebrity of the time was Adah Isaacs Menken, who caused a sensation while performing in Lord Byron's *Mazeppa* seemingly nude (but actually wearing a flesh-coloured bodystocking) and strapped to the back of a horse. Raised in New Orleans, where she debuted in 1857, she would die in Paris in 1868, aged 33, after an adventurous life, crossing paths with George Sand, Charles Dickens and Alexandre Dumas. A popular subject in avant-garde painting, the female circus rider would later be immortalised in the works of Toulouse-Lautrec, Seurat, Henri-Gabriel Ibels and Picasso, among others.[27]

When Degas chose Miss La La as the subject of his painting, trapeze acts were a recent invention. In 1859 Jules Léotard performed for the first time on a flying trapeze, taking Paris by storm. Fifteen years later, aerial acts were by far the most sought-after circus spectacles. By 1880, female acrobats outperformed men.[28] Among them was the American 'iron jaw' performer Leona Dare. Raised in New Orleans – like Menken, coincidentally – she became famous for hanging by her teeth to a hot-air balloon, which earned her the nickname 'the Aerial Queen'.

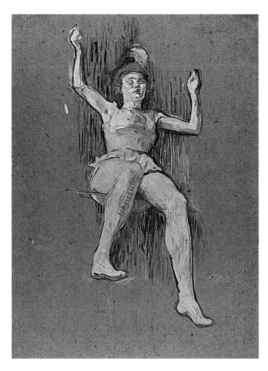

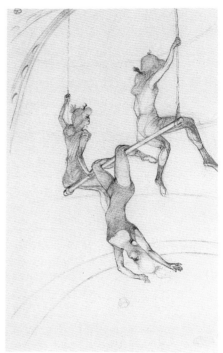

Fig. 28
Henri de Toulouse-Lautrec
(1864–1901)
Trapeze Artist at the Medrano Circus, 1887–8
Gouache on cardboard,
79.7 × 60.4 cm
Harvard Art Museums/Fogg Museum, Bequest of Annie Swan Coburn, 1934.34

Fig. 29
Henri de Toulouse-Lautrec
(1864–1901)
Trapèze volant, 1899
Illustration in *Au cirque: 22 dessins aux crayons de couleur* (Paris: Manzil, Joyant & Cie, 1905), no. 13
Bibliothèque nationale de France, Paris

Degas, who certainly knew Dare by name, might have attended her stunts in 1876–7 (at the Folies-Bergère, a gathering place for avant-garde artists and writers) or 1878 (at the Cirque d'Eté). Within his closest circle of friends she was highly appreciated: in December 1877, the poet Stéphane Mallarmé wrote to his British colleague Arthur O'Shaughnessy to tell him about the new form of theatrical drama he was then working on (one 'designed to dazzle the sovereign people in a way that no Roman emperor ever did'), adding: 'Do you remember Leona Dare (at the Folies-Bergère)? She'll have a place in this great spectacle.'[29] Edouard Manet admired her, too, and it has been speculated that the green boots on the trapeze visible in the top left corner of his *Bar at the Folies-Bergère* (1882, Courtauld Gallery, London) may be Dare's, or based on hers.[30] When Miss La La debuted at the Cirque Fernando, the parallel with the American aerialist was an obvious one: 'This young mulattress', wrote a journalist at the end of 1878, 'eclipses the memory and prestige of Leona Dare, who had the whole of Paris in a frenzy'.[31]

And yet, despite the success of these acrobats, the motif of the trapeze artist largely failed to capture the attention of artists until the twentieth century. An important exception is Henri de Toulouse-Lautrec, who made several drawings of an aerialist in the late 1880s, and returned again to the subject the following decade. In a gouache from the Fogg Museum (fig. 28), a woman acrobat, sitting on her trapeze, is depicted during a quiet moment of the performance or rehearsal. More unsettling are the three identical aerialists that Lautrec sketched during his confinement in the psychiatric hospital of Neuilly in 1899 (fig. 29). Their elongated bodies, highly sexualised – in line with Chéret's imagery rather

than Degas's – testify to the crucial role played by poster art at the end of the century.

Another tendency emerged in the literature and visual arts of *fin-de-siècle* Paris: the notion of aerial acrobatics as an androgynous fantasy, particularly in the context of the distinctively gendered polarity of the clown and the circus rider.[32] With surprising consistency, a number of texts alluded to the disordering of genders elicited by trapeze performers. This was partly due to the exceptional muscularity of female *trapézistes* – at odds with the contemporary expectations of womanliness – and, in parallel, to the supposedly 'feminine' grace required of their male counterparts. While aerial bodies hinted at mannishness, the delicate lightness of their movements alluded to femininity, creating a destabilisation of genders that was to become an artistic cliché. Moreover, the close-fitting costume used during aerial performances – called the 'léotard' after its inventor – was identical for men and women.

This theme and the question of androgyny seem to permeate Goncourt's novel *Les Frères Zemganno*, in which the antagonist character – the acrobat Miss Tompkins – is described as '*androgynous*, mannish in dress and attire'.[33] Five years later, in 1884, Huysmans would fully exploit the androgyne topos in his novel *A Rebours*. His fictional character, the American acrobat Miss Urania – with 'muscles of steel, and arms of cast iron' – seduces the protagonist Des Esseintes with her masculine features:

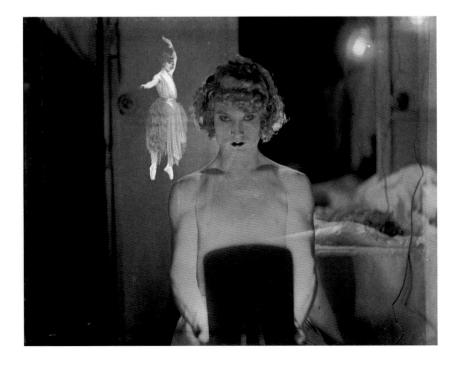

Fig. 30
Man Ray (1890–1976)
Barbette Vander Clyde, known as Barbette, 1926
Gelatin silver bromide negative on glass, 9 × 12 cm
Musée national d'art moderne – Centre Pompidou, Gift of M. Lucien Treillard, 1995

While he was admiring her suppleness and her strength, he began to discern an unnatural change of sex taking place in her; her graceful little ways, her feminine affectations became less and less apparent, while their place was taken by the agile, vigorous graces of a man; in a word, after having first been a woman, she then, after wavering, after toying with androgyny, seemed to make up her mind, to define herself, to become a man completely.[34]

At once titillating and terrifying, this type of androgynous fantasy echoes the desire and uneasiness of the male spectator looking at the female acrobat. Decades later, in real life, cross-dressing aerialist Barbette (Vander Clyde Broadway, 1899–1973) would exploit these fantasies, using them in her acts. Billed as 'man-woman', Barbette played with gender categories, starting her act in women's clothes before revealing her masculine identity as a *coup de théâtre*. After performing at the Cirque Medrano, she seduced the Parisian avant-garde of the roaring twenties. Poet Jean Cocteau praised her act in a 1926 essay, describing her performance as 'an extraordinary lesson in theatrical craft',[35] while Man Ray portrayed her in a series of stunning photographs (fig. 30).

Yet, in Degas's time, female circus performers were already perceived as blurring gender differences. As a performer, Miss La La may have sat at the very beginning of this imagery tradition. For the author Gaston Escudier, writing in 1875, strongwomen's charm lay in their hypermuscular body: 'The weaker sex taking on proportions of immeasurable strength becomes a powerful attraction for our eyes, all the more so as these women are often very pretty and I know more than one who has made many hearts beat faster.'[36]

Miss La La herself is described in circus reviews as a 'tawny Amazon',[37] 'small, but as muscular as the Farnese Hercules',[38] and 'strong above the average of womankind'.[39] The studio photographs showing her as a performer,[40] along with the accounts of her feats that emphasise her strength when lifting several men while hanging from the trapeze, and images of her in posters, all underline her exceptional athleticism rather than her grace. One commentator rated her higher than all 'her muscular rivals', claiming that, in the matter of strength, 'she is prepared to assert her superiority of the boastful people who will have it that all the virtues are associated with a light complexion'.[41] The erotic charge of circus bodies and acrobatics was an obvious reality to Degas's contemporaries.

Looking for the Perfect Feat

Despite the great success of women aerialists in the 1870s, by the end of the decade the most acclaimed trapeze artists in Paris were the aforementioned Hanlon-Lees brothers. Born in Britain, they debuted in London in 1847 (as 'The Hanlons'). The troupe toured extensively, and then rose to international fame during the Paris Universal Exhibition of 1878.[42] Combining daring acrobatic feats, comic acts, dark humour and an element of nonsense, their pantomimes attracted a wide and diverse audience, from the working classes to the cultural elite. In 1878, Chéret realised his iconic poster for their

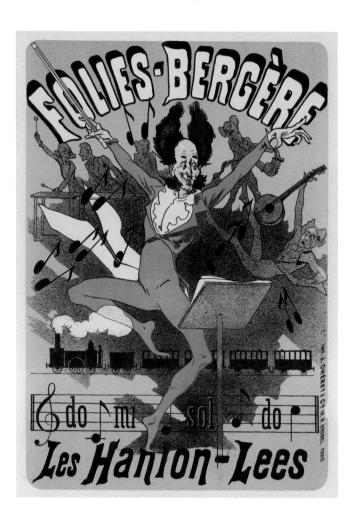

Fig. 31
Jules Chéret (1836–1932)
Folies-Bergère. Do-mi-sol-do.
Les Hanlon-Lees, 1878
Colour lithograph, 64 × 43 cm
Bibliothèque nationale de
France, Paris

show *Do-mi-sol-do* (fig. 31). Immediately after, Manet included this image
in his painting *At the Cafe* (fig. 32). Glued to the window of the Brasserie de
Reichshoffen, where the scene is set, Chéret's poster (although seen in reverse,
and only partially) testifies to the pantomime's fame. Degas might have
seen the Hanlon-Lees at the Folies-Bergère, where they performed between
July 1878 and April 1879; in 1879 alone almost 500,000 spectators attended
the venue.[43]

Between the 1870s and 1880s, the Hanlon-Lees were so famous that their
performances may have contributed to shaping the metaphor of the poet as
an aerial acrobat. In his *Odes funambulesques* (1857), Théodore de Banville had
been the first French writer to link poetry with funambulism, technical skill and
grace. He would later say of the Hanlon-Lees: 'I like them because they are the
poet's allies and accomplices, and because they pursue the same goal as the poet
himself.'[44] Writing in 1879, Banville commented on how the Hanlon-Lees, by
combining the instinctual nature of animals and an ethereal, divine dimension,
managed to rise above humanity, both literally and metaphorically – just

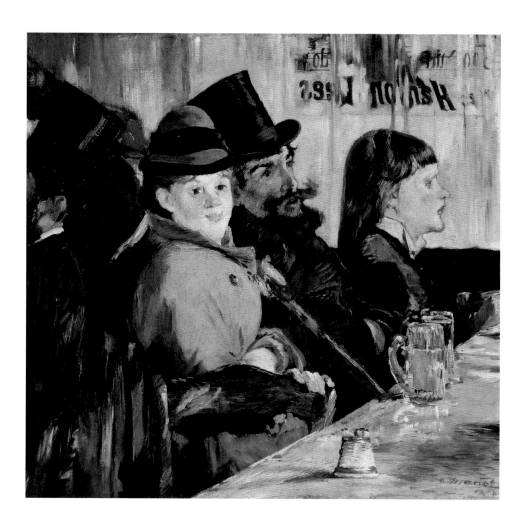

Fig. 32
Edouard Manet (1832–1883)
At the Cafe, 1878
Oil on canvas, 78 × 84 cm
Oskar Reinhart Foundation,
Winterthur, Switzerland

like poets and artists. Agile and swift in their rhythmic movements, they are relieved from the daily burden of human existence, transcending the earthly world through art.[45]

Other eminent writers of the time, from Emile Zola to Edmond de Goncourt, Mallarmé, Huysmans and Auguste de Villiers de l'Isle-Adam, referred to the Hanlon-Lees in similar terms. In his foreword to *Les Frères Zemganno*, Goncourt paid tribute to these 'gymnasts applauded by all Paris … who reason on their art as scholars and artists do'.[46] Zola, who watched the brothers perform several times, not least at the Folies-Bergère in 1878, was one of their most fervent admirers: 'What the Hanlon-Lees put into everything is an incredible perfection of execution. Their scenes are set to the second … They have finesse and strength.'[47] In addition, he praised the 'sombre fantasy of their feats' – a mix of cruelty and gaiety, dark satire and playful humour, reminding him of grand British caricatures.[48] Huysmans, likewise, considered the Hanlon-Lees 'wonderful and powerful artists', as well as reincarnations of 'Hogarth and Rowlandson, Gillray and Cruikshank'.[49] As for Mallarmé, having also watched the

Hanlon-Lees perform, he wrote of them 'how revealing [they] have been, and how difficult it will be in the future to treat (even in the novel) any modernity without something of their shortcuts, their flashes and their vertiginous simplification'.[50] Mallarmé identified in the Hanlon-Lees' pantomimes – with their disjointed narrative, their sense of discontinuity, dissonance and non-linearity – the ingredients of a modernity he was himself promoting in his writings. Degas – close to Goncourt and Mallarmé, and familiar with all these writers – was undoubtedly aware not only of the Hanlon-Lees' fame, but also of the aerialists' special status in the cultural debate of the time. Did this inform his choice of Miss La La, a skilful trapeze artist, as the model for his painting?

Acrobatics required, and therefore embodied, talent; and the circus itself was 'the only theatre where perfection is a must', as Barbey d'Aurevilly wrote; there, 'mediocrity is in constant danger of breaking its neck'.[51] This idea might have appealed to Degas, who was constantly dissatisfied with his art, and always striving for perfection. According to one of his early biographers, the artist would enjoy telling the following story:

> One day, at a rehearsal at the Cirque Medrano, a clown attempted a hoop exercise [jumping into a hoop covered with paper, piercing it] and failed; he tried it again, failed again, and failed a third and fourth time. 'Nothing is impossible for man', murmurs the clown as he tries it a fifth time with the same result, immediately adding: 'What he can't do, he leaves undone.'[52]

To which, allegedly, Degas always added, as an epilogue: 'When you're good, you'll smash everything.'[53]

The notion of rigorous exercise, strenuous training and continuous self-improvement in view of a single, final performance lies at the heart of Goncourt's *Les Frères Zemganno*. The affinity between Degas and Goncourt has often been acknowledged. Since they first met in 1874, the artist had followed his friend's writing career closely; in 1877, he planned to illustrate Goncourt's novel *La Fille Élisa*. Although their relationship cooled over time,[54] the artist and the writer – or writers, since Edmond wrote collaboratively with his brother Jules until the latter's death in 1870 – shared a common aesthetic sensitivity. For Huysmans, Degas's painted oeuvre 'can only have its equivalent in literature; if a comparison between these two arts were possible, I would say that the execution of M. Degas reminds me, in many respects, of the literary execution of the Goncourt brothers'.[55] Among other characteristics, Degas might have agreed with Goncourt's notion of algebraic talent – the ability to take risks while maintaining the balance between innovation and technical mastery.[56]

It is not known whether Goncourt accepted Degas's invitation to his studio, where Miss La La was coming to pose, one Saturday in January 1879. But we can imagine the artist and the writer discussing 'the work of sketching from life,

of rapidly and feverishly capturing for a whole evening, in a circus, these nothings that last a second', as the novelist wrote in his journal two weeks later.[57] Then, on 10 March, he added: 'Today finished *Les Frères Zemganno*'. The book would be published on 30 April. On 10 April, the Fourth Impressionist Exhibition had opened its doors at 28 avenue de l'Opéra: *Miss La La at the Cirque Fernando*, a late submission, was likely sent at the end of the month.

Degas would have had countless reasons to portray Miss La La, an admired, respected and incredibly famous performer. But the very choice of an aerialist as the subject of his only circus painting likely had broader cultural implications. More than clowns or bareback riders, in 1879 Paris acrobats embodied at the same time experimentation and disciplined training. They were 'the only actors whose talent is indisputable', as the Goncourts had written some years earlier, 'as absolute as mathematics or better still as somersaulting. For, in this, there is no false pretence of talent: one either falls or one does not.'[58]

DARCY GRIMALDO GRIGSBY

Seeing Black and White and Colour

'And the pretty women of pure blood and
the pretty quadroons and the well set up *négresses*!'

Degas, letter from New Orleans, 1872[1]

Eyesight and Blindness in New Orleans

Degas could not look Black people in the eye.[2] Or, more precisely, Degas could not look Black people in the eye when making art. And for this, he blamed his eyesight. In his letters from New Orleans, where he had travelled in 1872–3, he speaks of all that he sees: 'Everything attracts me here. I look at everything.'[3] And he speaks of all that he can't see. Outdoors, he is blinded by the 'brilliant light at which my eyes complain'.[4]

As soon as he arrived in New Orleans in October 1872, Degas was daunted by the sight of the immense Black population. He subsumed these persons into a collectivity too vast to picture: 'The Black world, I have not the time to explore it; there are some real treasures as regards drawing and colour in these forests of ebony.'[5] The ambiguous racial identity of Creoles, including his maternal family, exacerbated unspoken youthful anxiety about his own.[6] The painter was familiar with prevalent racial categories as the above epigraph's references to 'pure blood', 'quadroons' and '*négresses*' makes clear (note the adjective 'pretty' modifies only the first two).[7] His anxiety may have

Fig. 33
Portrait of Estelle Musson Degas in New Orleans, about 1872
Oil on canvas, 100 × 137 cm
New Orleans Museum of Art, Museum purchase through public subscription, 65.1

been manifested in his preoccupation with his own appearance: as a young man, he made over 40 self portraits whose faces are generally dusky, sombre, sometimes riven or sheltered by brown shadow, sometimes suffused by a deep orange.[8] Browns and oranges may have registered and deflected his concerns about his family's potentially compromised whiteness.

Degas's letters reveal his disappointment as well as his concerns that he could not see. Outside there was too much light to paint: 'The light is so strong that I have not yet been able to do anything on the river [e.g. paint Black workers on the river]. My eyes are so greatly in need of care that I scarcely take any risk with them at all.'[9] And inside, the scant 'impossible lighting' made it difficult to paint the expected portraits of his 'white' family.[10] Issues were arising with his eyesight, and he was horrified by the now 'total blindness' of his beloved cousin Estelle, who had been suffering a progressive loss of vision. In New Orleans, Degas twice painted Estelle in her shadowy home, barricaded behind flowers whose vivid colour and sharp shape render more poignant her incapacity to see them (fig. 33).[11] For Degas in New Orleans, Blackness, darkness and blindness were disturbingly interrelated.

While Degas claimed he could not paint the 'Black world' outside because of the brilliant light, he never acknowledged that he had the daily opportunity to paint Black workers inside his family's dimly lit home, where '*négresses* of different shades' cared for his family, including six young children. Degas only once tried to depict a domestic scene that included a Black servant. In *Courtyard of a House (New Orleans, Sketch)*, he prioritises architectural order – those boundaries provided by geometry's lines – and barely squeezes the Black governess into an impossible liminal space: the back step (cat. 42). With a single line suggesting the contour of her body, she is little more than a silhouetted head. A messy, ill-defined mound of fluttering thick and thin paint, she and the small children introduce the illogic of the organic into the order of the architectural.

Ultimately, however, the contrast of New Orleans's Black population with brilliant light had a lasting impact on Degas's art. In a letter anticipating his departure, he noted a revelation that he was very aware of racial difference: 'I shall be very surprised to live among white people only in Paris. And then I love silhouettes so much and these silhouettes walk.'[12] Here, astonishingly, skin colour becomes a lighting effect, not complexion. Degas turns his perception

of skin colour into shape set against light, what the French call '*contre-jour*' (literally, 'against day'), and we call 'backlighting'. Degas had become conscious of an effect of great tactical use. Once home in 1873, he did not forget what he had learned in New Orleans. That very year he painted the brilliant picture that he self-consciously entitled *Blanchisseuse (Silhouette)* (also known as *A Woman ironing*) – the silhouetted laundress who bleaches cloth (fig. 34).

Miss La La, Modelling, and Slavery

In New Orleans, Degas claimed: 'One loves and gives art only to the things to which one is accustomed.'[13] But, six years later, having long overcome his 'surprise' living 'among white people only in Paris', he resolved to paint Miss La La, a mixed-heritage woman, a foreigner, and a talented acrobat performing daring feats at the Cirque Fernando next door to his studio (cat. 40). Like the hawker who yells 'Never Before Seen!', the painting was predicated on its novelty: the novelty of Miss La La's circus act, and also the novelty of Degas's spotlight on a Black woman in Paris. In nineteenth-century French and Creole terminology, Miss La La was referred to as a *sang-mêlée* (mixed-blood) or *métisse* (mixed) or *mulâtresse* (half Black) or *femme de couleur* (woman of colour) or *négresse*.[14] All these terms were identified with Blackness at the time. Miss La La's birth in present-day Poland would not alter that racial identification.

In January 1879 Degas invited art critic Edmond de Goncourt to see Miss La La: 'Dear sir/Can you come Saturday morning to my studio, 19bis rue Fontaine? From 10.30 to half-past noon, I will have *my négresse* and her partner who will come expressly to be at your disposal.'[15] The language is proprietary and boastful. Finally, Degas had his own '*négresse*' in his studio, an especially famous and remarkable one at that.[16] Goncourt was writing a novel on the circus at the time.[17]

In nineteenth-century France, Black models had long been valued both by avant-garde and Academic artists. Théodore Géricault and Théodore Chassériau had both painted the popular Black acrobat and model Joseph, a Creole born in Saint-Domingue (now Haiti), in, respectively, the *Raft of the Medusa* (1819) and *Etude de nègre* (1836; fig. 35).[18] In the 1860s, Edouard Manet and Jacques-Eugène Feyen both painted the model Laure, the former in his *Olympia* and the latter in *Childlike Kiss*. Manet wrote in his notebook: 'Laure, very beautiful *négresse*, rue Vintimille, 11, 3rd floor.'[19]

Like slaves, artists' models were defined as bodies to be used and manipulated at will and expected to withstand pain. We know, for instance, that in Chassériau's study, Joseph's splayed Black body was constrained by ropes and propped on boxes. If William Blake's engraving *A Negro Hung Alive by the Ribs to a Gallows* (1796) reveals the disquieting role of the hook in the production of a murdered slave's silhouette, Chassériau erases the devices that artfully arranged the Black model's body.[20] In *Etude de nègre*, the suffering is repressed, save for the two hands at bottom right, which evoke dismemberment and mutilation.[21] The blue sky, signalling release, is a potent and liberatory lie.

Fig. 35
Théodore Chassériau
(1819–1856)
*Study of the Model Joseph
(Etude d'après le modèle
Joseph)* (formerly *Etude de
nègre*), 1838
Oil on canvas, 59 × 73 cm
Musée Ingres Bourdelle,
Montauban, France

Paradoxically, it was movement, not stasis, that required the inordinate subjection of the model to physical restraints; for instance, rigging 'a fire-escape belt' to represent 'the act of plunging into the river'; or suspending a model with 'a rope around his neck and his feet in a void' to represent a hanged man (fig. 36).[22] Caricaturists mocked the abjection endured by models strapped up, arranged on wooden boxes, and subjected to pain in scenarios that were often erotically charged (fig. 37).

In 1879, Degas had also tied up a rope from a pulley in his studio from which Miss La La would hang. In a 1918 letter, the sculptor Paul Paulin recalled how tirelessly Miss La La held her pose:

> He [Degas] worked long enough and suggested that the acrobat rest, because she was still hanging by her jaw, and Degas was amazed by the fact that after the barman [*sic*] asked Miss La La [in English], 'Are you tired?', she replied to him with a grunt that meant: a little but I can carry on posing.[23]

Degas was joining a lineage of artists who assumed they could move Black people into their studios, presumably for a wage, and vitalise their art by the frisson of their presence.[24] Miss La La was known for her acrobatic prowess, her ascent, and her flight. But as a model she was told to stay still. Models were not slaves, but Chassériau, for example, lamented any expression of

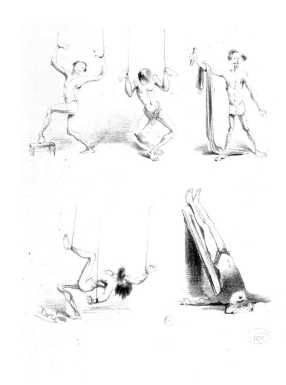

Fig. 36
Illustration in Paul Dollfus's
Modèles d'artistes (Paris: Ernest
Flammarion, 1889)
Bibliothèque nationale de
France, Paris

Fig. 37
Gustave Doré (1832–1883)
Lithograph of a model from
a series on painters, 1850
Bibliothèque nationale de
France, Paris

resistance: 'I had quite a bit of trouble with the model, who found the pose awfully tiring, and did not want to keep posing without [a] break.'[25] As a paid worker, Joseph insisted on his right to rest. Miss La La chose to continue.

Still, Degas's encounter was significantly different. His artistic predecessors shared an impulse to paint portraits of their Black models. They were all attracted to the specificity of these models' beautiful faces.[26] Not so Degas. Could he have found a subject that better justified the effacement of Miss La La? Degas positions her at so great a distance and height that her face escapes our view. Her head is turned radically upward, and diminished. Here is the peculiarity of *di sotto in sù* effect. Such a view entails the extreme foreshortening of figures to give the illusion that they are suspended above the viewer. This unique point of view was, of course, precisely what Miss La La's act delivered: her ascent far above the audience, an ascent dependent on the strength of her jaw to bear her full weight, an ascent that progressively hid her face from view. Seen from below, we see only the weirdly downward-sloping horizontal of her disappearing profile. In one of his preparatory sketches, Degas drew three repetitions of her profile where he seems to be testing how very little of her features he can show (cat. 35). Between the lower and upper sketches, a small, barely undulating line enacts her imminent disappearance: all but an eyelash has been flattened, the far right slightly darker mound is what is left of her nose; the squiggle resembles the horizon of a distant landscape more than a face.

In the final painting, Degas has successfully lit her from below, but our view from beneath her jaw further compresses the darker portion of her face; her head – called '*crépue*' (frizzy) by the writer and poet Armand Silvestre – does an immense amount of work defining her as Black.[27] Degas's many preparatory drawings of Miss La La sometimes simply outline her, leaving her the colour of the blank page; others crudely colour her in varying shades of brown, sometimes with visibly darker brown tights wrinkling behind her knees. In none of his studies did Degas make a frontal portrait of Miss La La's face.

Silvestre praised Degas's painting in 1879, describing Miss La La as in-between: 'a *mulâtresse* shaped like a young ephebe'; neither white nor Black; neither woman nor man; an androgynous dark figure whose 'poetic occupation' entails pain – the excruciating violence of throwing her head back, the arching of her spine, the clamping of her jaw. As an acrobat, she was accustomed to the extreme manipulation of her body. Silvestre noted that she had 'no equal in hanging by her teeth from the ridgepole of hippodromes'.[28] Endurance was her métier.

The acrobat's body, like the model's body, like the slave's body, was potentially a body in pain. Surely the spectacle of Miss La La's iron-jaw act was haunted by slavery's torment. Among prosthetics used to punish slaves were mouthpieces: 'A flat iron which goes into the mouth, and so effectually keeps down the tongue, that nothing can be swallowed, not even the saliva.'[29] Degas was interested in Miss La La's mouthpiece, even once drawing it separately (cat. 39). He included the potentially obscene, protruding, light-coloured strap in most studies (often relying on the colour of the paper) as well as the final painting. The picture's exercise of control over obscenity, even as it flirts with it, was perhaps one of its intended accomplishments. Not the eroticisation but the chastening of the Black woman with a leather tongue in her mouth. A spectacle thwarting desire.

In his third preface to *Flowers of Evil* in 1857, Charles Baudelaire (1821–1867) had asked:

> Do we invite the crowd, the audience, behind the scenes …? Do we show the public (enthusiastic today, tomorrow indifferent) the mechanism behind our effects? … Do we display all the rags, the rouge, *the pulleys, the chains*, the alterations, the scribbled-over proof sheets, in short all the *horrors* that make up the sanctuary of art?[30]

Degas, more than any other nineteenth-century artist, was drawn to the backstage 'horrors', 'the pulleys, the chains' behind 'the sanctuary of art'. When that art entailed a Black person hanging from a rope, the fickle public, 'enthusiastic today, tomorrow indifferent', was shown a 'mechanism' of slavery, albeit Miss La La's own art. Both audiences and artists alike were perpetually, disturbingly attracted to the spectacle of Black bodies, whether acrobats, models or slaves, in states of duress – a consequence and a perpetuation of the racism and denigration of slavery (only abolished in law decades earlier).

Black and White and Colour

Degas's *Blanchisseuse (Silhouette)* attests to the fluency, ease and confidence of a painter relieved to be back in a world of 'white people only', who were sometimes backlit (see fig. 34). But in the late 1870s, he was exploring an inverse process: carving light out of blackness in the dark field monotype, a printing process entailing the wiping away of a plate first covered with ink.[31] Rather than the silhouette's flattening of form as dark shape against a light ground, dark field monotypes are dominated by the colour black. Both silhouettes and monotypes diminish the role of line and draughtsmanship. And both foreground light-dark oppositions rather than colour.

Both processes – silhouettes and monotypes – can be considered further ruminations on the perceptual challenges that Degas experienced in New Orleans: Black bodies silhouetted across the brilliant outdoors, and Black bodies swallowed in the dim interior space of Estelle's blindness. If the silhouette was Degas's first response to his experience in New Orleans, six years later he was ready to confront the more disquieting presence of people he had seen in 1872–3 merging in shadowy interiors. He did so in black and white monotypes that were so obscurely improvisational as to suggest Degas's unconscious: ink-dark women in tubs; or stepping out of baths; or in foetal positions reading books; or as unsettling reflections in mirrors.[32] In *The Fireside* (fig. 38), for instance, what

Fig. 38
The Fireside, 1880–5
Monotype on paper,
42.5 × 58.6 cm
The Metropolitan Museum of Art, New York, Harris Brisbane Dick Fund, The Elisha Whittelsey Collection, The Elisha Whittelsey Fund, and C. Douglas Dillon Gift, 1968, 68.670

precisely do we see in the mirror over the mantle? If scholars have seen the distorted character of these strangely posed figures, they have been unwilling to speak about their evocation and denial of racial difference. The *Woman in a Bathtub* has been described as 'simian', unselfconsciously repeating the bestialisation used in the period's racist classifications (fig. 39).[33]

But the black colour can also be read simply as the profound sensual darkness of a barely lit room. Not the frothy whites bleached by laundresses, but the thick, inky, oily, viscous blacks from which dark figures partly, only partly, emerge when wiped by Degas's touch, sometimes his fingers. Here is a sticky, black space allowing for remarkable improvisational gestures: rubbing, removing, scribbling, incising, brushing, fingerpainting, wiping, all to make form barely emerge from the dark. Total darkness leads here to tactile intimacy. The dark field monotypes are obscene. And they are haunted by Degas's fear of blindness inside his uncle's darkly lit home in New Orleans. There he had watched servants 'of all shades' moving through the space his cousin Estelle negotiated solely by touch and memory (not vision).

In a letter of 1876, the French artist and printmaker Marcellin Desboutin (1823–1902) wrote:

> Degas ... is no longer exactly a friend, he is no longer a man, he is no longer an artist. He is just a zinc or copper plate blackened with printer's ink, and this plate-person is laminated by his press to the point of disappearing entirely between its rollers. The infatuations of this man are really phenomenal.[34]

While the image of 'this plate-person' is comical in intent, it nonetheless conveys the extent to which Degas's body was implicated in the physicality of the printing process, 'blackened' and squeezed by his 'infatuations'. But monotypes also entail a delay, a suspension of control when the paper is printed. The monotype confronts the maker with an image in reverse divided from his touch; he is no longer in it. If the monotype process is fabulously immediate, the paper print attests to the spatial and temporal interception of the press: the artist's hand has been withdrawn from the ink; that immersive intercourse is over. Until, that is, Degas continues his play by treating the print itself as his plate over which he applies pastel and paint.

None of this describes the preparatory sketches or final painting of Miss La La. At the very time that Degas is exploring how to compose without drawing in his monotypes, he retreats in his Miss La La pictures to an earlier additive strategy wherein figure and space are drawn separately with line and subsequently placed together and filled in. The elaborate and geometrically complex architecture of the Cirque Fernando had compelled Degas to attempt to delineate its structure: the challenge had made him fuss and make modifications, even, according to Walter Sickert (1860–1942), seeking an adviser skilled in architectural drawing (see p. 100).[35] Putting aside his new

experiment with overall patterns of light and dark as the basis of composition, Degas made structure with line. Later additions of colour were dictated not by lighting, but by the building's design: orange walls, green borders and buttresses and girders, gold pediments, columns and capitals. In this picture, Degas is careful, not fluent; cautious, not improvisational; delineating, not seeing. The sheer improvisational ease of *Blanchisseuse (Silhouette)* is gone when trying to integrate a Black person into French painting.

Colour can be undisciplined and excessive, released from the cognitive control of line, but here in *Miss La La* it is subordinated to description. In his only painting of a Black woman in Paris, Degas has returned to the tactics he used in *Courtyard of a House (New Orleans, Sketch)*, his only painting of a Black woman in New Orleans (cat. 42). Both focus on architectural details – their bounding lines and attempt to subordinate the figures to the setting. They also share a palette of oranges and browns. Degas does not make Miss La La a flat brown silhouette, nor does he turn to the black/white modelling of the monotypes. Instead, he carefully shades Miss La La's limbs with closely related colours. He acknowledges the colouristic range among '*gens de couleur*' by turning to hues – orange above all, but also brown – that permeated his own youthful self portraits as a man who was not quite white.[36]

Yet colour paradoxically can also restore whiteness. Degas sometimes used colour in this old-fashioned way: for instance, when he applied pastel to one impression of a bather in her bath (figs 39, 40). Here, the application of colour covers the intensity of the black ink wherein an ink-dark woman, who could be interpreted as Black, bathes in dark water. The result is a banal white world: a peachy bather, hair pulled back in a bun, in a sunlit room. Tighter, smaller and neater, this artwork takes none of the colouristic and compositional risks of Degas's most interesting pastels. Instead, those risks had been courted in the original monotype. In the pastel, it looks as if colour is being used by Degas to restore an imagined white racial purity.

Degas's initial drawings of Miss La La place her against a blank page or a minimally suggested background. Others delineate the architecture without her. In the final painting, Degas carefully calibrates their relation: the way Miss La La's arm parallels the green girder; the way the figure's size conveys the scale of the setting, and thus the height of her ascent. The result is a final painting that is careful and tight. Scholarly emphasis on the picture's 'daring', 'dizzying', 'vertiginous' composition has distracted us from its fixity, its grappling with perspectival rules, its conservative use of colour, and the way it stills the compact figure within the architectural grid.[37]

In Degas's painting, Miss La La hangs from a rope; she appears to be suspended, not rising; her ascent, after all, is dictated by someone else pulling the rope from below. As one end of the rope is brought down, she goes up. Where is her agency? Her strength and force? What Miss La La does is grip her jaw around the mouthpiece and allow her body to be moved upward. Her animation resides in making her body spin around the central axis of her core,

her columnar torso. Her arms and legs can twirl her body by alternating their extension and contraction; by their movement, that is, outward and inward. Here is a centripetal rather than centrifugal motion that can be produced by compactness. Not flying but torsion. A pulling inward as much as extending outward. Rather than flight we see constraint; rather than extension, we see contraction.

Ropes in artists' studios were intended to hold men and women still, to fix them, to lock them in place, even when they were meant to represent movement. Chassériau's model Joseph was uncomfortably positioned, but his pose was deceptively expansive, as if he was flying against the blue sky. Joseph was also propped up and hung from a rope for his climactic role in Géricault's *Raft of the Medusa*, yet he appears active and heroic, rising above to wave across the sea. In quick ink sketches by Géricault, we see Joseph's volition as an acrobat climbing, hanging and dismounting. Miss La La's acrobatic predecessor could convey movement.

Degas was the superlative maker of dancers whose limbs reach every which way, unpredictably, as if caught in mid-motion; he often placed them so close that we feel ourselves in their midst. Although he had seen Miss La La nearby when he hung her from a rope inside his studio, he chose to still her at a distant height. We do not sense their physical proximity when looking at the final painting. Miss La La is remote and static, and contained by her architectural setting. She may have spun in her performance; she may have rotated slowly or quickly, moving her arms and legs, but Degas shows her hanging, holding onto a mouthpiece for dear life, although her jaw does not appear strained. In Degas's painting, Miss La La appears more passive than active, and her strength is hard to gauge. Slavery was not forgotten, and nor was the taste for its racist hierarchy, but that appetite was diverted into entertainment – the spectacle of Black persons as bodies subjected to pain. Miss La La made a display of her inordinate, distressing exertion, but she was making a living out of it. Her art and her income were predicated on her physical endurance. Certainly, the painter could not stop looking at her from afar; he returned to the circus at least three times. Degas could not look Black people in the eye, but he could paint them remotely hanging from a rope with a metal prosthetic inserted into their jaw: watch her.

Fig. 39
Woman in a Bathtub,
about 1880–5
Monotype on paper,
20 × 41.6 cm
Private collection

Fig. 40
Woman in her Bath, sponging her Leg, about 1880–5
Pastel over monotype on paper,
19.7 × 41 cm
Musée d'Orsay, Paris

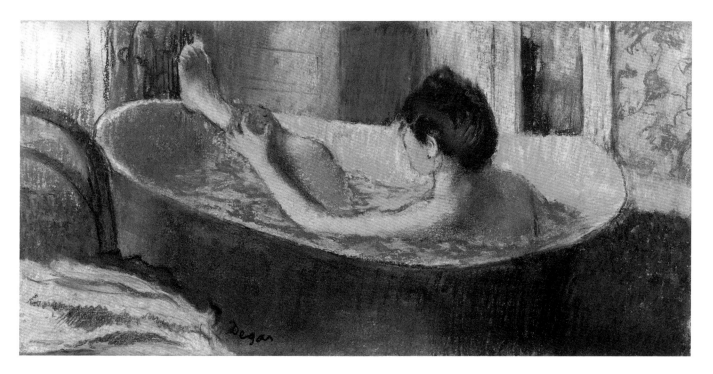

CHRISTOPHER RIOPELLE

Miss La La in Toronto

A circus performer is drawn by rope held in her teeth up to the dome of a vast vaulted performance space. *Miss La La at the Cirque Fernando* (cat. 40) is one of Edgar Degas's most visually arresting images – and today among his most intensely scrutinised as well – but it did not always figure large in assessments of the artist's achievement. For 46 years, between early 1879 when completed and briefly exhibited in Paris, and late 1925 when it entered the National Gallery in London, it was rarely seen or discussed. Indeed, between 1905 when a young Canadian collector bought it in London and 1920 when his widow sold it at public auction in Toronto, no sightings whatsoever are recorded. Its modern fame began a few years later when the Samuel Courtauld Fund bought the painting, by then back in London, and presented it to the nation. Discussion at the time largely concerned the controversial gifts of avant-garde paintings by which the industrialist, art collector and philanthropist Courtauld prodded a still-sceptical British public into a reluctant appreciation of modern foreign art, especially French, rather than individual pictures.[1] Nonetheless, the painting's early exhibition history and ownership in Europe and North America throw light on its initial reception.

First View

The Fourth Impressionist Exhibition – the first mounted by the French Impressionist artists under their provocative new *nom de guerre* of *Indépendants* – opened in Paris, on 10 April 1879. It was here, as we have seen, that Degas's *Miss La La* was first exhibited publicly (see p. 31). The painting did not arrive at the exhibition until approximately 27 April, however, and may have been on public view for as little as two weeks before the exhibition closed on 11 May, its

Fig. 41
Young Spartans exercising,
about 1860
Oil on canvas, 109.5 × 155 cm
The National Gallery, London

presence noted by only two critics.[2] After this inauspicious debut, *Miss La La* was not seen again in public for over two decades. It returned to Degas and for 24 years could have been admired only by visitors to his studio.[3]

There, Degas's friends saw *Miss La La* in the company of two works that, like the latter, the artist for his own reasons chose to keep near at hand for much of his life. In *Young Spartans exercising* (fig. 41), near-naked and fearless girls taunt and mock gormless boys, strutting naked but clearly cowed by unbridled female bravado. Four *Peasant Girls bathing in the Sea at Dusk* inhabit their own entirely female world, naked and oblivious to propriety (cat. 45). They are seen *contre-jour* (against the light), their features darkened, an example of the artist's fascination in the 1870s with ambiguity of skin tone, a subject addressed elsewhere in this catalogue (see p. 57). In all three works, women assume and exercise degrees of control over their own bodies and destinies far beyond social norms current in the day. They might almost have formed for Degas a single sequence celebrating untrammelled female audacity.[4]

To Durand-Ruel

On 29 November 1902 Degas deposited *Miss La La* with his long-time Paris art dealer Paul Durand-Ruel. It did not officially enter Durand-Ruel's stock at the time.[5] Some two years later the dealer sent it to London where he was preparing what may have been the most ambitious exhibition of French Impressionist paintings ever mounted, at the Grafton Galleries in Grafton Street, Mayfair, a chic, state-of-the-art commercial gallery-for-hire.[6] The exhibition opened in January 1905. It included some 315 paintings, culminating in the End Gallery with a sequence of major Degas paintings, *Miss La La* among them (fig. 42). The work was featured prominently at what was only its third public appearance, after the Fourth Impressionist Exhibition 26 years earlier.

Fig. 42
View of a room of the exhibition of French Impressionist paintings at the Grafton Galleries, London, showing *Miss La La*, 1905
Photo by Bedford Lemere & Co.
Photographic print
Musée d'Orsay, Paris

The London exhibition was not a financial success. In all, only 13 works sold. One buyer was a newcomer to – or rather a brief interloper in – the art world, a not-so-wild (but wildly rich) 'colonial', Cawthra Mulock (1882–1918), so-called 'Boy Millionaire of Toronto'. He had inherited a fortune at age 15, proved early on to be a dynamic entrepreneur, and at 22 was pursuing business interests in London, the political, financial and cultural centre of the British empire. On 16 March, the day the exhibition closed, *Miss La La* finally entered Durand-Ruel's stock books, and that same day Mulock bought it from the dealer.[7] Soon after, in May 1905, with *Miss La La* in tow, he returned to Toronto, at the time an 'outpost of Empire' overlooking Lake Ontario, with a population of some 300,000.

To Toronto

What explains Mulock's audacious, one-off acquisition? The impulses for buying art are many and various.

Mulock came from an impeccably proper Toronto family with important legal and educational credentials and ties to the Liberal Party of Canada (his father served in the Cabinet of Prime Minister Wilfred Laurier). Handsome and personable (fig. 43), the young man also seems to have had winning streaks of originality and independence. A wealthy aunt may have intuited as much as, in 1897 and largely bypassing his older sisters and brother, she bequeathed the stripling the greatest part of some $2.7 million,[8] a vast sum at the time. His father would administer the fund during the lad's minority. In addition, she left him Northwold, one of the largest houses in Toronto on its Millionaires' Row, Jarvis Street. Mulock was set for life.[9] Just a few doors up Jarvis Street lived the scion of another local plutocrat, four years younger than Mulock, Vincent Massey (1887–1967), who would later play a role in British cultural life as Chairman of the Board of Trustees of the National Gallery during the Second World War, and author afterwards of the seminal report establishing the National Gallery and Tate as separate institutions. As we shall see, he may have had a part in this tale as well.

Mulock came into 10 per cent of his fortune on his 21st birthday in 1903 (full control came at age 25). He was keen now to get on with life. He dropped out of university and almost immediately married. At 19 his wife was underage and a Roman Catholic, he Anglican; so-called 'mixed marriage' counted as scandal in the Toronto of the day, and when riches and position – her father was Chief Justice – were added to the mix it proved irresistible press fodder.[10] Mulock's actions suggest not youthful impulsiveness, however, but the opposite: calculation, and a biding of time until, with his majority, he could act decisively. His genius quickly revealed itself in entrepreneurship … of many kinds. Soon he was involved in banking; the stock market; insurance; electrical generating; the milling of flour; and real estate development, the latter two on a pharaonic scale.[11] In the words of his biographer Alexander Reford, Mulock was '[o]ne of the most colourful of a new generation of Toronto capitalists'[12]

who shaped the city's financial future. In the specific context of *Miss La La*, however, two Mulock enterprises stand out: iron making, and theatre building and management.

In 1905 Mulock was in London on a business trip. He and some partners were in the process of building a theatre in the heart of Toronto. Opening to the public in August 1907, the grand and imposing Royal Alexandra Theatre remains a leading cultural institution to this day (fig. 44).[13] Where better than London for Mulock to study theatre, theatre building, theatre production and management, than in the thespian capital of the world? Where else to pursue royal patronage as well? From the onset of their ambitions, Mulock and the syndicate he formed were determined to obtain a Royal Patent for the theatre, to display Royal Arms, to carve the word 'Royal' in stone on the facade, and to name the building after Her Majesty the Queen, Alexandra, wife of King Edward VII. That potentially lucrative business stratagem – in the entirely unobjectionable guise of fealty to the Crown – had to be chivvied along as well.[14]

Sailing from London via Liverpool aboard the SS *Baltic* on 10 May 1905[15] and arriving in New York on 19 May, Mulock was returning to the American metropolis where he had also sought advice on the new theatre. There, he had turned to the leading architecture firm of Carrère & Hastings. They recommended the Irish-born Canadian architect John M. Lyle (1877–1945), an associate of the firm, who was called back to Toronto and charged with design and construction of the new theatre. Lyle was a gifted designer but a practical technician as well, versed in modern construction methods. Theatre fires, for example, were a constant worry.[16] Steel-frame construction, a comparative novelty in North America, along with the use of poured concrete, offered protection. Lyle recommended both. It made construction more expensive but, serendipitously, Mulock and the syndicate members already had investments in the iron and steel industries. It was an entrepreneur's dream; synchronicity among business investments.

At 1,497 seats, the Royal Alex was to be one of North America's largest steel-frame theatres to date. The Cirque Fernando in Paris, from the rafters of which Miss La La hangs, was a steel frame structure as well, designed by Gustave Gridaine (1836–1903) and completed in 1875. Two of Gridaine's steel arches play central roles in Degas's vertiginous composition. In 2014 Anne Robbins was the first to propose a connection between Degas's painting and the simultaneous involvement in steel-frame construction of the young man who out-of-the-blue bought it in 1905.[17] Here was visual proof, if Toronto needed it, that the European entertainment world had long embraced steel construction.

One man whom Mulock invited to join his theatre syndicate, Ambrose J. Small (1866–about 1919), the owner of the Grand Opera Houses in both Toronto and London, Ontario, would have brought a certain high-culture gravitas to plans for the first theatre in town under Royal Patent.[18] He recommended instead another Toronto native, whose family was an early

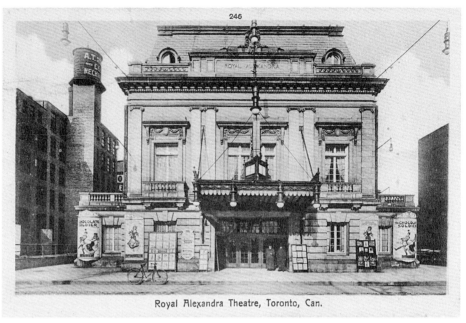

Royal Alexandra Theatre, Toronto, Can.

mainstay of the city's then-small Jewish community but far removed from the mansions of monied, patrician, insular Jarvis Street. Lawrence (Lol) Solman (1863–1931) was an entrepreneur in sports and popular entertainment. If, in the popular press, Mulock was Toronto's 'Boy Millionaire', Solman was its 'Weekend King'.[19] He ran a hugely popular summer resort hotel on the Toronto Islands opposite downtown; he also ran the ferry service that got visitors there (synchronicity, indeed). The resort included an amusement park at Hanlan's Point with circus acts and a 'museum of living curiosities', where, among others, performers of African descent were employed.[20] A highlight of the 1907 summer season was a diving horse. Solman built a stadium on landfill nearby and owned Toronto's first professional baseball team located there.[21] That stadium burned to the ground in 1903. Solman understood the threat of fire; he also put on extra ferries the day of the conflagration so that spectators could better thrill to the flames.[22]

With Solman aboard, the Royal Alex became an intensely popular venue, more circus than Shakespeare in the early years. (The opening pantomime in 1907 featured six performing collies.) With a businessman's instinctive acumen, Mulock invested his trust in Solman and followed his lead into populism. But cultural tensions – or rather social tensions expressed as cultural distinctions between elite and popular taste – were there from the beginning. Mulock and partners had to navigate them. Angled out over the theatre's proscenium, for example, would be a sedate mural by the academic painter Frederick S. Challener, *Venus and Attendants discover the Sleeping Adonis* (fig. 45). Here, reeking of Classical allusion for the delectation of gentlemen with university degrees, and suspended from the ceiling high above their heads, were several

Fig. 45
Frederick S. Challener
(1869–1959)
*Venus and Attendants discover
the Sleeping Adonis*, 1907
Mural in the Royal Alexandra
Theatre, Toronto

Fig. 46
Newspaper clipping regarding
the Toronto sale, *Saskatoon
Daily Star*, 6 May 1920

naked ladies. And here too in a London gallery another had hung, more modestly attired. Did *Miss La La* serve as an in-joke on the complicated 'high/low' aspirations of the theatre in Toronto? Perhaps this also drew Mulock to the painting.

In short, the speculative argument here is that Mulock's acquisition of *Miss La La* in London early in 1905 may have been prompted by largely extra-aesthetic concerns circumstantially related to the building and cultural positioning of the Royal Alexandra Theatre in Toronto. Perhaps it might also explain why, over 15 years between 1905 and 1920 at which point it left Canada again, *Miss La La* was never seen, or rather was never recorded as seen, in that city. Presumably it could be viewed by guests in the Mulock mansion on Jarvis Street. But it was not seen in public. The artist Degas would have carried little cultural weight there in 1905. Nor would Mulock have won cultural accolades for bringing to town a painting whose prime visual focus was an aerialist's thighs.

Diligent archivists at the City of Toronto, the Art Gallery of Ontario, the Royal Alexandra Theatre, and David Mirvish Enterprises which now runs the theatre, have searched for traces of the painting in Toronto between 1905 and 1920. Mulock's biographer, journalists, Toronto historians, art historians and curators have done so as well. So too have descendants of Mulock's family. All searches have been to no avail. The single mention of the painting in the Canadian press is an after-the-fact article reporting that the work had been auctioned in Toronto and had gone to a New York dealer, promptly leaving the country (fig. 46).

The painting's stay in Canada overlapped with the artist's death in Paris in 1917 and with publicity the following year, during the final days of the First World War, accompanying the posthumous auction there of Degas's vast haul of works by artists he admired and collected, and of his own works, finished and unfinished, which remained in his studio.[23] The sales were organised by the Galerie Durand-Ruel and supplemented by an exhaustive photographic campaign, an early example of the new and transformative role documentary photography would play in art history. Suddenly, hundreds of images of previously unknown works were available. Thus, *Miss La La* – off in Toronto, although not on view there – was invisible at a key moment in the modern reception of Degas's art.[24] Perhaps this too accounts for the painting's relatively late rise to the role it now plays as a key to the artist's achievement.

All we do know is that by 1917 Mulock's marriage had broken down and he was paying alimony to his estranged – but not divorced – wife and the mother of his four children. 'The defendant states that life with his wife is intolerable and impossible.'[25] He, for his part, was spending more and more time in New York, dying there on 1 December 1918 in the Spanish flu pandemic. In 1919 his widow almost immediately remarried – a cousin; a Catholic; no scandal – and the year after that, in May 1920, the now Mrs Moss sold *Miss La La* at Jenkins' Art Galleries in Toronto.[26]

WORKS OF ART CHANGE HANDS IN TORONTO

Many Notable Paintings Bought by United States—Some Come to Moose Jaw

Many thousands of dollars changed hands in Toronto recently when paintings from the estates of the late Cawthra Mulock and James Hugh Hamilton, as well as some smaller estates, were sold at auction at Jenkins' Art Galleries by Mr. Charles M. Henderson. There were many expressions of disappointment, says the Toronto Globe, however, that several of the most notable pictures went to the United States, being bought by Schulman Brothers of New York.

The highest price was brought by Degas' "L'Acrobate," a large study of a woman in acrobat's costume of pale pink, swinging by her teeth from the domed ceiling of some great hall. This began at $2,500, and Mr. Schulman got it for $6,500. His second purchase was "La Danse," a very lovely group of figures, against an unobtrusive background of green trees, marble portico, by Fantin-Latour. The central figure is a beautiful, fair, nude figure, about which floats a rose-colored drapery, and in whose right hand a tambourine is held aloft. The same buyer secured this artistic treasure for $4,600 and another of his purchases was a large and striking pastel drawing of a tiger drinking from a dark pool with water lilies, the work of J. M. Swan. The sum realised was $1,800. All three of these came from Cawthra Mulock's estate.

BIG PRICES

"Ploughing," a rather small but very fine example, of the work of Anton Mauve, Mr. H. S. Osler bought for $2,450.

A coast scene, with fishing boats, by J. H. Weissenbruch, Mr. H. Fleming of Brockville secured for $1,900, and "Low Tide," by the same artist, went to Mr. J. Bell for $1,000. Two paintings of horses and riders, full of color and action, by J. F. Jurres, "The Flight" and "Making Camp," went, the first to Mr. W. Rolph for $475, and the second to Mr. T. G. O'Flynn of Shelbourne for $1,100. Mr. O'Flynn also secured a charming street scene by Daniel Fowler, for which he paid $350.

Another out-of-town buyer who added some notable treasures to his collection was Mr. W. Grayson of Moose Jaw, to whom went a beautiful large picture of small girl learning to sew, by A. Harlamoff. This brought $1,000, and to the same buyer went a very characteristic small Dutch landscape, with cattle, of Willem Marie for $550. "Burdens," a large and very mournful study of a gray landscape and a gray and weary figure carrying a baby, slung in a shawl from its back, he got for $130. The same price bought for the same purchaser "Sunlight on the North Sea," a typical work of H. W. Mesday.

Back to London

Miss La La was acquired by the New York dealer Schulman Brothers for a princely $6,500. By 1923 it had returned via Schulman to London and the stock of the French Gallery, where it was exhibited in July of that year – shown for the second time in London, and only the fourth time in its history – at the Gallery's 117th exhibition.[27] That same year, Samuel Courtauld established the eponymous Fund to acquire modern works of art for the nation. Among its first purchases in 1924 was Degas's scene of female empowerment, *Young Spartans exercising* (see fig. 41); another was Vincent van Gogh's *Sunflowers* (1888, National Gallery, London). The following year the Fund acquired *Miss La La*, a second Degas image of female empowerment. Henceforth, they would hang in proximity either at the National Gallery or in the Gallery of Modern Foreign Art at the National Gallery's then-subsidiary institution, the Tate Gallery, Millbank.

Until the Second World War, Degas scholarship remained ignorant of the painting's Toronto connection. All sources, including Paul-André Lemoisne's authoritative catalogue raisonné, noted under provenance one 'Cawthra Mulock, London'.[28] Upon inquiry from the National Gallery, descendants of Durand-Ruel consulted stock books and confirmed the name and 1905 sale.[29] They did not know where Mulock hailed from. In 1953, however, a Gallery curator Martin Davies, preparing the first edition of his pioneering National Gallery catalogue *French School: Early 19th Century, Impressionists, Post-Impressionists etc.*, inquired by letter of a Mulock son in Toronto about the painting. He helpfully replied that, yes, his father may well once have owned a Degas, but he did not know which one. A lady hanging from the ceiling by her teeth; it meant nothing to him.[30]

Why did Davies write to a Mulock in Toronto, and how did he know where to find him? Is this where Vincent Massey enters the picture? Here again we speculate. Massey was the Canadian High Commissioner in London from 1935 and throughout the Second World War; in 1941 he became the Chairman of the National Gallery Board of Trustees as well, working closely with the young Director, Kenneth Clark. As war broke out, all the paintings were evacuated to a Welsh mineshaft, where they remained safe. (The Gallery itself, prominent on Trafalgar Square, was bombed twice during the Blitz.) Following VE Day, 8 May 1945, Massey and Clark oversaw the return of all the pictures to Trafalgar Square. It was Massey who officially greeted the King and Queen on their visit to the Gallery a month later to celebrate that auspicious occasion (fig. 47). As he saw the pictures return, did Massey perhaps turn to Davies and say: 'I know that very strange painting. It used to hang in a house just down the street from mine, years ago in Toronto. Here's a name and address.'

Fig. 47
Vincent Massey (third left;
Kenneth Clark is at second
right) with King George VI and
Queen Elizabeth on their visit
to the newly reopened National
Gallery in May 1945

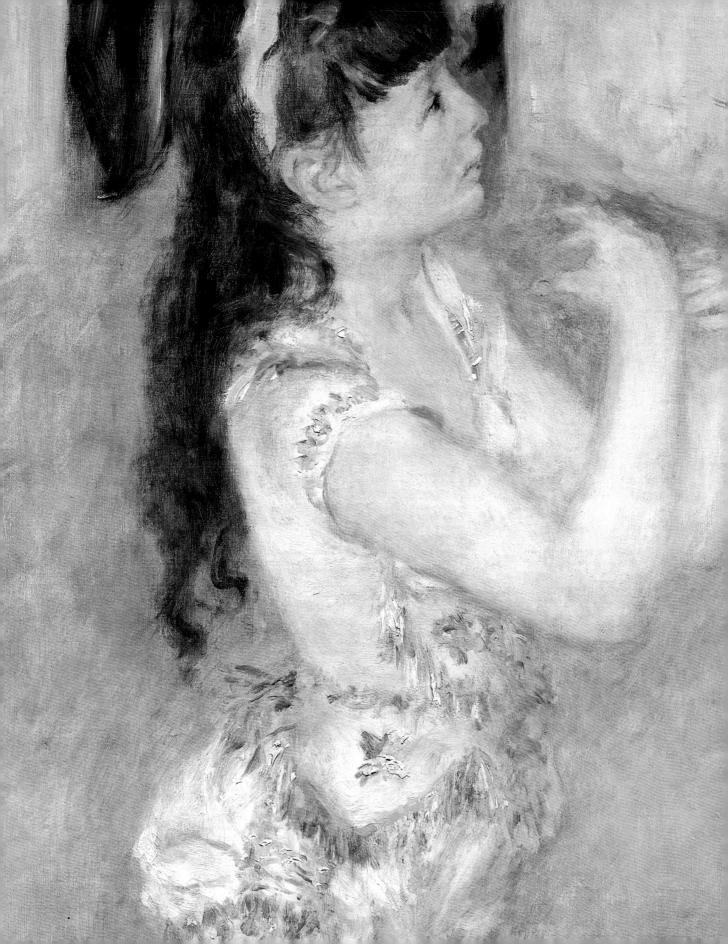

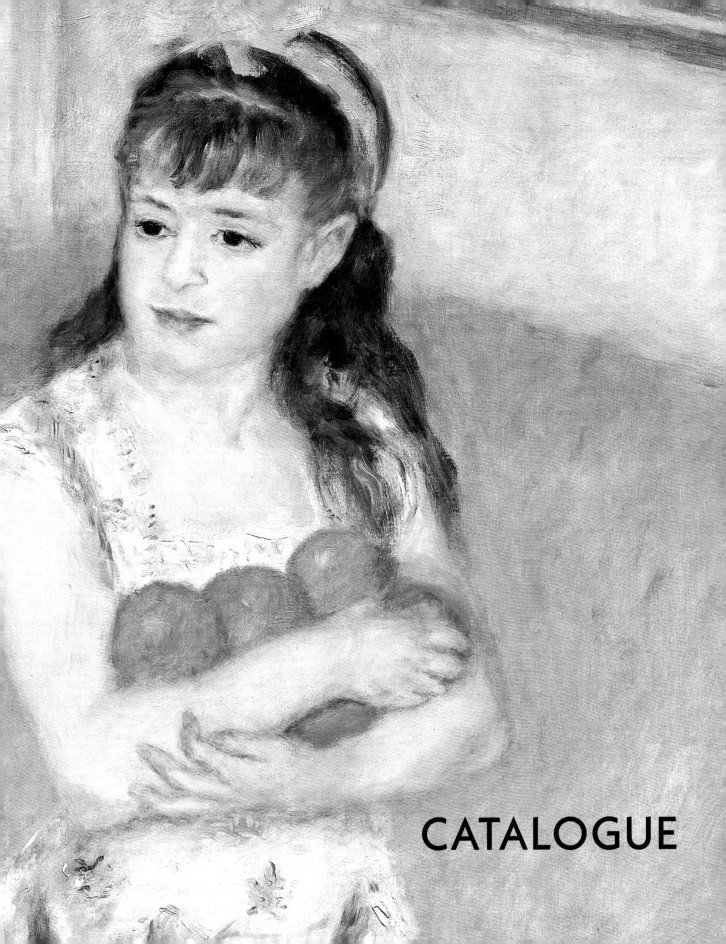

CATALOGUE

Miss La La: Background and Success

LAURIE FIERSTEIN

Miss La La was 20 years old when she was engaged by Paris's Cirque Fernando in the winter of 1878–9, and had already been performing professionally for half her life (cat. 2). She had only started using the stage name 'Miss La La' in January 1877 in Vienna, when her small travelling troupe began calling themselves 'The La La Kaira Troupe' (also known as The Kaira Family).

These new identities coincided with the launch of their unprecedented cannon-woman spectacle (cat. 1).[1] This was the centrepiece of the troupe's varied aerial iron-jaw show starring mixed-heritage Miss La La and supported by three white acrobats (cat. 3). Artistic director Louis Fernando had hired this wondrous troupe to perform in his family's circus in December 1878. In her signature act, the muscular young woman of just over 1.5 metres height[2] hung upside down from a trapeze while holding by her jaw a cannon barrel weighing over 300 kilograms, which would emit a fearsome blast when fired.[3] Miss La La immediately became the top circus celebrity in Paris (cat. 7).

An enthusiastic chronicler who witnessed another extraordinary feat, as depicted by Degas, observed: 'With a rope between her teeth, she is lifted up to the top of the circus building performing various poses, all of them [so] daring and exhilarating that they make you dream of some kind of fairy appearance'.[4] Where did she come from, this remarkably talented performer who so masterfully blended elegance, strength and audacity?

Olga (the name she is known to have used in her personal life) was born on 21 April 1858 in a tiny Baltic settlement called Kupfermühle, surrounded by fields and industry. The village clung to the northern boundary of the port city of Stettin (now Szczecin, Poland), then heartland of central Europe's Kingdom of Prussia.

She was baptised Anna Albertine Olga Brown in the Lutheran Evangelical Protestant religion, the same faith as her mother. Christine Maria Brown (née Borchardt; 1826–1879), a homemaker, came from rural Germanic folk, her father a humble village herder, as was his father before him. Christine grew up in a small farming community just north of where she gave birth to Olga, her fourth and last child. Olga's father, William Brown (about 1824–1866), born in Philadelphia, was an African American, who had arrived in the Stettin area in 1843, most surely as a seaman aboard a mercantile vessel, and had found lifelong employment as a labourer for a prosperous local wood merchant.

From this working-class, salt-of-the-earth family, how did Olga evolve into such a powerful queen of the air (cats 15–17)? Compelling circumstantial evidence suggests that her natural gifts were first nurtured amid the ubiquitous adoption in Prussia of gymnastics training for the youth. At that time aerial exercises using the *schwebereck* (flying bar) and *ringeschwebel* (flying rings) were well incorporated into schoolchildren's gymnastic instruction.[5] Not only were these classes being taught in Grünhof'sche Elementschule,[6] the elementary school Olga would have attended, but the Brown family lived within walking distance of a plethora of private and public gymnastic training facilities, some of which were for young girls.[7]

By age 9, when Olga left home to begin her career as a professional aerial acrobat, she was most certainly already an accomplished gymnast. That is when she started travelling as the sole protégée of respected Prussian aerial equilibrist Gustav Alexander Neumann (1842–1870) and his spouse Elisabeth Henriette Therese (née Blottner; 1847–1895).

In early spring 1869, during her first known public performance, 10-year-old Olga flew the trapeze with Gustav at Dresden's legendary Lincke'sches Bade garden. For the next six and a half years she used variations of the stage name 'Miss Albertine the African', with monikers including 'The Flower of the Night'.

In the summer of 1869 the duo performed in Prussian Silesia's capital Breslau, where 7-year-old Theophilia Szterker, later known as Kaira, is believed to have joined the Neumann Troupe. The daughter of an impoverished Silesian shoemaker and a Polish seamstress, she was, like Olga, Prussian-born, and an outstanding acrobat trained in a strict academic gymnastic education.[8] For 19 years hence they would perform together (cats 4, 5).

After Gustav Neumann's death on 6 December 1870, his widow Elisabeth kept working with Olga and Theophilia as their impresario. While engaged with a travelling circus at Brno in October 1872, they met Franziskus 'Franz' Pospischil (1849–1916), a gifted acrobatic clown and aerialist from Vienna. He and Elisabeth became artistic and conjugal partners, although not formally wed. Franz assumed the role of the troupe's impresario as well as co-performer with Olga and Theophilia. In the autumn of 1874, the Pospischil Troupe added a young boy, believed to be named Theodor Jüttner, as its fourth performer (cat. 3).

During these years Olga and Theophilia performed complicated gymnastic and strength routines in various trapeze acts, including flying and static aerial bars done singly, in duos or trios, as well as the so-called flying Roman Rings, flying ring, tightrope and slack rope (cat. 11). Their performances were said to achieve 'astonishing splendour'.[9]

Such accolades would continue throughout their careers as aerial artists, notably after 1877 when they emerged with avant-garde iron-jaw acts as 'Miss La La and The Kaira Troupe', watched in Paris's Cirque Fernando in 1879 by Degas, who chose to represent Miss La La in one of her solo acts, but also drew Theophilia (see cat. 30). From 1882 they became the flying vaulting superstars 'Olga and Kaira, the Black and White Butterflies' (cats 9, 10). They attracted crowds of admirers all over Europe, where they were continuously engaged by famous circuses, hippodromes, variety theatres and music halls (cats 11–14). Even after Theophilia's tragic death in 1888, caused by an accident during a rehearsal, Olga continued to perform solo, drawing acclaim as 'Miss Olga the Black Butterfly' or sometimes as 'The African Butterfly'.

Her continuous designation as being from African origins assigned Olga as an 'exotic' other/fantasy. Unsurprisingly, racist reactions to her appeared in the press on multiple occasions. As early as her second public performance in the summer of 1869 with the Rappo Company at the Summer Theatre in Breslau, she was referred to as a 'Hottentot'.[10] During the Cirque Fernando engagement, a Paris columnist opined that 'her black skin and frizzy hair are lacking charm'[11] – among the many offensive comments she no doubt had to endure.

In October 1888 Olga married celebrated African American contortionist Emanuel Charles 'Manuel' Woodson (about 1859–1915). He and Olga met six months earlier in Rotterdam, while they were engaged with the Wulff Circus. Manuel had come from his home in St Louis, Missouri, and had been performing in Europe since 1884.

After Olga ended her performance career in 1891, aged 33, a new life opened up for her. She had

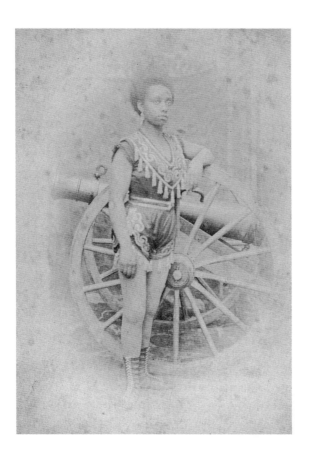

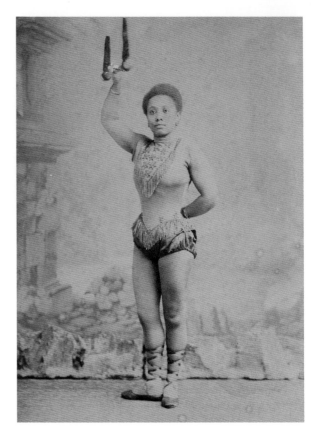

taken guardianship of two young nieces, daughters of her oldest sister. Together she and Manuel mentored and managed two successful travelling acrobatic acts, both involving her niece Albertine Marie. During this time, Olga became a devoted mother to daughter Rose Eddie 'Teddy' Woodson (1894–1952).[12]

Once settled with her family in Brussels in 1899 (where Manuel became the stage manager of the Palais d'Eté), Olga embarked on shepherding the dancing career of her daughter (cat. 19). Fluent in at least three languages,[13] she also briefly became a cafe-restaurant entrepreneur and worked on assisting other performing artists. After Manuel's death in 1915, she twice became a grandmother and always lived with her daughter's family, who lovingly called her 'Moukie' (cat. 20). Olga Woodson died one month shy of her 87th birthday on 21 March 1945 in southeastern Brussels's Ixelles/Elsene Commune, where she was laid to rest.

Cat. 1
Unknown
Anna Albertine Olga Brown, aged 20–21, as Miss La La with her Cannon, 1878–9
Photograph, 16 × 11 cm
Private collection

Cat. 2
Unknown
Miss La La at the Cirque Fernando, about 1880
Albumen silver print on paper, 39.3 × 28.8 cm
Collection Zimmerli Art Museum at Rutgers University, Museum purchase

Cat. 3
Unknown
Olga, Kaira la Blanche, Popischill et le petit Kara (Trapèze Volant), about 1878–9
Photograph, 13.7 × 8.9 cm
Mucem, Marseille

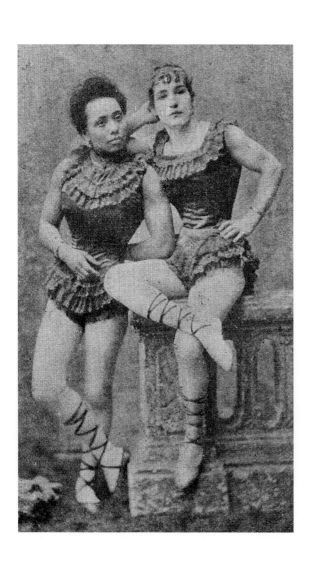

Cat. 4
Olga and Kaira in
La Culture physique magazine,
15 March 1910
Bibliothèque nationale de
France, Bibliothèque de l'Arsenal

Cat. 5
Unknown
*Anna Albertine Olga Brown,
and Theophilia Szterker*, 1886
Photograph, 16.4 × 10.7 cm
Private collection

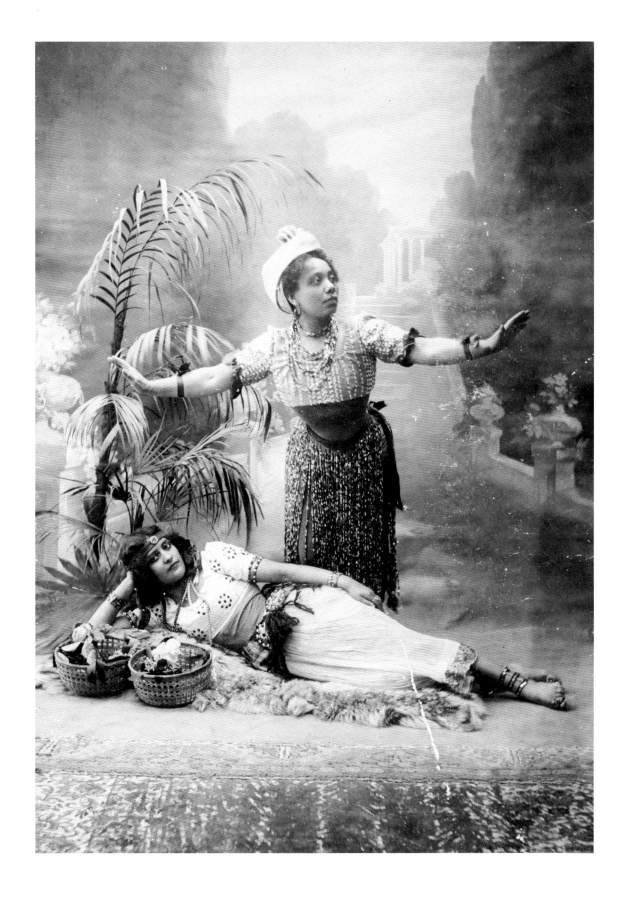

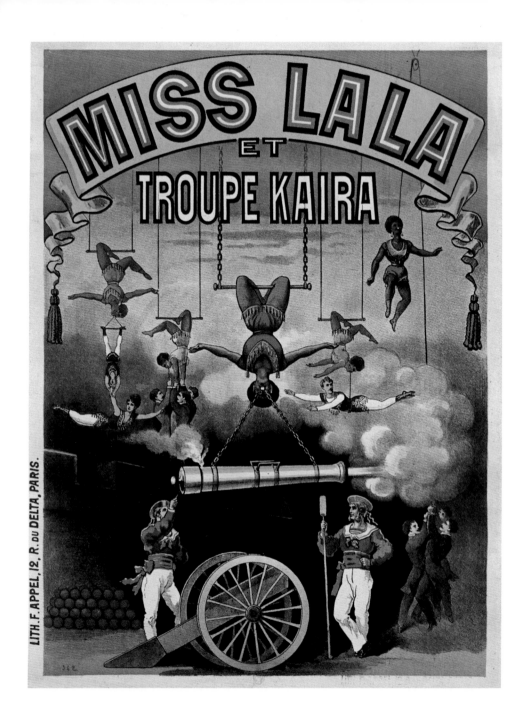

Cat. 6
François Appel (1821–1882)
Miss La La et Troupe Kaira,
1878–9
Colour lithograph, 56 × 43 cm
Bibliothèque nationale de
France, Département des
Estampes et de la photographie

Cat. 7
Jules Chéret (1836–1932)
Folies-Bergère, Miss Lala, 1880
Colour lithograph, 55 × 39 cm
Bibliothèque nationale de
France, Bibliothèque-musée de
l'Opéra, Affiches Illustrées

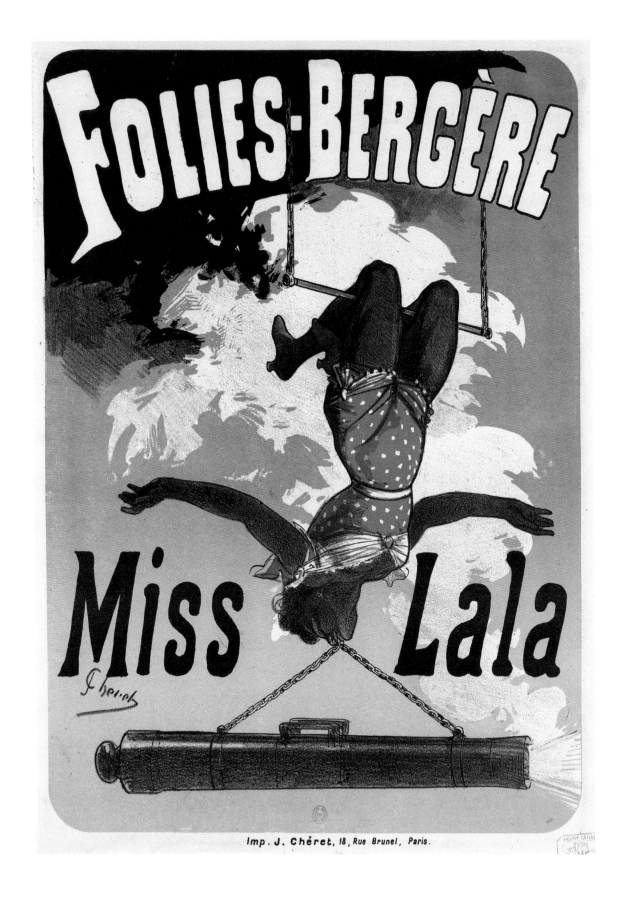

Imp. J. Chéret, 18, Rue Brunel, Paris.

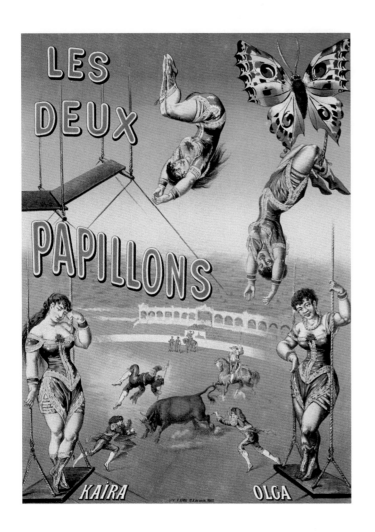

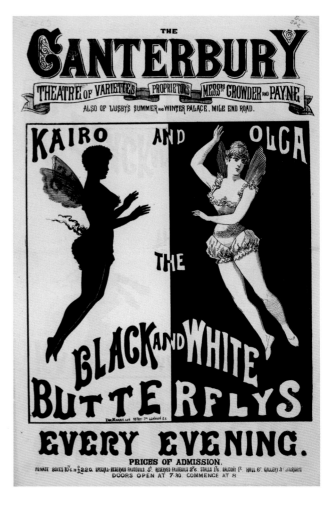

Cat. 8
Unknown artist
Les deux papillons (Kaira & Olga),
1884
Colour lithograph, 69.1 × 54.3 cm
Le Signe, Centre National du
Graphisme, Chaumont

Cat. 9
Unknown artist
*Kairo and Olga, The Black and
White Butterflys*, 1883
Lithograph, 76.8 × 50.8 cm
The British Library, London

Cat. 10
Emile Lévy (1826–1890) (printer)
*Cirque d'Hiver ... Les Papillons
Noir et Blanc*, 1884–5
Colour lithograph, 58.9 × 84.5 cm
Musée Carnavalet – Histoire de
Paris

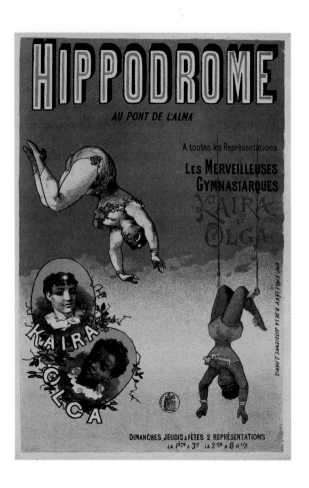

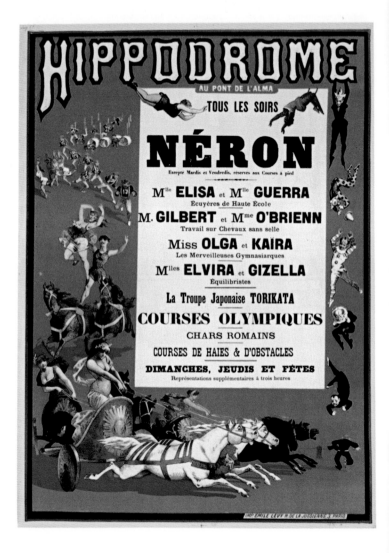

Cat. 11
Emile Lévy (1826–1890) (printer)
*Hippodrome au Pont de l'Alma,
A toutes les Représentations Les
Merveilleuses Gymnasiarques Kaira
et Olga*, 1883
Colour lithograph, 59.5 × 39.7 cm
Musée Carnavalet – Histoire de
Paris

Cat. 12
Emile Lévy (1826–1890) (printer)
*Hippodrome au Pont de
l'Alma ... Miss Olga et Kaira Les
Merveilleuses Gymnasiarques*, 1883
Colour lithograph, 80 × 60 cm
Bibliothèque nationale de France,
Département des Estampes et de
la photographie

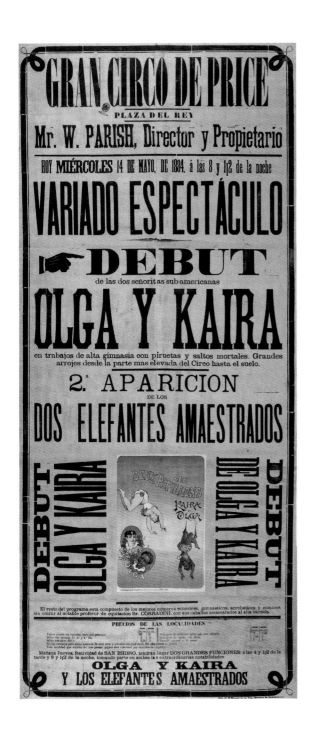

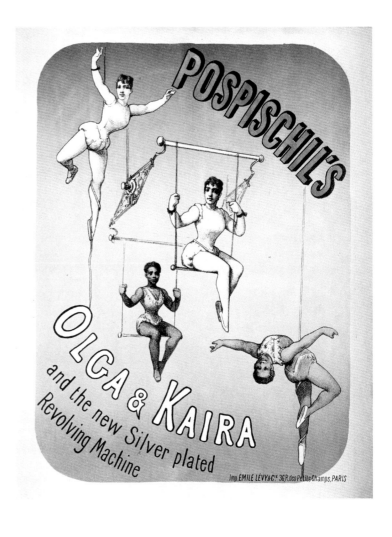

Cat. 13
Unknown artist
*Gran Circo de Price ... Olga y
Kaira*, 1884
Poster, 276.5 × 120.5 cm
Biblioteca Nacional de España,
Madrid
Original not exhibited

Cat. 14
Emile Lévy (1826–1890) (printer)
*Pospischil's Olga & Kaira and
the new Silver plated Revolving
Machine*, 1886–7
Colour lithograph, 55.4 × 43.7 cm
Le Signe, Centre National du
Graphisme, Chaumont

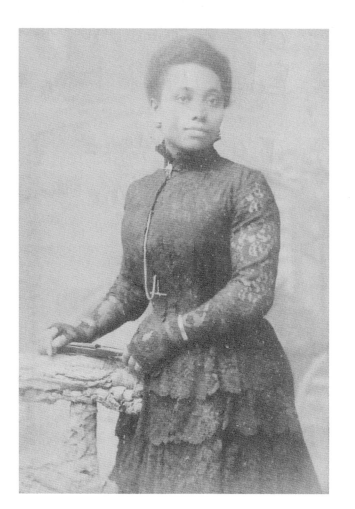

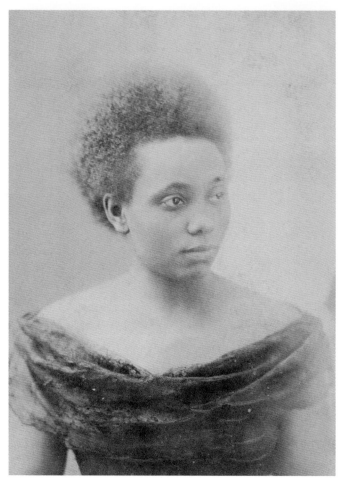

Cat. 15
Unknown
*Anna Albertine Olga Brown
in Paris*, about 1887
Photograph, 16.6 × 11 cm
Private collection

Cat. 16
Unknown
Anna Albertine Olga Brown,
about 1882
Photograph, 16.4 × 10.7 cm
Private collection

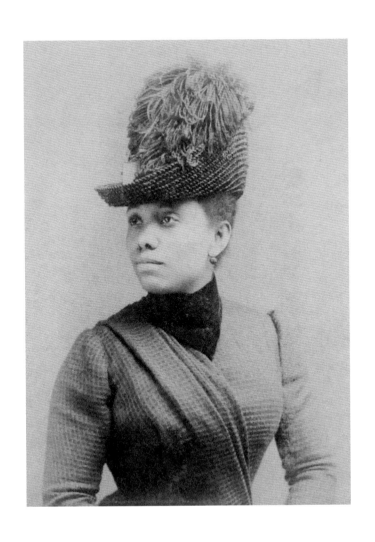

Cat. 17
Unknown
*Anna Albertine Olga Brown
in Nancy, aged 27–29*, 1885–7
Photograph, 11.2 × 7.5 cm
Private collection

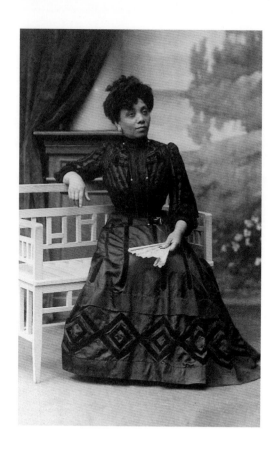

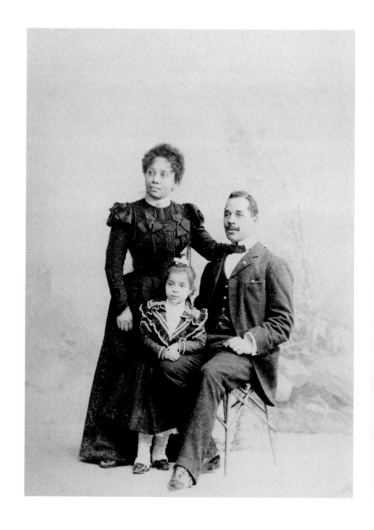

Cat. 18
Unknown
Anna Albertine Olga Brown Woodson in Brussels, about 1908
Photograph, 13.6 × 8.5 cm
Private collection

Cat. 19
Unknown
Anna Albertine Olga Brown Woodson in Cologne with Manuel and Rose Eddie, 1899
Photograph, 16.6 × 11 cm
Private collection

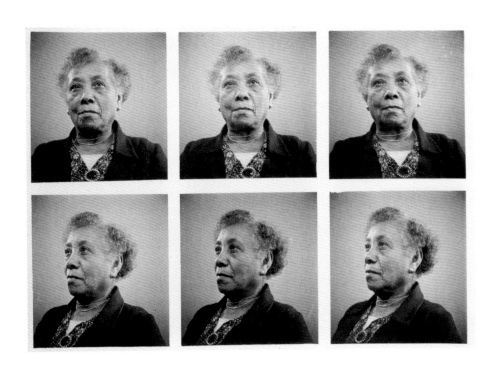

Cat. 20
Unknown
*Anna Albertine Olga Brown
Woodson in Brussels, aged
80–82*, 1938–40
Photograph, 7.1 × 10.8 cm
Private collection

The Cirque Fernando

CHIARA DI STEFANO

Immortalised by Pablo Picasso, Georges Seurat and Henri de Toulouse-Lautrec, among others, the Cirque Fernando, later renamed Cirque Medrano, immediately brings to mind some of the most arresting avant-garde paintings created in late nineteenth- and early twentieth-century Paris.

In 1873, the Belgian rider and acrobat Ferdinand Constantin Beert, known as Fernando, set up a circus tent at the corner of the boulevard de Rochechouart and the rue des Martyrs in Paris. Conveniently located at the edge of Montmartre – an area increasingly popular with artists, close to Paris's ever-expanding entertainment district – his venture soon proved successful. At the time of its creation, it was Paris's cheapest permanent circus.[1] This, combined with a rich and varied programme which included the clown Boum-Boum (Gerónimo Medrano) – one of the most popular attractions of the day – drew in a broad bohemian audience.

Encouraged by the venue's popularity, Fernando obtained a 30-year lease and on 25 June 1875 a new, permanent building opened its doors on the site. A 16-sided polygon designed by the architect Gustave Gridaine, built in stone, brick, wood and metal, it was about 21 metres high and could host no fewer than 2,080 spectators. Its iconic facade would be recorded in countless posters (cats 21, 22) and drawings (cat. 24), as well as postcards (cat. 23).

To increase publicity at no cost, artists were granted free access to rehearsals and, sometimes, performances. The strategy worked well: 'painters and poets meet in this circus', observed a journalist in 1878.[2] One of them was the Lyonnais painter and engraver Maurice Blum, who depicted the Cirque Fernando several times, focusing on scenes observed during rehearsals (cats 25, 26). In May 1879, he showed the (now lost) Les Chiens savants (Performing Dogs) at the Salon taking place at the Palais des Champs-Elysées (cat. 25).

Not far from there, a few weeks later, works by Pierre-Auguste Renoir would feature in a one-man show (the artist's first) at the newly opened gallery, La Vie Moderne (19 June–3 July 1879). Among the exhibited works was Acrobats at the Cirque Fernando (Francisca and Angelina Wartenberg) (cat. 28). Renoir focuses on two circus girls saluting at the end of a performance; one is bowing, while the other is collecting oranges thrown by the public in tribute. The two sisters – aged 14 and 17 at the time, though Renoir made them look younger – were actually posed by the artist in his studio, under natural light, as he would have done with the daughters of his wealthy patrons. Although painted at the same time as Degas's Miss La La – in the winter or spring of 1879 – and though both show circus acrobats wearing the same attire (a white and gold satin costume), these two Impressionist masterworks could not be more different in composition and spirit.

According to Degas's early biographer Georges Rivière, the artist was interested 'in circus people … almost as much as in ballet dancers'.[3] This fascination may only have translated into one finished oil painting, but Degas explored the subject of the circus in at least two other finished works: the monotype The Clown (fig. 7) and the lithograph At the Cirque Fernando (cat. 27). In the latter, a male acrobat performs with his dogs in the circus ring. Dated 1879, this image reverses Miss La La's viewpoint: instead of looking up at the circus ceiling we are looking down at the arena, which occupies at least three quarters of the composition, with members of the public barely discernible behind the circus ring.

From the stalls, notebook in hand, Degas also sketched the clown Gougou, then nicknamed the *Clown-soleil* (Sun-clown) on account of his sumptuous costume. A skilled performer descending from a well-established circus lineage, Arsène Loyal (1853–1925) started performing as Gougou in 1878. Degas made two studies of him performing the *jeu des chapeaux* (game of the hats) (cat. 29), his rotund, comical silhouette contrasting with Miss La La's aerial lightness and grace.

Degas also drew Miss La La's performing partner, the aerialist Theophilia Szterker, at least once, on 24 January 1879, as attested by the date he inscribed on the sketch. Rapidly outlined, she appears to press down on a trapeze bar, although in fact Degas sketched her in his studio using a prop (cat. 30; see p. 21). 'Theofila Paira', as spelled by Degas, was a member of the Kaira troupe, and was therefore also known as Kaira (cat. 6).[4] Theophilia (cat. 4) performed with Miss La La in the Kaira troupe from 1877 to 1881. From 1882, they formed a duo alternately billed as 'The Two Butterflies', 'The Black & White Butterflies', and 'Kaira la blanche and Olga la noire' (cats 3, 8, 9), perpetuating stereotypical and caricatural views about racial otherness. Szterker died in 1888 after a tragic fall, aged only 26.

By 1897, years of catastrophic financial management had led the Cirque Fernando to bankruptcy, and clown Gerónimo Medrano bought its lease. Renamed Cirque Medrano and under new management, the circus would soon be restored to its former glory – until at least the 1920s. It remained a regular haunt of artists and inspired the work of Alexander Archipenko, Fernand Léger and Georges Rouault, among others. After Medrano's death in 1912, the circus was managed by his widow and their descendants. In 1943, the plot of land on which the circus was built was acquired by the Bouglione family, an illustrious circus dynasty since the nineteenth century. After a long legal battle, the Bougliones took formal possession of the Cirque Medrano in 1962. It hosted its last performance on 7 January 1963.

Longstanding neglect led the famous building to decay. On 25 November 1972, while filming its demolition (see p. 135), the French national newscast relayed the public outcry: 'Through these sad ruins, a little of Paris is leaving and dying, forever depriving Montmartre of one of its many charms.'[5]

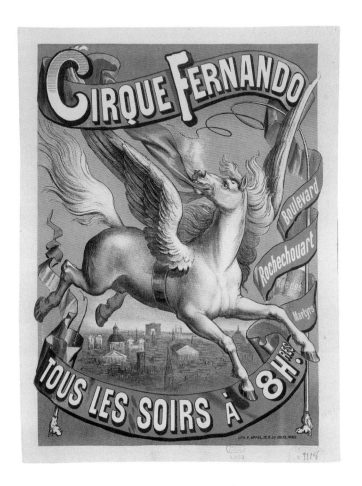

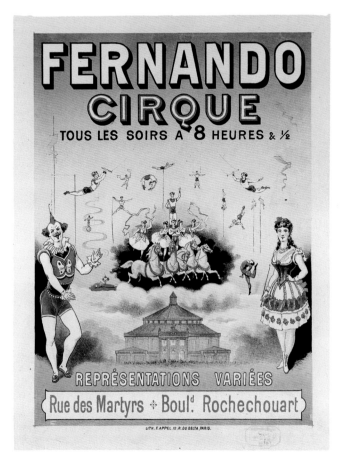

Cat. 21
François Appel (1821–1882)
Cirque Fernando ...,
date unknown
Colour lithograph, 40 × 30.5 cm
Bibliothèque nationale de
France, Bibliothèque-musée de
l'Opéra, Affiches Cirque

Cat. 22
François Appel (1821–1882)
Fernando Cirque ...
Représentations variées, 1875
Colour lithograph, 41 × 30.7 cm
Bibliothèque nationale de
France, Bibliothèque-musée de
l'Opéra, Affiches Cirque

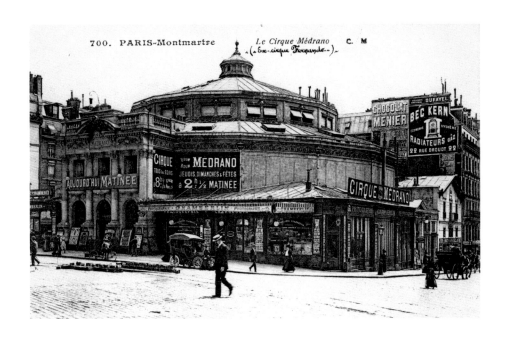

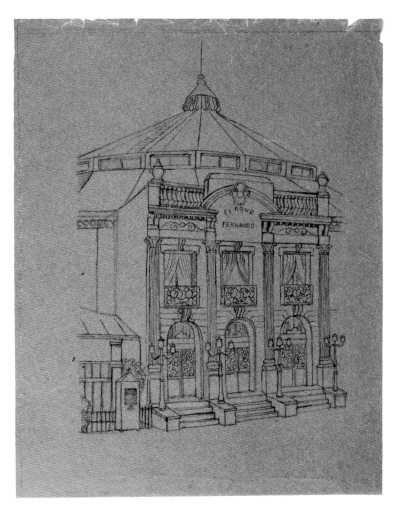

Cat. 23
Unknown
Cirque Medrano (formerly Cirque Fernando), about 1897
Photograph, 8.8 × 13.7 cm
Mucem, Marseille

Cat. 24
Marthe Vesque (1879–1949) and Juliette Vesque (1881–1962)
Cirque Fernando, date unknown
Pencil on paper, 19.3 × 15.4 cm
Mucem, Marseille

LES CHIENS SAVANTS, tableau de Maurice BLUM.

Cat. 25
Unknown
Print after Maurice Blum's *Les Chiens savants (Une répétition au Cirque Fernando)*, 1888
Reproduced in *Paris Illustré* magazine, no. 13, 31 March 1888, about 15 × 11 cm
Private collection

Cat. 26
Maurice Blum (1832–1909)
The Circus Performers (Artistes de cirque, or Leçon de maintien), 1875
Oil on canvas, 128.5 × 96 cm
Megan and Joseph Cook

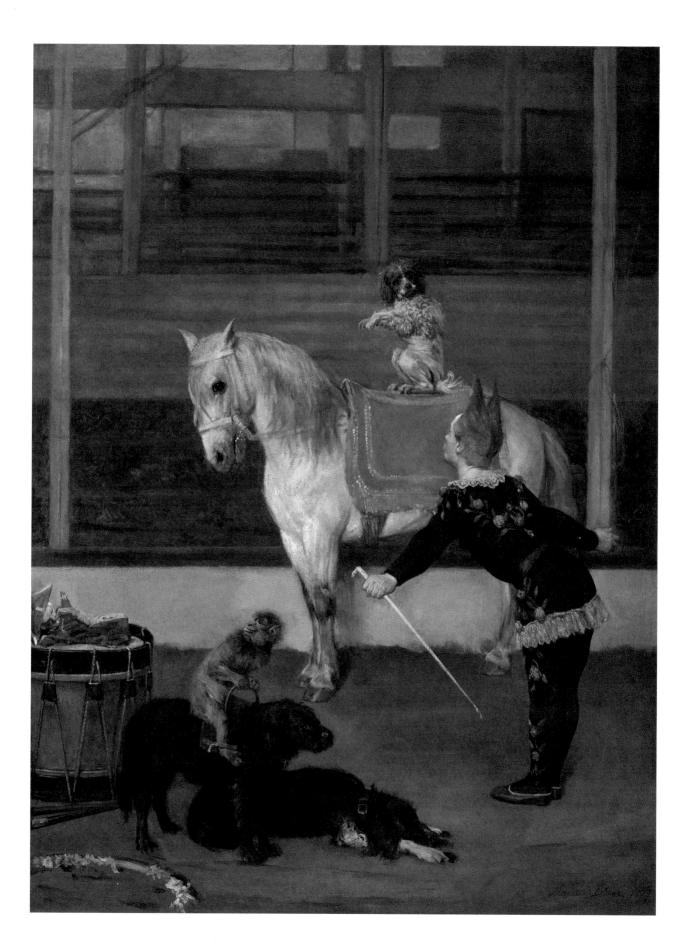

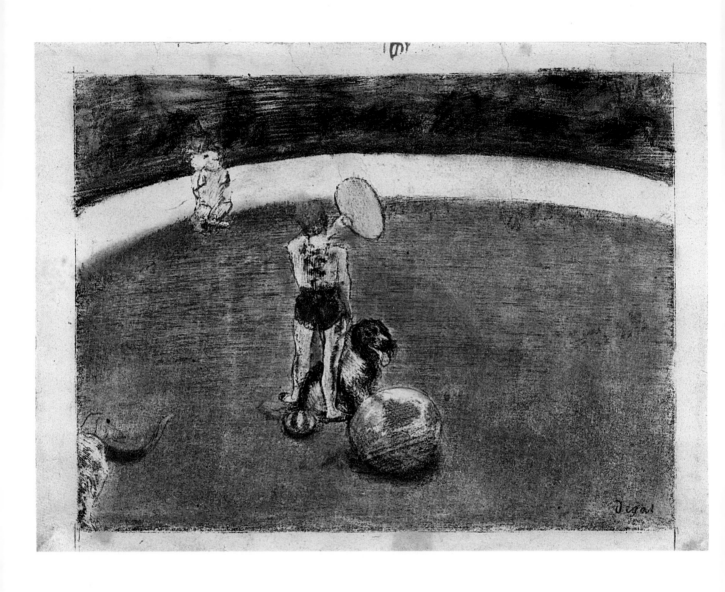

Cat. 27
At the Cirque Fernando, 1879
Lithograph heightened with
pastels, 11.9 × 16 cm
Bibliothèque de l'Institut national
d'histoire de l'art, collections
Jacques Doucet, Paris

Cat. 28
Pierre-Auguste Renoir
(1841–1919)
*Acrobats at the Cirque Fernando
(Francisca and Angelina
Wartenberg)*, 1879
Oil on canvas, 131.2 × 99.2 cm
The Art Institute of Chicago,
Potter Palmer Collection

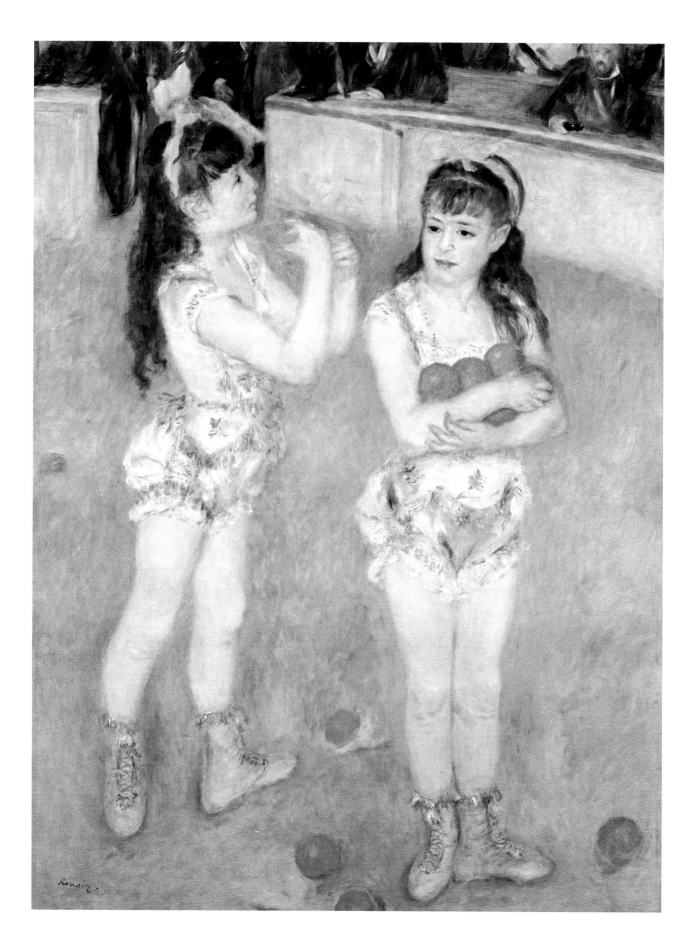

Cat. 29
Gougou (Arsène Loyal),
about 1879
Pencil on paper, 21.4 × 17.5 cm,
folios 7 and 9 from notebook 9
Bibliothèque nationale de
France, Département des
Estampes et de la photographie

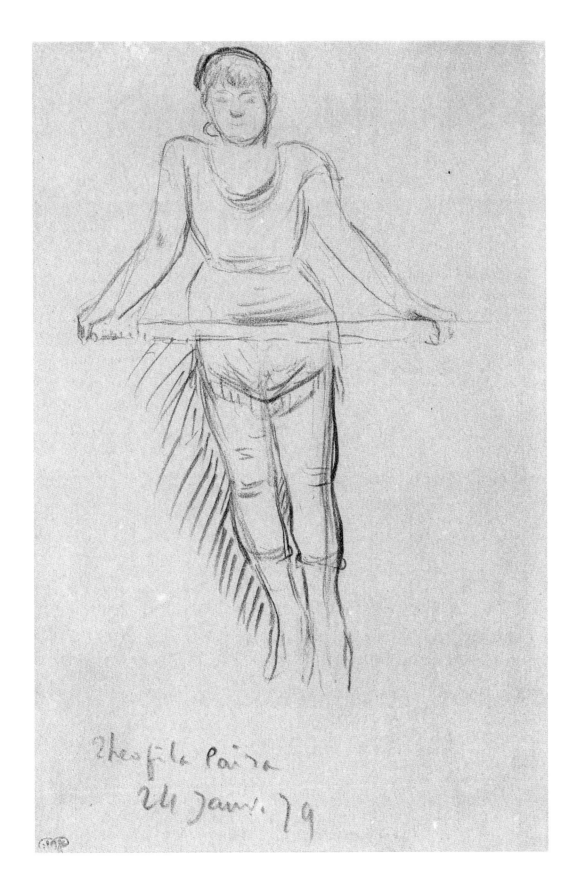

Cat. 30
Theofila Paira, 1879
Black pencil on beige paper,
16.9 × 11.3 cm
Galerie la Nouvelle Athènes,
Paris

Watching, Drawing, Posing Miss La La

ANNE ROBBINS

The exceptionally rich body of work relating to Degas's *Miss La La at the Cirque Fernando* provides us with a unique opportunity to follow the artist's progress in the material elaboration of his painting, while casting invaluable light on his working process. At least nine sketches done on the pages of a notebook, and no fewer than eight preparatory drawings or pastels on single sheets – more or less detailed, and sometimes squared-up for transfer – make it possible to follow closely the development of Degas's 'project'. They also demonstrate the artist's considerable experimentation and perfectionism as he went along, through painstaking adjustments and alterations to the pose of the sitter, as well as to the elaborate interior of the circus in the background.

On account of the dates inscribed by Degas on four of these studies, likely executed in his studio,[1] the artist worked intensely on this project for at least a week, between Sunday 19 January and the following Saturday, 25 January 1879. However, he would no doubt have embarked on it earlier, with some initial sketches; and the elaboration of the painting itself extended far into the following weeks. Yet its making cannot have covered more than a period of four months – between 10 December 1878, when 'Miss La La and The Kaira Troupe' started to perform in Paris, and 27 April 1879, the date by which the finished painting had joined the Fourth Impressionist Exhibition.

The earliest dated study of Olga in the middle of her act, a large pastel sketch done on 19 January (fig. 8), shows her head-on, frontally, wearing an arresting red outfit adorned with fringes – a figure strikingly similar in colour, shape and pose to the small figure visible at the top right of the poster advertising her 1878 Cirque Fernando performance (cat. 6; see p. 24). A now untraced pencil study showing Olga spread diagonally across the sheet (a pose entirely devoid of gravity, and possibly unrelated to her pulley ascension, not least since no rope or mouth bit are visible), may likewise be dated early in Degas's evolutionary process towards the painting (fig. 11). If we assume that once Olga's 'final' pose (in profile, in three-quarter view) was determined, the artist would not deviate from it, both works sit apart within his Miss La La oeuvre (see p. 25).

At about the same time (mid-January 1879), or possibly earlier, Degas was at the Cirque Fernando, sitting in the audience during one or several of Miss La La's performances, and sketching his surroundings – the ornate columns, curved arches and square windows – in a small notebook,[2] adding written notes to later remind himself of the interior's colour scheme (cat. 31), in anticipation of the painting he was already planning. Two rough pencil sketches in this notebook also record Miss La La's ascension, or rather Degas's rapid impression of it: a stick figure seen in profile, arm outstretched, and already framed; and a quick study of the performer's thighs and knees tightly gripped together.

The pastel dated 21 January (cat. 32) shows Miss La La's legs positioned in that exact same way, twisting together to facilitate her ascension in a rotating movement. With nothing more than blue pastel strokes applied diagonally, the artist evokes the ceiling's angled trusses, here rendered with denser and more oblique hatching than in the pastel executed two days earlier. As indicated by its grid of squaring lines, Degas may have used this work to transfer the figure of Miss La La onto canvas – possibly for the tall, narrow, slightly unresolved oil and pastel study for *Miss La La at the Cirque Fernando* (cat. 33, preceding the National

Gallery picture and also showing the dark, lower part of the circus interior). With her head bent far backwards (revealing her chin), and her open hand and outstretched thumb, Olga's pose in the squared-up pastel and the painted sketch look virtually identical. However, conceivably dissatisfied with his first attempt at recording his subject in paint, Degas would make changes to this format and design.

Three days later, on 24 January, in Degas's studio (where Olga came accompanied by her stage partner Theophilia, who sat for him on the same day; cat. 30), Degas completed another even larger pastel (fig. 9). The blue hatchings now delineate a clearer architectural background of trusses and beams. Yet here, Degas's attention focuses entirely on Miss La La, more closely observed than ever, her legs hanging vertically and further apart in a balletic 'fourth' position. Her effort and the strength of her grip are wholly palpable.

Finally, in a drawing completed the next day (25 January, likely the Saturday mentioned in Degas's letter to Edmond de Goncourt; see p. 21) – the last in this sequence of precisely recorded works (cat. 36) – the artist decided to combine elements from previous studies. Degas opted for Olga's earlier pose, with folded legs, but from the stunning pastel done the previous day he borrowed the sense of compressed energy and immediacy, as well as some distinctive features: the tension in Olga's upper body, seen with a stronger *di sotto in sù* effect; and her arm raised high, obscuring her chin. Compact, tightly gripped, Olga's right hand is now bent, revealing the inside of her wrist, as will be the case in the finished painting. Two additional large sheets, undated, but presumably done at the same time, similarly show Olga's twisted right wrist: in one (cat. 34), the delicate details of Miss La La's outfit,

with its tiny folds of satin, are precisely defined, next to a separate study of her arm and hand. The other drawing, no less accomplished, shows these latter elements no fewer than three times, and also features three isolated studies of the contours of her face in lost profile (cat. 35).

The study dated 25 January, highlighted with bright touches of pastel, thus represents the culmination of Degas's observations, and may well be the most definitive of all known Miss La La preparatory compositions, squared-up and ready for transfer onto the large canvas.

There remained, for Degas, the challenge of integrating the figure into the circus interior. A small, double-sided drawing[3] (possibly a page from a notebook) might constitute his earliest attempt to place the figure within her architectural surrounds (cat. 37). Tentative and loosely drawn, it shows how much the artist struggled with the ceiling's complicated structure. Well into his project, Degas even returned to the Cirque Fernando – on at least one occasion with his friend Paul Paulin, whom he asked for a 'carte de visite, and with a quick sketch he made notes on the hang of the space, which allowed him to complete the complicated and impeccable architecture that you find in the finished painting'.[4]

In addition to these extra spatial notes sketched on the spot, and those in his notebook (cat. 31), Degas may have employed a professional architectural draughtsman – or '*perspecteur*' – to help him achieve a satisfactory rendering of the circus space. The stiff lines of the architectural drawing of the Cirque Fernando interior (cat. 38), likely executed with a ruler – a method difficult to relate to Degas's drawing style and approach – support this assumption, later made by his friend Walter

Sickert.[5] Whether or not by Degas's hand, this drawing provided the base for the background of the painting. Technical examination of the latter has revealed that three sets of beams – the same number as in the architectural drawing – were originally intended, and painted onto the canvas, before the composition was modified in favour of a tighter crop.[6] Degas possibly shifted the viewpoint even later in the process, by altering the painting's format: its painted edges suggest that the composition initially extended further, before being cut to achieve the desired view. These final operations may well have delayed the completion of the painting, which was late joining the Fourth Impressionist Exhibition. In the rush to get the picture ready, the varnish may also have been applied too quickly, when the painting's upper layers were barely dry. This would help explain the painting's dominant overall warm, coppery tones, the varnish having mixed with the paint's orange pigments.[7]

Cat. 31
Pages from notebook 23,
about 1879
Pencil and charcoal on paper,
16.6 × 11.3 cm, folios 18, 21
and 36
Bibliothèque nationale de
France, Département des
Estampes et de la photographie

A year later, or possibly more, Degas made one last drawing of Miss La La (cat. 39), repeating in a large notebook the pose he had so painstakingly fixed over the course of those few weeks of intense work. It was executed at his friend Ludovic Halévy's house, possibly at his invitation,[8] while reminiscing about Miss La La and her performances of the winter of 1878–9 in Paris. Degas remembered her, and his painting, vividly enough to draw it from memory, with a free, if slightly awkward hand. He precisely recalls the key elements of her act: the diagonal, tightly pulled rope (absent from most preparatory works); the mouth bit, which he would have seen close up during Miss La La's studio sittings, but sketched here separately for the first time; her contorted body; the 'circus roof leaning wholly to one side'.[9] This 'summary' of the painting and of its making tells us, in just a few pencil lines, of *Miss La La*'s exceptional place in Degas's career, and reminds us of how much he valued it.

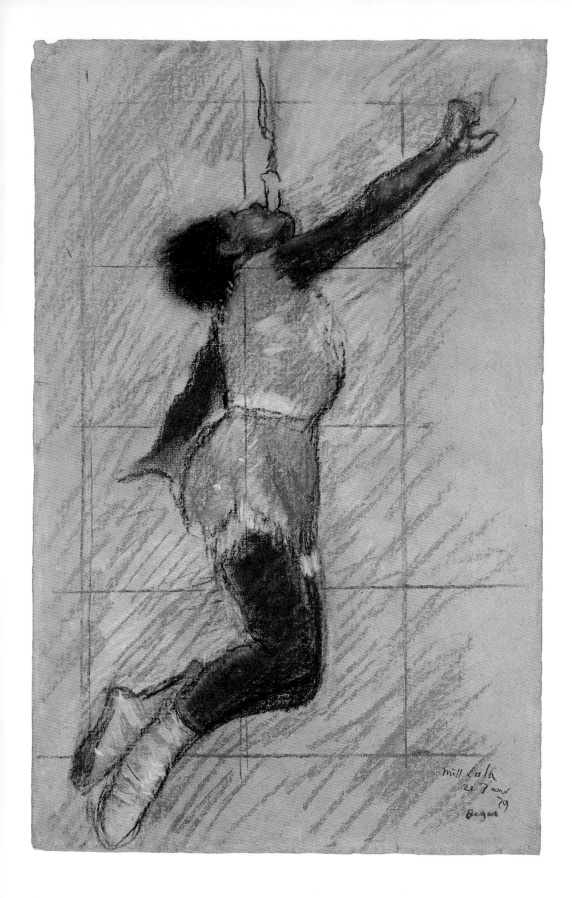

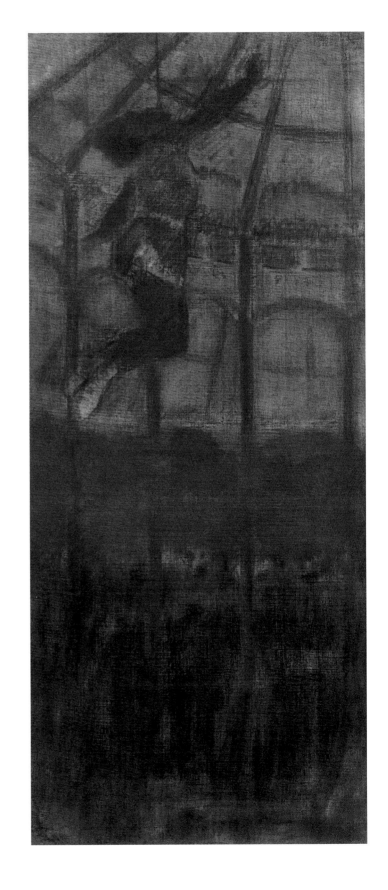

Cat. 32
*Miss La La at the Cirque
Fernando*, 1879
Pastel on faded blue paper,
46.4 × 29.8 cm
The J. Paul Getty Museum,
Los Angeles

Cat. 33
*Study for Miss La La at the
Cirque Fernando*, 1879
Oil and pastel on canvas,
88.9 × 39.7 cm
Private collection

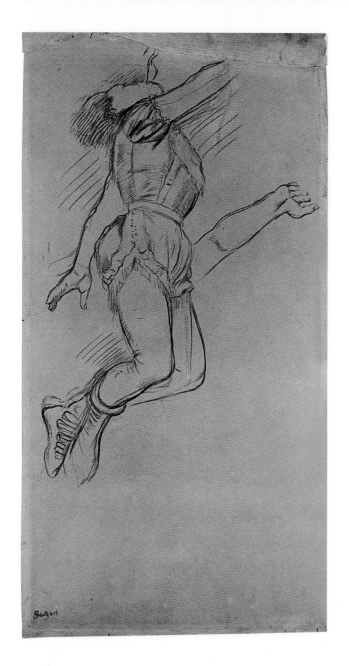

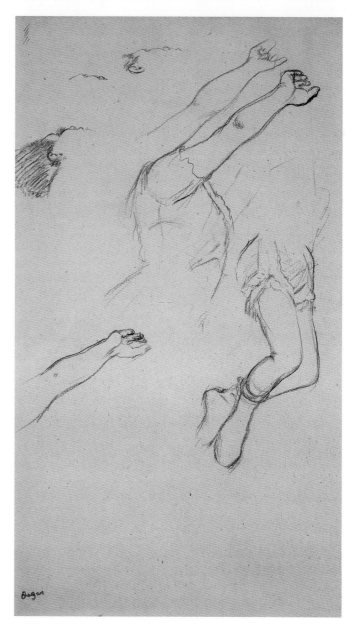

Cat. 34
*Miss La La at the Cirque
Fernando*, 1879
Black crayon on brown wove
paper, 45.4 × 23.8 cm
Detroit Institute of Arts,
Bequest of John S. Newberry

Cat. 35
*Miss La La at the Cirque
Fernando*, 1879
Charcoal and black pencil on
paper, 47.7 × 26.5 cm
Private collection

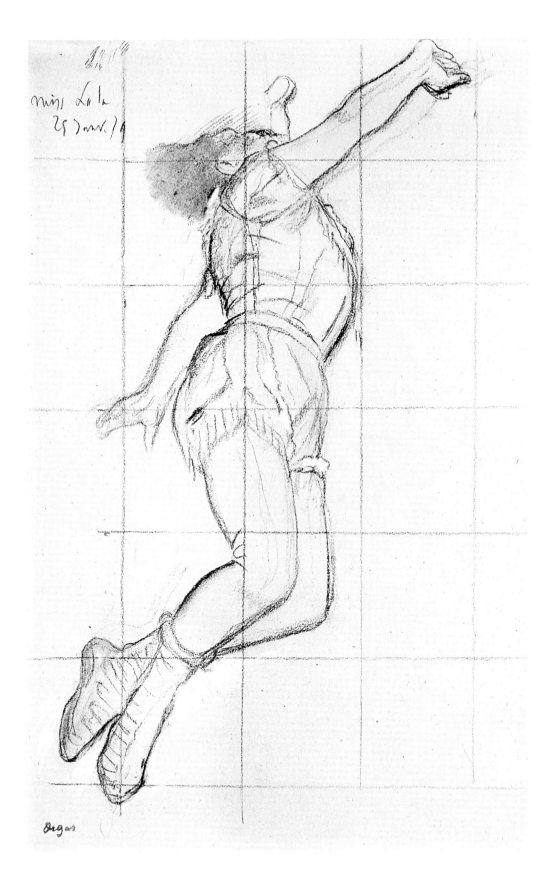

Cat. 36
*Miss La La at the Cirque
Fernando*, 1879
Black chalk and pastel on paper,
47 × 32 cm
The Henry Barber Trust, the
Barber Institute of Fine Arts,
University of Birmingham

Cat. 37
Double-sided study for
*Miss La La at the Cirque
Fernando*, 1879
Pencil on paper,
16.8 × 10.2 cm
Dylan and Emilee Ferguson

Cat. 38
*The Cirque Fernando –
Architectural Study*, about 1879
Pencil, black and red chalk on
two sheets of joined pink paper,
48.4 × 31.5 cm
The Henry Barber Trust, the
Barber Institute of Fine Arts,
University of Birmingham

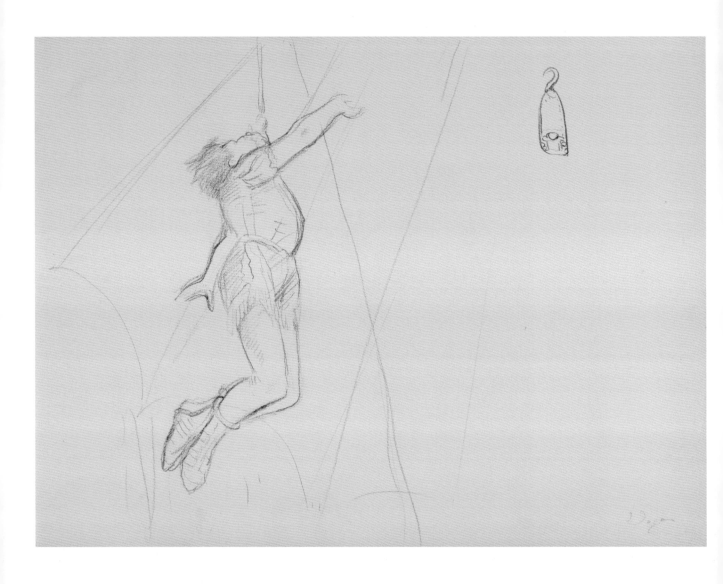

Cat. 39
Page from notebook 29,
1880 and after
Pencil on paper, 25.1 × 33.9 cm,
folio 26
The Morgan Library & Museum,
Thaw Collection, New York

Cat. 40
Miss La La at the Cirque
Fernando, 1879
Oil on canvas, 117.2 × 77.5 cm
The National Gallery, London

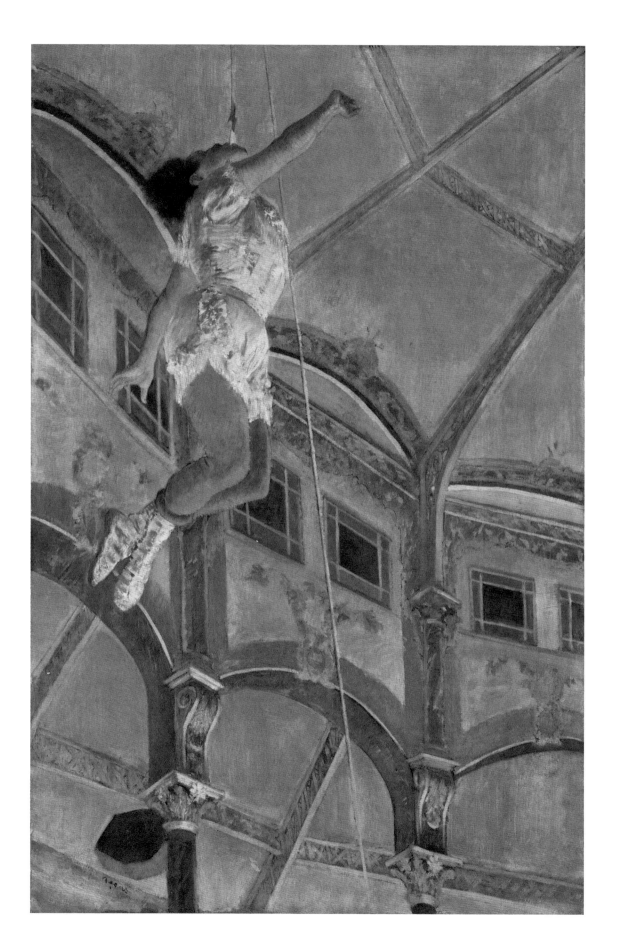

Degas and 'the Black World'

DARCY GRIMALDO GRIGSBY

Seven years before Degas saw Anna Albertine Olga Brown's acrobatic performance as Miss La La in Paris, he had confronted what he called 'the Black world' of New Orleans. For five months between 1872 and 1873, the painter had visited the Creole family of his late mother, Marie Célestine Musson, whom he had lost at the age of 13. His maternal grandparents tied him not only to Creole New Orleans, but back to France's slave economy in Saint-Domingue, present-day Haiti. Born in Saint-Domingue in 1787, Degas's maternal grandfather, Germain Musson, a Creole of French descent, fled the colony in 1810 because of the Haitian revolution. Degas's maternal grandmother, Marie Céleste Désirée Rillieux, also linked the painter to the history of slavery; her brother had seven children with a free woman of colour named Constance Vivant. Their son Norbert Rillieux (fig. 17) became a famous inventor of a sugar-refining process, and would later emigrate to Paris, where he taught, and assisted the Egyptologist Jean-François Champollion. Prominent free persons of colour were thus first cousins of Degas's mother.

During his visit to New Orleans, Degas resided in the family home of Germain Musson's son Michel, his uncle, who continued his father's cotton business after Musson's death in 1853. Having emigrated to New Orleans, Degas's brother René had married his cousin Estelle Musson, and with his brother Achille had founded a company exporting cotton to France. In New Orleans, Degas's entire family depended on cotton, an industry underpinned by enslaved labour, and they depended on it before, during and after the Civil War, which had all but decimated the trade. French-speaking, Creole and Confederate, their enemy was the pro-abolitionist 'Yankee' from the northern states. In the many letters Degas wrote while in New Orleans, the fact that the Mussons had been slaveholders is suppressed. Instead, the artist wrote his correspondence on the headed paper of the 'De Gas Brothers, New Orleans' firm; he was proud of their cotton business and painted it twice (see fig. 19).[1]

In a letter to artist James Tissot, Degas conceded that he had not made much art during his five-month stay with his Creole relatives: 'The Black world, I have not the time to explore it; there are some real treasures as regards drawing and colour in these forests of ebony.'[2] Surprisingly, perhaps, Degas extolled the beauty of a world permeated by racial difference, reiterating then-current terminologies: 'And the pretty women of pure blood and the pretty quadroons and the well set up *négresses*!'[3] But he never painted New Orleans's Black population, although he admitted that other artists, such as Edouard Manet, painter of *Olympia* (1863), may have found a way to do so.

Degas's correspondence stressed the difficulty of painting outdoors in the brilliant sunlight, which hurt his eyes. His preoccupation with his eyesight was justified, given that his vision had started to decline in one eye. In New Orleans, moreover, his most beloved cousin, Estelle, forced him to confront the spectre of encroaching blindness. When Estelle, a Confederate widow, had fled the Civil War to France, she was blind in one eye. By 1872, she was almost completely blind. Her courage astounded and horrified the artist, whose very profession depended on sight.

Although Degas claimed that he could not paint the 'Black world' because of the brightness outside, his letters barely acknowledge that Black women 'of all shades' were inside his family's dimly lit home, working as servants and caretakers for six

young children. The painter seemingly attempted to depict a domestic scene with a Black nanny only once. In *Courtyard of a House* (*New Orleans, Sketch*), Degas positions the nanny down low on the border between inside and outside, the back step (cat. 42). But the cropped, diminished and cramped nursemaid is barely resolved. Exceptionally, Degas experiments here with the colours of a range of complexions: the child facing us, for example, appears darker brown than the other children. We cannot determine whether the toddler is in shadow or has a dark complexion. Lighting confuses our apprehension of skin colour. While Degas avoided that confusion in his paintings in New Orleans, he would exploit the ambiguity after he left.

Indeed, the sight of New Orleans's Black population, contrasted to the brilliant light, had a lasting impact on his art. In his letter to Tissot, he had added, 'I shall be very surprised to live among white people only in Paris. And then I love silhouettes so much and these silhouettes walk.'[4] New Orleans had heightened Degas's awareness of an effect of great tactical use. He was a skilful, decisive draughtsman, but the lightly drawn pencil sketches thought to have been made on his way to New Orleans are unusually tentative (cat. 41). By contrast, on his return trip – drawing on the stationery paper from his family's firm – Degas confidently uses an ink wash to represent his fellow travellers as dark shapes against the white brightness of sea and sky and paper (cat. 43). Degas was experimenting with silhouettes.

Once home in 1873, he painted a picture of a laundress, entitled *Blanchisseuse* (*Silhouette*) (fig. 34), which he displayed at the Second Impressionist Exhibition in 1876. He had always enjoyed backlighting, but after his stay in New Orleans he experimented more boldly (cat. 44). *Blanchisseuse* (*Silhouette*), which in its title alone draws attention to whiteness (*blanc*) and blackness, makes the white laundress into a dark shape set against a brilliant light and bleached cotton. At the same exhibition, Degas may also have included *Peasant Girls bathing in the Sea at Dusk* (cat. 45), in which young girls appear in silhouette, standing facing the setting sun.

After his voyage, Degas could see French and he could see Creole. To see French was to presume an uncontested 'norm' of whiteness; to see Creole was to perceive racial heterogeneity (even among so-called 'whites'). Once Degas returned to France, a silhouette could be a backlit white woman or a Black person in broad daylight, but he notably felt far more comfortable painting the former. His pictures of Anna Albertine Olga Brown suggest he was ready, seven years later, to try painting the woman of colour he had noted only once in New Orleans in *Courtyard of a House* (*New Orleans, Sketch*). Degas remained unsure how to do so. Miss La La is notably remote, and her face is eclipsed like the earlier nanny's. Her complexion across Degas's studies leaves in question whether she is Brown or Black or merely poorly lit. Degas was a man descended from the fraught history of slavery and miscegenation, a man whose family's wealth derived from the cotton trade; he may simply have needed to push her far away so that we do not see her face.

Cat. 41
Pages from notebook 24, 1872
Pencil on paper, 18.7 × 12.5 cm,
folios 161 and 164
Bibliothèque nationale de France,
Département des Estampes et de
la photographie

Cat. 42
Courtyard of a House
(New Orleans, Sketch), 1873
Oil on canvas, 60 × 73.5 cm
Ordrupgaard, Copenhagen

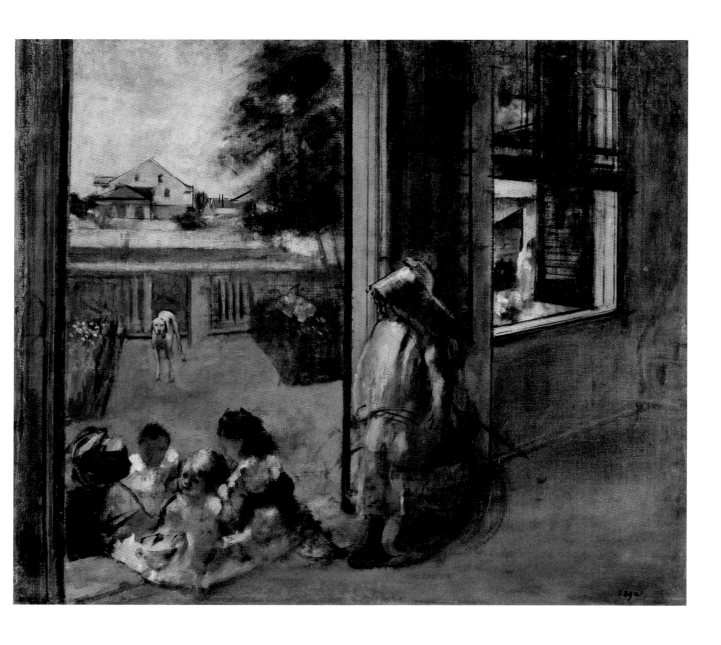

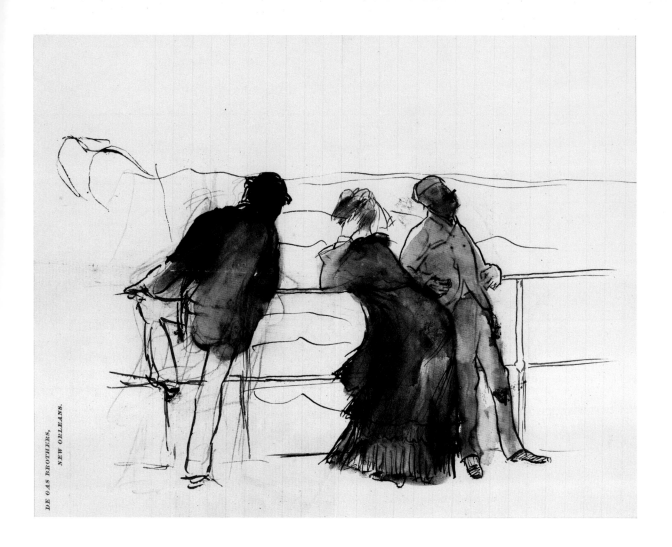

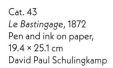

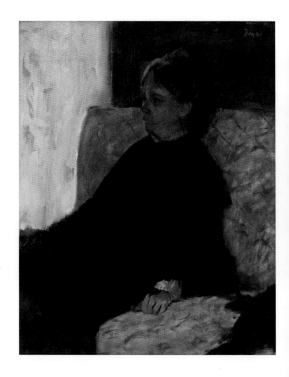

Cat. 43
Le Bastingage, 1872
Pen and ink on paper,
19.4 × 25.1 cm
David Paul Schulingkamp

Cat. 44
Lady in Black, 1875–8
Oil on canvas, 60 × 51 cm
Nationalmuseum, Stockholm,
Gift 1913 Nationalmusei Vänner

Cat. 45
*Peasant Girls bathing in the Sea
at Dusk*, about 1875–6
Oil on canvas, 65 × 81 cm
Private collection

Miss La La in Britain

CHRISTOPHER RIOPELLE

Not counting a little-noted Toronto auction of 1920, *Miss La La at the Cirque Fernando* was seen in public only three times in its first 41 years. It turned up for the final weeks of the Fourth Impressionist Exhibition in Paris in spring 1879 – few critics commented – then 26 years later, after a short trip to Berlin in 1903, had pride of place among Degas paintings in French dealer Paul Durand-Ruel's Impressionist exhibition of 1905 at the Grafton Galleries in Mayfair (see pp. 60–2).[1] There it was purchased by the Canadian entrepreneur Cawthra Mulock, who returned home with it soon after; it was his widow who sold the picture at auction 15 years later, unexhibited in Canada during that time.[2]

Bought by a New York dealer, *Miss La La* was back in London by 1923. That July it figured in the 117th exhibition of the French Gallery in Pall Mall, long a source for modern and contemporary Continental art in the British capital. That same year the industrialist Samuel Courtauld established his Fund for the acquisition of modern foreign art for the National Gallery.[3] Among its early purchases were Georges Seurat's monumental *Bathers at Asnières* (NG3908) and Vincent van Gogh's dazzling *Sunflowers* (NG3863). Courtauld began as he meant to go on, with one audacious acquisition after another; thanks to him, in 1925 *Miss La La* too came to the nation.

Its public 'career' now can be said to begin. From 1926 to 1950 *Miss La La* was on permanent display (Second World War excepted, when pictures were evacuated from the capital), not in Trafalgar Square but rather at the Tate Gallery, Millbank, a subsidiary of the National Gallery under the administration of the latter's Trustees. It was where the nation's collection of British art – ancient, modern, contemporary – was shown. 'Modern Foreign Pictures' were shown there as well. For decades, then, visitors saw *Miss La La* in proximity to modern British art. Those visitors included British artists – the audience perhaps most alive to lessons learned from foreign counterparts, not least Degas's long-time friend and admirer Walter Sickert.[4]

In 1950 the picture was permanently transferred from the Tate to the National Gallery, where it has been on permanent display since. The date of transfer is not insignificant. The Massey Committee, chaired by Vincent Massey, former chairman of the National Gallery, had issued its report recommending that the Tate have separate statutory status from the National Gallery, as well as its own Trustees (the division was later enacted by Parliament). Perhaps it was felt that, however uncanny the subject, at just over 70 years old, comparatively traditional in technique and unambiguously representational, *Miss La La* could now comfortably hang in Trafalgar Square. By comparison, the more stylistically experimental *Bathers at Asnières* and *Sunflowers* came to Trafalgar Square only in 1961; and as late as 1964, when the National Gallery acquired Cezanne's even more outré and anti-naturalistic *Bathers* (*Les Grandes Baigneuses*) (NG6359), the British press could still whip up quaint indignation at the excesses of modern art.

It is not possible to quantify the impact Degas's work has had on the British public; one can merely record reverberations. In 1947, Tate director John Rothenstein included it among the hundred most important modern pictures there.[5] It figures prominently in exhibitions and publications on Courtauld's pioneering philanthropy, noted elsewhere in these pages. Visitors to the National Gallery, not least schoolchildren, still crowd in amazement around the dizzying image. Increasingly, scholarly

attention focuses on Miss La La herself, one of the most famous and daring circus acrobats of her day, in a line of African American women – professional performers, including Josephine Baker and Leontyne Price among them – who would electrify European audiences. To what degree, indeed, must we consider the work a collaboration between two artists?

One gauge of impact may be the rise of circus imagery in British painting in the early twentieth century. Sickert probably saw *Miss La La* first, *chez* Degas, in Paris as early as 1885.[6] It stuck with him. With its daring upward perspective, *The Trapeze* of 1920 (cat. 47) owes a debt not least to the contrast between the taut architectonic rigour of the space and the vulnerability of the single, tiny, swaying figure. As Sickert would have perceived, that tension, implicit with danger, had been Degas's singular contribution to circus imagery in the fine arts, borrowed unashamedly as it was from popular sources like advertising posters. Sickert's third wife, Thérèse Lessore (1884–1945), was no less drawn to derring-do. In *The Daredevils* (cat. 46), three trapeze artists – seen twice, caught in a searchlight high above the audience, and again, lower down, as cast shadows – suggest the magic of bravura performance and camaraderie among *artistes* who share a risky profession.

Dame Laura Knight (1877–1970) was no less an habitué of the circus, also drawn to trapeze artists, as her sketchbook page of around 1925 shows (cat. 48). Surely she identified, sensing like Lessore a reciprocity between the fragility and courage of the circus performer and the artist, lonely in their daring; exposed, ever at risk. Conversely, for Duncan Grant (1885–1978), it was the hubbub of the arena, the crowds, the noise, the wild animals, an untamed world teetering on the verge of chaos, so different

from his own polite, introspective Bloomsbury portraiture. His *Circus* of 1923 (cat. 49) reveals passion like little else in Grant's career, beyond his homoerotic drawings – further testimony, perhaps, to the liberating example of Degas.

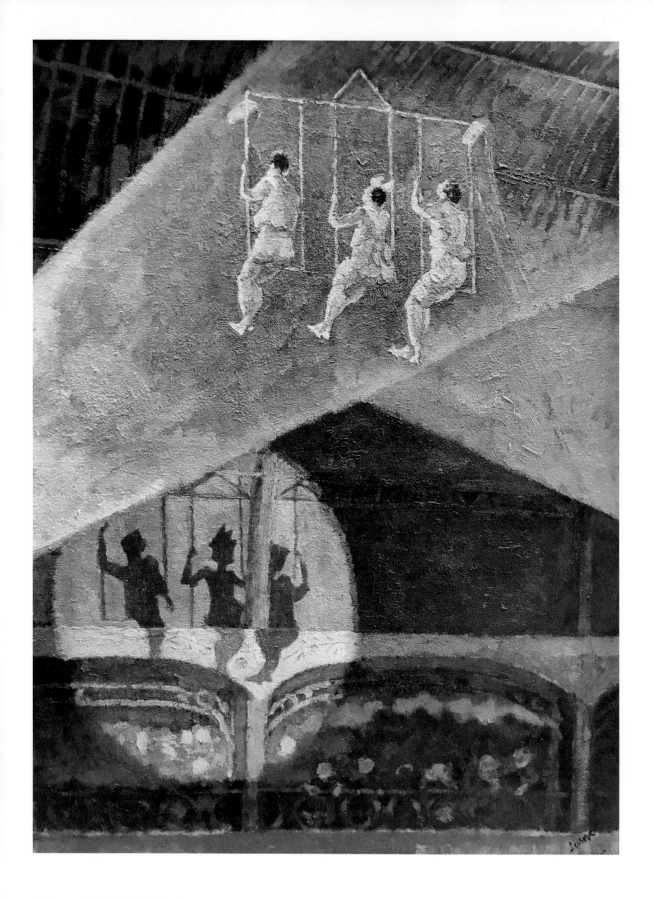

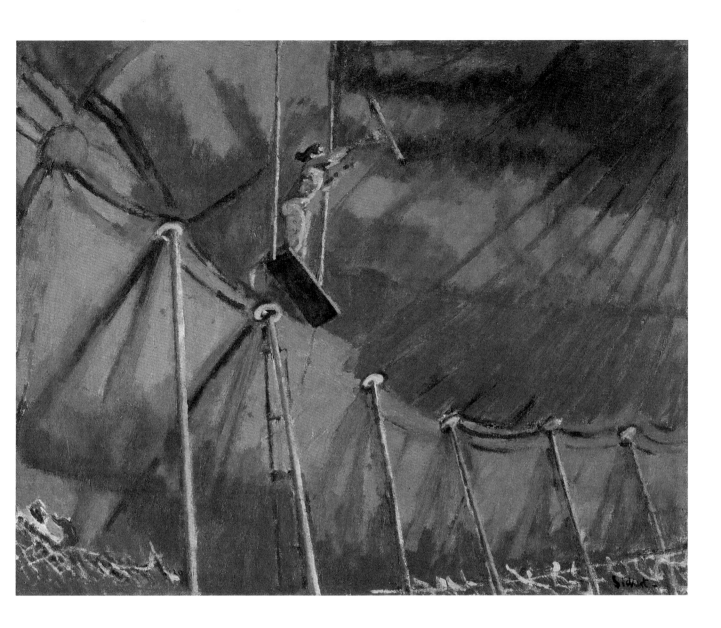

Cat. 46
Thérèse Lessore (1884–1945)
The Daredevils, date unknown
Oil on canvas, 91.4 × 71.1 cm
Hastings Museum & Art Gallery,
Hastings Borough Council.
Purchased for the museum by
the Went Tree Trust

Cat. 47
Walter Sickert (1860–1942)
The Trapeze, 1920
Oil on canvas, 64.7 × 81 cm
The Syndics of the Fitzwilliam
Museum, University of
Cambridge

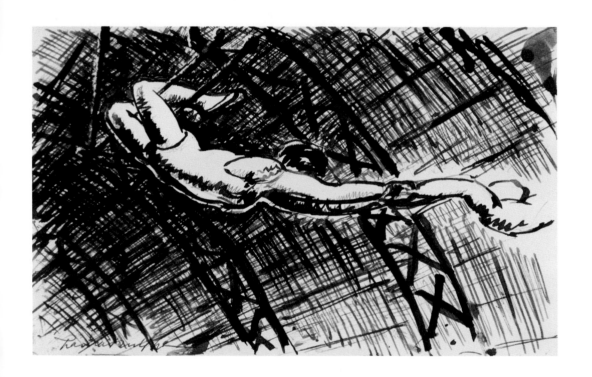

Cat. 48
Laura Knight (1877–1970)
Trapeze Artists, about 1925
Pen and brush with blue ink on
card, 16.1 × 26.2 cm
Royal Academy of Arts, London

Cat. 49
Duncan Grant (1885–1978)
Circus, 1923
Oil on board, 76.5 × 88 cm
UK Government Art Collection,
London

CHRONOLOGY: ANNA ALBERTINE OLGA BROWN WOODSON, 'MISS LA LA'
COMPILED BY LAURIE FIERSTEIN

1858

21 April: Born Anna Albertine Olga Brown in Kupfermühle, suburb of Stettin, Province of Pomerania, Kingdom of Prussia (present-day Szczecin, Poland), to German-Prussian mother and African American father. Youngest of four siblings (Wilhelmine Caroline, Wilhelm Julius Ferdinand and Marie Henriette).

1867

Around October–November: Leaves home to become aerial acrobat apprentice of Gustav Alexander Neumann and his spouse Elisabeth. Starts travelling as part of 'The Neumann Troupe'.

1869

4 April–17 May: First known professional performance, aged 10, at Lincke'sches Bade, Dresden, Saxony. Uses stage name 'Miss Albertine the African' until 1877.

June–July: Performs in Summer Theatre, Breslau, Silesia, Prussia (present-day Wrocław, Poland). Starts using lasting moniker 'The Flower of the Night'. Acrobat Theophilia Szterker joins The Neumann Troupe. Until her death, she will be Olga's close friend and circus partner.

1870–1

1 December 1870–11 January 1871: Billed as 'Albertine and her Company', Orpheum Theatre, Vienna. Gustav's illness and death at the beginning of this engagement lead to Olga (then aged 12) being named as head of the troupe for the first and only time.

January: After Gustav's death in December 1870, continues travelling in the Austro-Hungarian Empire (away from the Franco-Prussian War) with his widow, Elisabeth, now Olga's and Theophilia's impresario.

1872–3

October 1872–May 1873: While engaged with Circus Equestro Italiano Sidoli in Brno, Moravia, meets acrobatic clown and aerialist Franziskus 'Franz' Pospischil, soon to become Olga's and Theophilia's impresario. Continues travelling with Sidoli's circus in the Austro-Hungarian Empire, including performances in Tarnów (now in Poland) (fig. 6).

June–July: Starts travelling (beginning in the Kingdom of Hungary) with Franz as 'The Pospischil Troupe'.

1873–4

December 1873–March 1874: Engaged as a featured performer at the famous Renz Circus, Berlin, where on 11 March falls from the trapeze, suffering severe neck and hand injuries.

September–October: Performs at Odeon Theatre, Hanover. First appearance of boy believed named Theodor Jüttner, who becomes the fourth performing member of The Pospischil Troupe.

1875

January–February: First engagement in England at London's Metropolitan Music Hall, performing as 'Miss Albertine and Signor Amerigo' (Franz). The Pospischil Troupe is represented during this time by London theatrical agents Parravicini and Corbyn.

29 October: Gives birth to Gustave, son of Franz (otherwise in a relationship with Elisabeth Neumann), while in Saint-Etienne, France.

1875–6

26 December 1875–June 1876: Engaged with Spanish Rizareli Brothers circus in the UK. Called alternatively 'Sisters Albertina and Theophila' [sic], 'Sisters Africane' and 'Sisters Amerigo'. Appear in London, Halifax, Manchester, Oldham, Chester, and Wrexham in Wales. The Pospischil Troupe is first known to use the safety net during this engagement.

1877

January–February: Seemingly called Miss La La for the first time, during the first known performance as 'The La La Kaira Troupe', Schwenders Colosseum, Vienna. Starts the iron-jaw acts which will earn her fame in Western Europe.

1878

14 September: Advertised as 'African La La, the lady with the lion's jaw' in the Brünner Tagesbote (p. 8), for an appearance at Marowsky Hall, Brno.

1878–9

10 December 1878–9 February 1879: Performs as 'Miss La La and The Kaira Troupe', Cirque Fernando, Paris (cats 1, 2, 6).

1879

'Saturday', January 1879 (possibly 25 January): Degas invites friend, writer Edmond de Goncourt, to come to his studio in Paris to be introduced to Olga, who is going to pose and will be accompanied by her 'partner', possibly Theophilia (unknown whether Goncourt actually attended).

February–April: Miss La La and the Kaira Troupe are in England, often as just 'La La'. Appear at the Gaiety Theatre of Varieties in Manchester and at London's Royal Aquarium. Troupe represented for these engagements by Paris-based theatrical agent Rodolphe Rosinsky, who will again arrange some bookings in 1880.

May–November: Headlines as 'Miss La La the Brazilian' with Cirque Fernando's seven-city Belgian tour led by Fernando Beert. Returns to the circus in Paris for part of the autumn season, where on 26 October Theophilia suffers severe injuries from a fall while performing the iron-jaw rope act.

1880

January–March: In England with Myers American Circus in Hanley and Birmingham, and again at the Royal Aquarium in London.

May: Called 'Miss Lala' while engaged at the Folies-Bergère music hall in Paris (cat. 7).

1881

October–December: Troupe travels through France. In December, at the Palace-Théâtre in Paris, they perform for the last known time as 'The La La Kaira Troupe'.

1882

July: Performs with Theophilia as 'The Olga Sisters', Cirque Royal, Brussels.

December: Performs with Theophilia as 'Olga and Kaira' for the first known time, while engaged with Sidoli at Teatro Vittorio Emanuele, Turin.

1883

February–March: First known performance as 'Olga and Kaira, The Two Butterflies', Rancy Circus Hippodrome, Lyon.

March–August: Performances in Berlin, Brussels, and Paris where they are featured as 'The Marvellous Gymnasts Olga and Kaira' at the Hippodrome at Pont de l'Alma (cats 11, 12).

October–December: Back in London at the Royal Aquarium, where they perform for the first known time as 'Olga and Kaira, The Black and White Butterflies'.

1883–4

December 1883–January 1884: At London's Canterbury Theatre of Varieties music hall (cat. 9); Olga's last known performance in England.

1884

Performs in Belgium, Portugal and Spain.

May–July: In Madrid, at Circo de Price, where they are called 'South American' Olga and Kaira. Represented during this time by the Richard Warner Agency, London (cat. 13).

1884–5

August 1884–April 1885: Engaged by director Victor Franconi for his two iconic Paris circuses, Cirque d'Eté (Summer Circus) and Cirque d'Hiver (Winter Circus), where Olga and Theophilia are called 'Les Papillons Noir et Blanc' (cats 4, 10).

1885

May–October: Engaged with Valérie Léon's Cirque Continental in France.

1886

March–June: First use of aerial apparatus called the 'New Silver-plated Revolving Machine', Neue Welt amusement park, Berlin.

June–December: Engaged with the travelling Rancy Circus in Belgium, then France. In July, during a performance in Amiens, injures her jaw. In August–September, in Lille, meets physical culturist Edmond Desbonnet (1867–1953), who, 25 years later, will remember her in his book *Les Rois de la force*, in which he confesses to be 'jealous of her biceps'.

1887

January–February: Called 'Pospischil's Olga and Kaira' when appearing on the revolving machine at Folies-Bergère (cat. 14) (the next and last time Olga performs at this venue is in 1889–90, during the Paris Universal Exhibition as 'Miss Olga the Black Butterfly').

March–September: Engaged with Cirque Plège in Belgium, then through France.

1888

14 June: During a rehearsal at Wulff Circus, Barmen (Wuppertal, Germany), Theophilia breaks her neck in the net and, a week later, dies of her injuries.

11 October: On Heligoland island (then British), at the Evangelical Lutheran St Nicolai Church, Olga marries African American contortionist Emanuel Charles 'Manuel' Woodson from St Louis, Missouri. Henceforth, Olga begins travelling with Manuel and ends her professional association with Franz Pospischil and Elisabeth Neumann.

October: First appearance on husband's US passport, in Munich. Continues travelling under US passports as an American citizen until around 1921, this status based upon marriage to an American.

1888–9

October 1888–July 1889: Takes guardianship of two nieces, Albertine Marie Köppe (1877–?) and Anna Hulda 'Gaby' Köppe (1885–1936). Does not perform during this time; instead travels with Manuel, who performs with the Busch Circus in Central Europe.

1889–91

July 1889–June 1891: Travelling alongside Manuel's act, performs solo throughout Europe as 'Miss Olga the Black Butterfly', 'The African Butterfly' and 'The Black Fly'. Trains niece Albertine Marie as aerial acrobat.

1891

May–June: Final performance of her career, at the Cirque Corradini, Luxembourg.

November: Begins travelling in France, Italy and the German Empire on a tour (ending September 1893) accompanying Manuel's contortion act and Albertine Marie's 'Miss Irmgare the Aerial Fairy' act, booked together at venues.

1892

2 March: Gives birth to son Charles Louis Ernst Woodson, in Rome. The child will die less than a year later (on 16 January 1893) in Breslau.

1893–4

October 1893–June 1894: Resides with Manuel and nieces on Portland Street, London. Manuel manages and performs at Ed Wulff's circus, located at the Hengler's Grand Cirque building, while Olga trains 'The Three Keziah Sisters', consisting of niece Albertine Marie and British apprentices Kezia Ann Skinner (b. 1878) and Ethel Mary French (b. 1881).

1894

3 March: Gives birth to daughter Rose Eddie 'Teddy' Woodson, in London. She is baptised at the Anglican All Souls Church in Marylebone.

July: Starts travelling with The Three Keziah Sisters. Their acrobatic freestanding ladders act performs in tandem with Manuel's act from 1894 to 1902. Olga and Teddy travel with them until 1899. For five years they will tour Europe, Russia, Scandinavia, Australia and New Zealand (cat. 19).

1899

November: Settles with her family in Saint-Gilles/Sint-Gillis, Brussels, where she stays while Manuel continues to perform, travelling with The Three Keziah Sisters until 1902, followed by his new act The Woodson's comedy pantomime. In 1904 Manuel stops performing and becomes a stage manager at entertainment venue the Palais d'Eté/Pôle Nord, Brussels.

1901–2

March 1901–July 1902: Family moves to rue Royale/Konigsstraat, Brussels. Olga and Manuel open cafe-restaurant *Au Singhalais* there with impresario John Hood and his spouse Emma. Olga and Emma operate the establishment.

1906–14

Conducts family **pension** business for performing artists engaged at the Palais d'Eté. Olga's work often takes her to Luxembourg for banking purposes.

1909–14

Manages daughter Teddy's dancing engagements throughout Europe.

1915

20 August: Manuel Woodson dies in Brussels.

September: Olga moves to Holland with Teddy, where they will live during the rest of the First World War.

1919

March: Returns to Brussels with Teddy. Mounts campaign for release of niece Gaby, a nightclub singer and entertainer, incarcerated during a post-war round up of German nationals. Enlists support of influential individuals in Brussels, including artist Philippe Swyncop (1878–1949), for whom Gaby had posed during the war.

1926

July: Family moves to Ixelles/Elsene, Brussels.

1938

April: Refused a US passport by the American Consulate, Brussels, which had marked hers as 'cancelled'. US State Department contests her American citizenship, suggesting a 'stateless' identity, citing that she was born in Germany, had never been to the US and had no intention of settling there permanently (cat. 20).

1941

January: Moves with her family (including two grandchildren) to avenue Emile de Béco/Emile de Bécolaan, Ixelles/Elsene. Lives there during the Second World War.

1945

21 March: Dies at Hôpital d'Ixelles/Elsene.

24 March: Buried at Cimetière d'Ixelles/Elsene (gravestone no longer present).

CHRONOLOGY: DEGAS AND *MISS LA LA AT THE CIRQUE FERNANDO*
COMPILED BY STERRE OVERMARS AND ANNE ROBBINS

1834

Born Hilaire-Germain-Edgar De Gas at 8 rue Saint-Georges, Paris. His maternal grandfather is a cotton merchant living in New Orleans. His paternal grandfather had established a banking business in Naples; Degas's father manages its Paris branch.

1847

Degas's mother, Marie Célestine Musson, dies aged 32.

1853

Graduates from Lycée Louis-le-Grand in Paris.

1855

Admitted to the Ecole des Beaux-Arts, Paris, as pupil of Louis Lamothe (1822–1869), follower of Ingres. Attends for one term only.

1856–9

Travels through Italy to paint, draw and visit family.

Late 1861–early 1862

Meets Edouard Manet while copying at the Louvre. Manet will eventually introduce Degas to Claude Monet, Pierre-Auguste Renoir and Emile Zola.

1865

Debuts at the Paris Salon, where he will show works every year until 1870. These attract little attention.

1870

Publicly criticises the Salon in the newspaper *Paris-Journal*. Growing interest in ballet and theatre subjects. Enlists in the French National Guard during the Franco-Prussian War (1870). His eyesight problems are recorded for the first time.

1872

His youngest brother René visits Paris from New Orleans. Degas accompanies him on his return. They depart from Liverpool and travel to New York on the *Scotia*, arriving in New Orleans on 28 October. Degas stays with his maternal uncle, Michel Musson, and his family. Completes a few paintings and portraits of his relatives in the Musson home.

1873

March: Returns to Paris after five months in New Orleans.

1874

15 April–15 May: First exhibition of the 'Société anonyme des artistes, peintres, sculpteurs, graveurs, etc.' (today known as the First Impressionist Exhibition), which Degas helped organise. He shows 10 works, mainly dancers, racecourses and washerwomen.

1876

1–30 April: Second Impressionist Exhibition, held at the Durand-Ruel gallery in Paris, 11 rue Le Peletier. Degas shows 24 works, including some from his stay in New Orleans and with *contre-jour* effect. Attends Cirque Fernando with some of his artist friends.

1877

5–30 April: Third Impressionist Exhibition, held at a rented apartment on 6 rue Le Peletier. Degas exhibits 25 paintings.

1878

The Musée des Beaux-Arts de Pau acquires *A Cotton Office in New Orleans* (1873) – the first work by Degas to enter a public collection in France. It depicts the interior of the Musson firm in the city's 'Cotton District'.

1879

January: Attends performances at the Cirque Fernando featuring Miss La La. Draws and paints her. Four of his pastels are dated to 19, 21, 24 and 25 January.

10 April–11 May: At the Fourth Impressionist Exhibition, Degas shows 25 works, including *Miss La La* (no. 62), which only joins the show about halfway through its run (by 27 April).

1880

Degas takes part in the Fifth Impressionist Exhibition. He will also join the Sixth in 1881, and finally the last one organised in 1886.

1892

First solo exhibition of Degas's works, organised by the Durand-Ruel gallery in Paris.

1902

Late November–early December: Degas deposits *Miss La La* with the Durand-Ruel gallery as *L'acrobate*, although it doesn't enter its stock immediately.

1903

April–May: *Miss La La* is exhibited at the Kunstsalon Paul Cassirer, Berlin.

1905

January–February: *Miss La La* is exhibited in the landmark French Impressionist exhibition at the Grafton Galleries, London, organised by art dealer Paul Durand-Ruel.

16 March: Canadian collector Cawthra Mulock purchases *Miss La La* from Durand-Ruel for 25,000 francs and takes the painting to his home in Toronto.

1917

27 September: Degas dies in Paris, aged 83.

1918–19

The works remaining in Degas's studio are sold in his posthumous estate sales. The first (6–8 May 1918), third (7–9 April 1919) and fourth (2–4 July 1919) sales include preparatory works for his *Miss La La* painting.

1920

Following Cawthra Mulock's death, New York art dealer Schulman Brothers acquires *Miss La La* at Jenkins' Art Galleries, Toronto.

1923

July: *Miss La La* is exhibited at the French Gallery, London.

1925

Miss La La is acquired by the Samuel Courtauld Fund and presented to the National Gallery, London.

1926

The painting goes on display for the first time at the National Gallery, Millbank (renamed Tate Gallery in 1932).

1933

Samuel Courtauld presents the Tate with the *Miss La La* pastel he had acquired in 1926 (fig. 9).

1935

The New York art dealer Pierre Matisse (Henri's son) offers the National Gallery the *Miss La La* study in oil and pastel (for purchase) (cat. 33); declined by the Gallery.

1936

The Barber Institute, Birmingham, purchases a preparatory drawing for *Miss La La* (cat. 36). A second drawing will be purchased in 1938 (cat. 38).

1937

Miss La La at the Cirque Fernando is shown at the National Gallery in Trafalgar Square for the first time; back to Millbank the same year.

1950

The painting is transferred from the Tate to the National Gallery permanently.

2024

The National Gallery organises the UK's first major exhibition dedicated to *Miss La La at the Cirque Fernando*, in celebration of the 100th anniversary of its acquisition.

NOTES

Paris, 1879: Degas and Miss La La

1 *Paris 1874. Inventer l'impressionnisme/Paris 1874. The Impressionist Moment*, Musée d'Orsay, Paris, 26 March–14 July 2024, and National Gallery of Art, Washington, DC, 8 September 2024–19 January 2025.

2 Bayer 1998.

3 Edinburgh 1979 (the painting was included in this exhibition as no. 47; see p. 49).

4 The painting was purchased by the Courtauld Fund in October 1925, from the French Gallery, Wallis & Son, for £3,350; Tate Gallery Archives.

5 *Samuel Courtauld Memorial Exhibition*, Tate Gallery, London, 13 May–13 September 1948, no. 25; *Impressionnistes de la collection Courtauld de Londres*, Musée de l'Orangerie, Paris, 20 October 1955–8 January 1956, no. 22.

6 *The New Painting: Impressionism 1874–1886*, National Gallery of Art, Washington, DC, 17 January–6 April 1986, and Fine Arts Museums of San Francisco, M.H. de Young Memorial Museum, 19 April–6 July 1986, no. 74.

7 *Degas*, Galeries nationales du Grand Palais, Paris, 9 February–16 May 1988; National Gallery of Canada, Ottawa, 16 June–28 August 1988; The Metropolitan Museum of Art, New York, 27 September 1988–8 January 1989. The painting, however, features in black and white in the exhibition catalogue (see Paris, Ottawa and New York 1988–9, p. 204, fig. 98).

8 Ten *Artist's Eye* exhibitions were held at the National Gallery between 1977 and 1990; in them were exhibited Degas's *After the Bath, Woman drying herself* (three times), *Young Spartans exercising* (twice), and *Hélène Rouart in her Father's Study*, *Combing the Hair* ('*La Coiffure*') and *Beach Scene* (once). (R.B. Kitaj in 1980 and Lucian Freud in 1987 each selected three works by Degas.)

9 *La Grande Parade. Portrait de l'artiste en clown*, Galeries nationales du Grand Palais, Paris, 12 March–31 May 2004, and Musée des beaux-arts du Canada, Ottawa, 25 June–22 August 2004 (see exh. cat. Paris and Ottawa 2004, p. 148); *Circus! Show of Shows*, Weston Park Museum, Sheffield, 25 July–4 November 2018.

10 *Art in the Making: Degas*, The National Gallery, London, 10 November 2004–30 January 2005; see exh. cat. London 2004, no. 4.

11 *Black Victorians: Black People in British Art 1800–1900*, Manchester Art Gallery, 1 October 2005–6 January 2006, and Birmingham Museum and Art Gallery, 28 January–2 April 2006.

12 In partnership, *Posing Modernity: The Black Model from Manet and Matisse to Today*, Wallach Art Gallery, Columbia University, New York, 24 October 2018–10 February 2019, and *Le modèle noir de Géricault à Matisse*, Musée d'Orsay, Paris, 26 March–21 July 2019. See Brown 2007 and Brown 2017 B.

13 Two preceding exhibitions were *Re-united: Degas and 'Miss La La at the Cirque Fernando'*, The Barber Institute of Fine Arts, Birmingham, 18 February–15 May 2005 (display featuring the National Gallery painting, the Tate pastel and the two Barber Institute drawings), and *Degas, Miss La La, and the Cirque Fernando*, The Morgan Library & Museum, New York, 15 February–12 May 2013.

14 The author is grateful to Henri Loyrette for having drawn her attention to the current whereabouts of this drawing, which is dated 24 January 1879.

15 This list of works is described as 'complete' in New York 2013, before these new discoveries.

16 *Catalogue des tableaux, pastels et dessins par Edgar Degas et provenant de son atelier dont la 4e et dernière vente aux enchères publiques, après décès de l'artiste*, Galerie Georges Petit, 8 rue de Sèze, Paris, 2, 3, 4 July 1919, p. 220, no. 256c. The work was also included in the exhibition *Arts et traditions du cirque*, Musée des arts et traditions populaires, Paris, 21 December 1956–25 March 1957 (no catalogue).

17 See Desbonnet 1910. Republished in Edmond Desbonnet, *Les Rois de la force*, Paris 1911, pp. 351–2.

18 The troupe first used this name in 1877 (see p. 72).

19 For a list, dates and addresses, see Namur 2002, pp. 9–10. Circuses were first introduced in Paris in the late eighteenth century. Opened in 1843, the Cirque d'Eté was one of the first permanent circuses, built on the Champs-Elysées to a design by architect Jacques Hittorff. The greatest increase in the number of Paris circuses occurred during the Second Empire (around 1852–70).

20 This contrasted, for example, with the huge Hippodrome at Pont de l'Alma (opened in 1877, and famous for its equestrian shows), where Miss La La would perform in 1883.

21 See Jando 2018, pp. 6–10.

22 The Paris Universal Exhibition was held 1 May–10 November 1878.

23 Boum-Boum (Gerónimo Medrano) was a resident performer – part of the circus's permanent staff (he later became owner/director of the circus). See Jando 2018, p. 10.

24 *L'Ordre de Paris*, 1 January 1879, a.8, no. 2598, p. 4.

25 '*un succès foudroyant*': *La Lanterne*, 14 December 1878, a.2, no. 602, p. 4. Reprinted with minor changes in *L'Eclipse*, 19 December 1878.

26 Gladiateur II, 'Cirque Fernando', *L'Orchestre*, 17 December 1878, n.p.

27 On the mythology of the cannon as both a nationalistic symbol and an outlet for anxieties in the context of post-war Paris, following the Franco-Prussian conflict and the Commune, see Namur 2002, p. 19.

28 *La Lanterne*, 14 December 1878, a.2, no. 602, p. 4.

29 *Le Temps*, 30 December 1878, no. 6462, p. 4.

30 *Le Figaro*, 17 December 1878, no. 351, p. 3.

31 *L'Evénement*, 15 December 1878, a.7, no. 2444, p. 3.

32 See Brown 2017 B, p. 104.

33 Namur 2002, p. 9.

34 The author thanks Laurie Fierstein for drawing her attention to this poster, which features a portrait of 14-year-old Olga, the earliest known image of her. Produced in February 1873, the poster advertises her 'first debut ... in her great gymnastic productions' at Circus Olimpico Equestro Italiano Sidoli in Tarnów (today in Poland). She is called 'The South American Miss Albertine' for the first known time, a name which may have been suggested by Olga herself, possibly as an homage to her recently deceased 'father-teacher' and first impresario, Gustav Neumann (who had often portrayed himself as South American even though he was of German-Prussian origin). Fierstein has also argued that the sensitive nature of Olga's depiction here is the result of its artist/engraver being a fellow acrobat, the clown Volta, long-time friend of ringmaster Sidoli. I am grateful to her for this information, and her translation of the poster.

35 Gladiateur II, 'Cirque Fernando', *L'Orchestre*, 24 December 1878, n.p.

36 In 1876–7, Degas's residence and studio were located at 4 rue Frochot. See Degas, Reff (ed.) 2020, T.3, pp. 366–7.

37 Félix Fénéon, 'Souvenirs sur Manet', in Fénéon, *Œuvres plus que complètes*, ed. Joan U. Halperin, Geneva and Paris 1970, p. 377.

38 Jando 2018, p. 8.

39 Carnet BNF, notebook 23, folio 68; see also Reff 1976 A, no. 31. Seven out of nine drawings relating to *Miss La La at the Cirque Fernando* are upside down.

40 'M. Gabriel Astruc nous rappelle...', *Paris-soir*, 11 November 1932, p. 8.

41 Perruchot 1964, p. 126.

42 Besides, Degas strongly disliked being seen 'at work'. The author is grateful to her colleague Caroline Corbeau-Parsons, Curator of Drawings at the Musée d'Orsay, for sharing her insight.

43 All were on large sheets of paper, of comparable size: at least 45 × 25 cm, up to about 60 × 47 cm.

44 By 1879 Degas had left rue Frochot and moved to 50 rue Lepic, on the other side of Montmartre (1877–82). His studio was on the nearby rue Fontaine, at no. 19bis (1879–88). See Degas, Reff (ed.) 2020, T.3, pp. 366–7.

45 Henri Loyrette argues that a number of drawings and pastels of Miss La La – Lemoisne 523–5 and 4th Degas sale 255a – were completed in the studio (respectively, those kept at Tate, Getty, Speed and Barber): Loyrette 1991, p. 382 and note 275.

46 Degas to Goncourt (Paris, undated [23 January 1879]), in Degas, Reff (ed.) 2020, letter 97, p. 242. The now-derogatory term '*négresse*' was commonly used in France at the time.

47 Jando 2018, pp. 9–10.

48 'All communications for La La and Troupe to her Sole Agent, R. Rosinsky, 5, Rue Desbrousses, Paris', noted in 'La La, La La, La La', *The Era*, 16 March 1879, p. 17.

49 'It's the Rosinsky troupe. Twelve Poles in tights ...': *Le Jockey*, 9 July 1879, a.16, no. 42, p. 2.

50 Brown 2017 B, p. 104: 'Another notice in the same paper [*The Era*, 16 March 1879] called her "the African Princess," yet indicated that she was an accomplished businesswoman with a busy schedule who received independent billing as the leader of her act and who, moreover, had her own agent in Paris.'

51 *Le Figaro*, 28 July 1896, no. 210, p. 4, and *Le Temps*, 4 August 1896, no. 12848, p. 3.

52 Letter from Paul Paulin to art critic

François Thiébault-Sisson, 2 March 1918, partly cited in Marie-Claire and Daniel Brukarz, *Librairie Monogramme, Catalogue XIII*, Paris n.d., no. 16.

53 On that day, Degas executed at least this drawing of Theophilia and the pastel of Miss La La now at Tate (fig. 9); both bear that date.

54 Degas misspelled Theophilia Kaira's name, but this inscription confirms that he interacted with her directly (i.e., in the studio), as she was not named on posters and would not have been introduced in the circus ring; he would have had no other chance to know her name. Degas's second drawing of her is known only through a photograph: Institut National d'Histoire de l'Art, Paris, Fonds Paul-André Lemoisne, Archives 69, carton no. 28. The author thanks Laurie Fierstein for this information.

55 This information is according to announcements of her act published in daily newspapers (for instance, *Le Figaro*) for every day of the week.

56 *La Lanterne*, 14 December 1878, a.2, no. 602, p. 4.

57 Brown 2017 B, p. 109.

58 Ibid., p. 105.

59 While the author questions the assumption, too often made, that these dates correspond to Degas's actual visits to Cirque Fernando to attend performances or rehearsals, there is no reason to doubt that the date on each of these drawings does indeed indicate the day when they were made.

60 Georges Seurat, *Le Cirque*, 1891, oil on canvas, 186 × 152 cm, Musée d'Orsay, Paris; based on Karl Gampenrieder, *Au cirque*, after 1848, printed in paper and canvas (lithograph), 41 × 31 cm, Musée d'Orsay, Paris. Seurat owned this poster.

61 New York 2013, p. 18. See also Manchester and Cambridge 1987, pp. 89–92.

62 When Degas's collection was sold at auction after his death – the sale took place at Hôtel Drouot, Paris, on 6–7 November 1918 – it comprised no fewer than 100 prints, drawings and books by Japanese artists, showing scenes set in private households, but also in public spaces, streets, cafes and theatres. See New York 1997, pp. 247–8.

63 Carnet BNF, notebook 9, folio 29; see also Reff 1976 A, no. 30. Further in the notebook, under

the title 'Projets d'atelier', he proposed: 'Put up steps all around the room, to get used to drawing things from below and from above' (folio 210).

64 New York 2013, pp. 29–30.

65 Degas, Reff (ed.) 2020, letter 104, p. 249.

66 Carnet BNF, notebook 23, folio 68; see also Reff 1976 A, no. 31.

67 Paris Salon, 1867, no. 1066.

68 Paris Salon, 1870, no. 379.

69 Paris Salon, 1874, no. 195.

70 Paris Salon, 1875, no. 222.

71 The Third Impressionist Exhibition in 1877 included a watercolour by Ludovic Piette, *Cirque forain*, no. 149; the Eighth in 1886 would feature Seurat's drawing *Une Parade, Clowns et poneys* (The Phillips Collection, Washington, DC, under the title *Sidewalk Show*), no. 181. It should also be noted that, intriguingly, one of the reviews of the First Impressionist Exhibition (1874) mentions Degas's 'circus views' next to his 'theatre interiors', 'Opéra pits' and 'laundries' (Ariste, 'Salon de 1874 à Paris', *L'Indépendance belge*, 13 June 1874, p. 3), quoted in Berson 1996, vol. I, p. 9.

72 Gladiateur II, 'Cirque Fernando', *L'Orchestre*, 30 December 1878, n.p.

73 'Nouvelles diverses. Informations parisiennes', *Le Soleil*, 10 April 1879, a.7, no. 99, p. 3.

74 Along with the comtesse de Luchaire, the marquise de Rambures is probably the least known of the five women who took part in the Impressionist exhibitions; the others were Berthe Morisot, Marie Bracquemond and Mary Cassatt.

75 See Basel 2021, p. 9, and Méndez-Méndez and Cueto 2003, pp. 349–50.

76 The marquise de Rambures was born Louise Amour Marie de Bouillé in the town of Petit-Bourg (Guadeloupe), where her father was mayor. Degas invited her to join the Second and Third Impressionist exhibitions, and she also took part in the Eighth, even though her works are not listed in its catalogue. The pictures she showed were mostly still lifes, together with a few genre scenes and female portraits that have not been identified. On the marquise de Rambures, see Morrison 2021.

77 Montjoyeux, 'Chroniques parisiennes: Les Indépendants', *Le Gaulois*, 18 April 1879, p. 1, quoted in Berson 1996, vol. I, pp. 232–4.

78 Degas did not take part in the Seventh Impressionist Exhibition, in 1882. *Young Spartans exercising* (The National Gallery, London), listed in the catalogue of the Fifth Impressionist Exhibition in 1880, is a larger work, but also an earlier one (about 1860), and was probably never actually sent, as it attracted no reviews. The Second Exhibition, in 1876, included *A Cotton Office in New Orleans*, 1873 (Musée des Beaux-Arts de Pau, France), which could lay claim to being Degas's most ambitious work shown in these exhibitions.

79 *Un Domino* [Jules Renard] review, quoted in Washington and San Francisco 1986, p. 250.

80 See, for example, 'Nouvelles diverses. Informations parisiennes', *Le Soleil*, 10 April 1879, a.7, no. 99, p. 3.

81 Caillebotte to Claude Monet, dated 'Thursday evening' [10 April 1879], quoted in Berhaut 1978, letter 16, p. 245.

82 A total of 25 works by Degas are listed in the catalogue of the Fourth Impressionist Exhibition, 1879.

83 See 'One has to admire "Au cirque Fernando" …', in Jean de Tarade, 'L'Exposition des peintres indépendants', *L'Europe artiste*, 27 April 1879, pp. 1–2, quoted in Berson 1996, vol. I, pp. 244–5.

84 The wall decoration project was possibly never sent.

85 'A brilliant engagement calls her to London, to the Crystal Palace', *L'Evénement*, 29 January 1879, a.8, no. 2489, p. 4. See also *Le Petit Caporal*, 5 February 1879, a.3, no. 762, p. 4: 'Miss Lala will terminate her engagement at the Cirque Fernando on 9 February. Notice to those who have not seen this marvel.'

86 Degas to Ludovic Halévy, 25 March 1879, 'I'm doing Duranty this morning [pastel portrait, Burrell Collection, Glasgow]. This evening we will agree on a day for you', in Degas, Reff (ed.) 2020, letter 99, pp. 243–4. In March and April 1879, Degas was also working on the portrait of Madame Dietz-Monnin (Art Institute of Chicago).

87 Armand Silvestre, 'Le monde des arts', *La Vie Moderne*, 1 May 1879, p. 52, quoted in Berson 1996, vol. I, pp. 240–1.

88 F.-C. de Syène [Arsène Houssaye], 'Salon de 1879', *L'Artiste*, 1 May 1879, pp. 289–93, quoted in Berson 1996, vol. I, pp. 242–4.

89 Huysmans 1883, pp. 85–123, quoted in Berson 1996, vol. I, pp. 285–93.

90 Galerie La Vie Moderne, 19 June–3 July 1879.

91 L. de Beaumarchez, '5e exposition de la "Vie moderne", P.-A. Renoir', *La presse*, 23 June 1879, p. 2. The painting would ultimately be included in one of the subsequent Impressionist exhibitions (the Seventh), in 1882.

92 The painting is recorded several times in the Archives Durand-Ruel, in the stockbooks and 'Brouillard'. In the 'Tableaux reçus en dépôt': '*No. 10347 Degas L'Acrobate (Miss Lala au cirque Fernando 1875), 12 décembre 1902. Prix de demande 60 000; acheté le 16 mars 1905 pour 25 000*'; in the Brouillard: '*12 décembre 1902. 10347. M. Degas dépose L'Acrobate (Miss Lala au cirque Fernando, 1874)*'. We are deeply grateful to Flavie and Paul-Louis Durand-Ruel, who generously shared this information.

93 In the Archives Durand-Ruel, the painting is also recorded in the 'Tableaux remis en dépôt': '*10 janvier 1903; rendu le 22 avril*'. Indeed, the picture left the Durand-Ruel gallery in early 1903 for Berlin, loaned to Cassirer's Kunstausstellung: 'Professor Franz Skarbina, Degas, Claude Monet, Edouard Manet, Renoir, Nic. Friedrich, Prof. O. Halle', 1 April to early May 1903: see Echte and Feilchenfeldt 2011, II, pp. 309–16 (p. 316: 'Katalog: Nicht nachgewiesen. Edgar Degas, "Zahnakrobatin", L522'). Echte and Feilchenfeldt quote two reviews of this exhibition that mention *Miss La La*: Hans Rosenhagen, 'Aus den Berliner Kunstsalons', *Die Kunst für Alle*, 7, vol. 18, no. 15 (23 April 1903), pp. 359–60 (Echte and Feilchenfeldt 2011, pp. 313–14), and Max Osborn, 'Aus den Kunstsalons', *National-Zeitung*, no. 246 (23 April 1903) (Echte and Feilchenfeldt 2011, pp. 314–15). The author thanks Sarah Herring for drawing her attention to these reviews.

94 'At the Grafton Galleries it was a realist rather than an Impressionist that we saw in the early *Carriage at the Races*, in *Washerwomen*, even in the supremely decorative, slightly Japanesy *Mlle Zozo au Cirque Fernando*'. Frank Rutter, 'Impressionists at the Grafton Gallery, 1905', in Rutter 1933, pp. 101–20, quoted in Flint 1984, p. 194. In another review – 'Round

the galleries', *The Sunday Times*, 26 March 1905, p. 5 – Rutter describes Degas's painting as 'The large Degas, "Mlle Zaza au Cirque Fernando"', Flint 1984, p. 220.

95 It went first on display in the exhibition of Courtauld Fund purchases at Millbank in January 1926, and then in July 1926 it was included in the hang of the new Duveen Wing, Modern Foreign Art Galleries, National Gallery of British Art, Millbank (Gallery IX). See Anne Robbins, 'Courtauld and the National Gallery: "An assault on a big scale"', in London 2018, pp. 18–35, and revised and expanded in Paris 2019 B, pp. 28–41.

96 This pastel, bought by Samuel Courtauld from the Leicester Galleries in London in 1926, is part of the Tate Gallery's collection. It could not be included in the present exhibition, as it had been committed to a different show (*Discovering Degas: Collecting in the Age of William Burrell*, The Burrell Collection, Glasgow, 24 May–30 September 2024).

97 Léo Jasmy, 'Les mises en cadre de M. Degas', *Le Carnet de la semaine*, 21 October 1917.

98 Emile Zola, 'Nouvelles artistiques et littéraires', *Le Messager de l'Europe*, July 1879 (a review of the Fourth Impressionist Exhibition), quoted in Berson 1996, vol. I, p. 253.

99 See Brown 2023, pp. 118–30.

100 'The Westminster Aquarium', *The Era*, 16 March 1879, p. 4.

The Artist, the Writer and the Aerialist

1 Although ambiguous, the term 'partner' (in the original version, in the masculine form of 'son camarade') likely refers to Olga's agent Rosinsky (see Robbins, 'Paris, 1879: Degas and Miss La La' in the present volume, pp. 20–1). The derogatory terms used by Degas, who refers to Miss La La as *ma négresse*, are discussed elsewhere in this volume (see Grigsby, 'Seeing Black and White and Colour' in the present volume, p. 51) and in Brown 2007 and Brown 2017 B. The undated letter (possibly 23 January 1879) is translated in Degas, Reff (ed.) 2020, letter 97, p. 242.

2 Rivière 1935, p. 107.

3 Huysmans 1880, n.p. *Croquis parisiens* was illustrated by Degas's friends Jean-Louis Forain and Jean-François Raffaëlli. On circus novels in nineteenth-century France, see Basch 2002.

4 Reff 1976 B, pp. 147–99. The title of the present essay is a homage to the chapter 'The Artist and the Writer' in Reff's text.

5 See, for example, Starobinski 1970, Paris and Ottawa 2004, Monaco 2002, New York 2013 and New York 2017.

6 Desnoyers 1836.

7 New York 1997 and Reading 2007.

8 Huysmans (1928–34), vol. V, p. 14. See also Collins 1985.

9 See Le Men 1991 and Le Men 1994.

10 See Paris and Washington 2019–20. Olga's identity, long neglected, has been brilliantly investigated, and recent research on non-white models and performers has added new contextual elements to the reading of the picture (Brown 2007; Brown 2017 B; Smalls 2003; Ward 2021). The painting can be contextualised in Degas's corpus. As a celebrity portrait, it can be compared, for instance, to the *Portrait of Mlle Fiocre in the Ballet 'La Source'* (about 1867–8, Brooklyn Museum) or the *Portrait of Rose Caron* (about 1892, Buffalo AKG Art Museum). For its setting, it attests to Degas's longstanding fascination for entertainment venues.

11 See, among others, Jamot 1924, p. 93, and Starobinski 1970, pp. 33–5.

12 Rivière 1935, p. 173.

13 Fénéon 1920, p. 606.

14 Coquiot 1924, p. 137.

15 Ibid., p. 139.

16 Starobinski 1970, Paris and Ottawa 2004, and Jones 1984.

17 Csergo, in Corbin 1995, p. 161.

18 Haxell 2000.

19 The Cirque Molier, a *cirque amateur* (the first of its kind in Paris, founded 1880), consisted of members of the public – largely from the haute bourgeoisie and aristocracy (the man in red on the trapeze is thought to depict Count Antoine de La Rochefoucauld) – performing in the ring for the amusement of their friends.

20 Cavailhon 1878, n.p.

21 Haxell 2000, p. 784.

22 Ibid., p. 792.

23 Tait 2005, p. 41.

24 An early example in print is Félicien Rops's etching *La Femme au trapèze*, 1875, 19.8 × 12.3 cm. Reproduced in Brown 2007, p. 758.

25 Maurice Talmeyr belongs to the first category: in his 'L'Age de l'Affiche' (1896), he worries about 'grimacing and licentious' posters one could find on the streets of Paris, a 'symbol of moral decay'. On the opposite end of the spectrum, Huysmans praised the eroticism and the hysterical joy of the 'Chérettes'. See Carter 2012.

26 See Jones 1984.

27 See, for instance, Toulouse-Lautrec, *Equestrienne (At the Cirque Fernando)*, 1886–7, oil on canvas, 100.3 × 161.3 cm, Art Institute of Chicago; Seurat, *Au Cirque*, 1891, oil on canvas, 186 × 152 cm, Musée d'Orsay, Paris; Ibels, *Au cirque*, 1893, lithograph in four colours on wove paper, 59.3 × 42.1 cm, Van Gogh Museum, Amsterdam; and Picasso, *Au cirque* (from the series *Saltimbanques*, no. 9), 1905, etching and drypoint on wove paper, 22 × 14 cm, Buffalo AKG Art Museum.

28 Tait 2005, pp. 36–7.

29 Letter of 28 December 1877, in Mallarmé (1965), p. 159. See also Ross 1982.

30 Li Bassi 2015, p. 257. Another hypothesis is that the boots might refer to Katarina Johns's trapeze performances.

31 Gladiateur II, 'Cirque Fernando', *L'Orchestre*, 1 December 1878, n.p.

32 See, in particular, Ritter 1989 and Forrest 2020.

33 Jones 1984, p. 223.

34 Huysmans 1884 (2009), digital edition, loc. 2307.

35 Cocteau 1926, p. 33.

36 Escudier 1875, p. 272.

37 *The Daily Chronicle*, 11 March 1879, p. 6, quoted in Tait 2005, p. 41.

38 Gladiateur II, 'Cirque Fernando', *L'Orchestre*, 16–23 December 1878, n.p.

39 *The Morning Advertiser*, 13 March 1879, p. 2, quoted in Tait 2005, p. 41.

40 Ibid. These photographs were commonly used by nineteenth-century performers to promote their acts.

41 Ward 2021, p. 110. Also quoted on Tait 2005, p. 42, note 17.

42 See Cosdon 2009 and Cosdon 2014.

43 Boston and New York 1991, p. 11.

44 Banville, in Hanlon Lees 1879, p. 6.

45 Ibid.

46 Goncourt 1879, p. XI.

47 Zola 1881, p. 333.

48 Ibid., p. 327.

49 Huysmans 1880, p. 25.

50 Letter to Félicien Champsaur (1888), cited in Bonnet 2013, p. 453.

51 Barbey d'Aurevilly 1881, p. 23.

52 Lafond 1918, p. 40. With small variations, Jamot 1924, p. 67.

53 Ibid.

54 See Loyrette 1991, pp. 356 and 382, and Reff 1976 B, pp. 147–200.

55 J.-K. Huysmans, 'L'Exposition des Indépendants en 1880', in Huysmans 1883, p. 117.

56 See Charlier 2012.

57 Goncourt 1851–95, 11 February 1879.

58 Ibid., 15 November 1859.

Seeing Black and White and Colour

1 Letter to Lorenz Frølich, 27 November 1872, in Guérin 1947, p. 21. For original French correspondence, see Degas, Reff (ed.) 2020.

2 This essay builds on Grigsby 2022, Ch. 9, pp. 260–93. The author is indebted to the careful research of Brown 2007. See also Smalls 2003.

3 Letter to Lorenz Frølich, 27 November 1872, in Guérin 1947, p. 21.

4 Letter to James Tissot, 19 November 1872, in ibid., p. 18.

5 Letter to James Tissot, 18 February 1873, in ibid., p. 31.

6 For 'Creole' as a capacious and thus ambiguous category, as well as the French terminology of the period, see Grigsby 2022.

7 Letter to Lorenz Frølich, 27 November 1872, in Guérin 1947, p. 21.

8 See, for example, Degas, *Self-Portrait with White Collar*, about 1857, National Gallery of Art, Washington, DC, and *Self-Portrait (with Hat)*, about 1857–8, Clark Art Institute, Williamstown.

9 Letter to Henri Rouart, 5 December 1872, in Guérin 1947, p. 25.

10 Letter to Lorenz Frølich, 27 November 1872, in ibid., p. 22.

11 Letter to Dihau, 11 November 1872, in ibid., p. 15: 'My poor Estelle, René's wife, is blind as you know'.

12 Letter to James Tissot, 18 February 1873, in ibid., p. 31.

13 Letter to Henri Rouart, 5 December 1872, in ibid., p. 25.

14 See vocabulary list in Grigsby 2022, pp. 303–4; see also Grigsby 2002.

15 Italics are the author's emphasis. Brown 2007, p. 746.

16 Degas, Reff (ed.) 2020, vol. I, p. 243, n. 5.

17 Regarding Goncourt's novel, *Les Frères Zemganno* (1879), see Brown 2007, p. 738.

18 In Ingres's letter of 1836 to engraver Jacques Edouard Gatteaux, he wrote, 'I want only a simple figure of a negro [*nègre*] in this pose' – for his project on the *Lord chasing the Devil from the Mountain*, in which the Black model's body was intended to represent the Devil – a subject withheld from both the teenage artist Chassériau and the model Joseph. 'As for the student, he does not need to know.' See Grigsby 2022, p. 67. While the recent *Posing Modernity: The Black Model from Manet and Matisse to Today* exhibition at the Wallach Art Gallery, New York (24 October 2018–10 February 2019), and expanded as *Le modèle noir de Géricault à Matisse*, Musée d'Orsay, Paris (26 March–21 July 2019),

has laudably restored models' names to paintings, it is politically imperative not to gloss over the racist histories we reconstruct by erasing original titles. The present author's work restores the names of those who have been un-named, but she does not change the titles by which the works were known and conceived.

19 On Joseph and Laure, see Grigsby 2022, Chs 3 and 7. A version of the latter chapter was first published as 'Still Thinking about Olympia's Maid', *Art Bulletin*, 97, no. 4 (2015), pp. 430–51.

20 For Blake's illustrations to John Gabriel Stedman's *Narrative of a Five Years Expedition to Surinam*, see Grigsby 2022, p. 96.

21 Both hands were specifically requested by Ingres: 'Repeat and paint separately a clenched fist and, without moving the arm, the hand in a relaxed position'. See Grigsby 2022, p. 84.

22 See Grigsby 2022, p. 88, and Morrow 1899, p. 69.

23 Letter from Paul Paulin to François Thiébault-Sisson, 2 March 1918. Cited in *Librairie Monogramme, Catalogue XIII*, Paris n.d., no. 16.

24 The sheer novelty and artistic challenge excited many of the white French artists who invited Black persons to model in their studios, among them Anne-Louis Girodet, Théodore Géricault, Théodore Chassériau, Edouard Manet and Frédéric Bazille, to name a few. The author uses the term 'frisson' (thrill) here to convey not only these artists' excitement but also their latent, if disavowed, erotic desire. See Grigsby 2002, Grigsby 2022 and Paris 2019 A.

25 See Grigsby 2022, p. 95.

26 See ibid., pp. 101–5, 206–7.

27 Silvestre, *La Vie Moderne*, 1 May 1879, p. 52, quoted in Berson 1996, vol. I, pp. 240–1.

28 Ibid.

29 Branagan 1807, p. 271.

30 Italics are the author's emphasis. Cited in Teneriello 2015, p. 27.

31 See New York 2016, and the recent exhibition *Degas en noir et blanc*, Bibliothèque nationale de France, Paris, 31 May–3 September 2023.

32 See especially Janis 1967. Janis interprets the dark ground monotypes as releasing Degas from a reliance on line and liberating his use of colour, but she simplifies the complexity of colour by implying it easily conforms to a dark–light tonal spectrum.

33 Carol Armstrong, 'Degas in the Dark', in New York 2016, p. 38, notes: '*Woman in a*

Bathtub contrasts with its pastel counterpart ... The simian aspect of the woman's profile ..., her outsized and highlighted ear, the enlarged clumsiness of her foot, the clawing gesture of her hand on the sponge and the exaggerated fragmentation of the whole all combine to render her a caricature. The unmitigated inkiness of the image also yields a bath of dark grease for the she-creature to bath in ... Her pastel other, meanwhile, is dressed up by decorous redrawing in colour.' Xavier Rey uses similar terms: 'the facial features seen in *Woman in her Bathtub, sponging her Leg*, highlighted with pastel, have lost all physical signs of mental deficiency that Degas attributed to certain prostitutes, present in *Woman in a Bathtub*'; Boston and Paris 2012, p. 97.

34 Letter from Marcellin Desboutin to Madame De Nittis. Cited in McMullen 1984, p. 352.

35 Brown 2007, p. 740 and p. 760, n. 12.

36 The French used '*gens de couleur*' throughout this period, and it remains in use today. The designation 'people of colour' invited experimentation on the part of artists such as Delacroix, Chassériau and Degas: colour itself could suggest racial mixing – unlike the use of whites, creams and pinks to describe white persons, a wide array of hues, some dark, some light (yellows, oranges, greens, blues, purples or browns), could be blended or simply made adjacent (that is, continuous or contiguous) in depictions of *gens de couleur*.

37 See, for example, Brown 2007, p. 754: 'the experience of looking up can even become vertiginous, with sections of the ceiling seeming to revolve around our heads like a giant carousel or kaleidoscope'.

Miss La La in Toronto

1 Karen Serres, 'Introduction: Samuel Courtauld, Champion of Impressionism', in Paris 2019 B, p. 4.

2 See Washington and San Francisco 1986, p. 258.

3 Degas never again took up circus subject matter, although younger contemporaries like Pierre-Auguste Renoir (cat. 28), Louis Anquetin, Fernand Pelez, Georges Seurat and Henri de Toulouse-Lautrec – many of them studio visitors – remained fascinated by this circumscribed world of high artificiality, intense

physicality and social marginalism.

4 Thanks to the generous long-term loan by a private collector of *Peasant Girls bathing in the Sea at Dusk*, Degas's unexpected 'triptych' of female empowerment has hung side-by-side on the walls of the National Gallery since 2020.

5 Anne Robbins, in London 2015, cat. 16, p. 241.

6 Ibid., p. 186.

7 Mulock was not Durand-Ruel's first Canadian client: the Montreal railroad magnate William Van Horne had been a customer since the early 1890s. Nor did Mulock share Van Horne's insatiable passion for collecting. *Miss La La* seems to have been the only painting with claim to avant-garde credentials that the young man ever owned.

8 *The Buffalo* (New York) *Evening News* of 24 November 1897, p. 12, reports a fortune 'estimated at' $4 million, of which only $202,000 is accounted for as going to legatees other than the young Mulock. With thanks to Alexander Reford for the reference.

9 If life imitates art, then we can compare Mulock's good fortune to that of Isabel Archer in *Portrait of a Lady* by Henry James (1881), who similarly is bequeathed a vast windfall by a near relation so that she can live up to the potential her uncle and first cousin so tenderly intuit in her.

10 Alexander Reford, in the *Dictionary of Canadian Biography*: www.biographi.ca/en/bio/mulock_cawthra_14E.html (accessed 1 February 2024).

11 Real estate development would become the international calling card of Toronto business acumen in the twentieth century: Canary Wharf in London, for example, and the World Financial Center in Manhattan are both vast real estate undertakings that were conceived and executed entirely by the shores of Lake Ontario.

12 Alexander Reford, in the *Dictionary of Canadian Biography*: www.biographi.ca/en/bio/mulock_cawthra_14E.html (accessed 1 February 2024).

13 On the 'Royal Alex', as it is referred to in Toronto, see Brockhouse 2007.

14 Ibid., p. 20.

15 See the website of 'The Statue of Liberty – Ellis Island Foundation, Inc' for information on the SS *Baltic*'s passenger list, arriving from Liverpool in New York on 19 May 1905: www.statueofliberty.org/statue-of-liberty/ (accessed 1 February 2024).

16 Brockhouse 2007, p. 32.

17 Anne Robbins, in London 2015, cat. 16, p. 241.

18 Brockhouse 2007, p. 19.

19 Bruce Kidd, in the *Dictionary of Canadian Biography*: www.biographi.ca/en/bio/solman_lawrence_16E.html (accessed 1 February 2024).

20 Edward Brown, 'How a strong, kind Toronto woman became a sideshow act', *Toronto Star*, 11 February 2023. Fascinated by this moving newspaper article about Letitia Campbell, Canadian-born of African descent, and her performances as a 'fat lady' (stage name Dolly Varden) at Hanlan's Point, the present author asked Brown if there were any points of contact with Mulock. His swift reply, 'Look at business partner Lol Solman', who ran Hanlan's Point, led to much that follows.

21 Bruce Kidd, in the *Dictionary of Canadian Biography*: www.biographi.ca/en/bio/solman_lawrence_16E.html (accessed 1 February 2024).

22 Ibid.

23 For more information on the Degas estate sales, see New York 1997.

24 Some drawings and pastels, however, were included in the artist's posthumous sale. See Robbins, 'Paris, 1879: Degas and Miss La La' in the present volume, p. 34.

25 Alexander Reford, in the *Dictionary of Canadian Biography*: www.biographi.ca/en/bio/mulock_cawthra_14E.html (accessed 1 February 2024).

26 Do we detect another distant literary echo here? Could Evelyn Waugh have heard the story of the Mulock marriage, which anticipates the marriage in *Brideshead Revisited* (1945) of the louche Canadian millionaire Rex Mottram from Montreal trying his luck in London and (comically) impervious to Catholic doctrine, with Lady Julia Flyte, daughter of the Catholic and adamantine Lady Marchmain?

27 French Gallery (London, England), *One Hundred and Seventeenth Exhibition of Pictures by Modern French and Dutch Artists,* July 1923, cat. no. 33.

28 Lemoisne 1946–9, no. 522, p. 295.

29 Stated in dossier NG4121 in the National Gallery archive.

30 Ibid.

NOTES TO CATALOGUE SECTION

Miss La La: Background and Success

1 Ed Cointrie, 'Chronique des Art et des Théâtres', *Le Constitutionnel* (Paris), 14 December 1878, p. 3: 'This remarkable act is brand new and was invented by Miss Lala [*sic*]'. Several other daily Paris newspapers wrote the same.

2 Emergency Passport Application taken at the American Legation in Brussels, 23 November 1910, for Mrs. Emanuel Charles Woodson, born Anne [*sic*] Albertine Olga Brown. *Stature: 5 feet 1 inches (Eng)*. Source citation: National Archives and Records Administration, Washington, DC; General Emergency Passport Applications, 1907–1923; ARC Identifier 1244182 / MLR Number A1 543; Box #4342; Volume #126.

3 The exact weight of the cannon barrel Miss La La used in her act is not known, and press accounts about it varied widely. However, from photographs, poster images and illustrations of the cannon provided by this author to Christophe Pommier, Deputy Curator, SCP Artillery Department, Musée de l'Armée (Army Museum) in Paris, he confidently identified the artillery as a Hitte System 'L'Aubry' 4 rifled model 1858 field gun. This was adopted by the French army in 1858 and phased out during the 1870s, thus it is unsurprising to find a piece of this type for non-military use in 1879. The barrel, nearly 1.5 metres long, legally weighed 330 kilograms, though the models produced varied between 325 and 340 kilograms. Information from an email to this author from Christophe Pommier, 10 August 2022.

4 Gladiateur II, 'Cirque Fernando', *L'Orchestre*, 16–23 December 1878, n.p. Laudatory reviews appeared in all the Paris dailies during the La La Kaira Troupe's Cirque Fernando engagement.

5 Eiselen 1861, pp. 105–14; Spiess 1842, pp. 35–6.

6 Keil 1863, p. 20.

7 *Neue Stettiner Zeitung* (Stettin), 25 April 1867, p. 4; Berghaus 1865, p. 1343; Euler 1896, 'Stettin', pp. 64–6.

8 *Bremer Morgenpost* (Bremen), 24 December 1869, n.p.

9 Ibid.

10 In a review, 11-year-old Olga (as Miss Albertine) is referred to as 'a small and dainty Hottentot' (*Rübezahl* 1869, 'Der erste Wintergarten', p. 259). The word 'Hottentot' (the history of which is debated) is generally accepted to have come from seventeenth-century Dutch colonial settlers on the southern African Eastern Cape, who used it as a name for the indigenous Khoikhoi peoples. Throughout the colonial world, the word quickly came to be used as a derogatory name, not only for Africans in the homeland, but for all Black people.

11 Jacques de T. [Tarade], *L'Europe Artiste* (Paris), 12 January 1879, p. 1.

12 Rose Eddie was Olga's third and last child. Two years earlier, in 1892, Olga and Manuel had a son, born in Rome and named Charles Louis Ernst Woodson, who died in infancy. Seventeen years earlier, aged 17 and unwed, Olga had a son, Gustave (29 October 1875–?), in Saint-Etienne, France. His father was her impresario Franz Pospischil, who was then in a conjugal relationship with Elisabeth Neumann. The circumstances of Olga and Franz's liaison are unknown, as is much of the life and destiny of Gustave Pospischil. All evidence points to an estranged relationship between Olga and her son, although it is likely that, as a child, he travelled with her, Franz and the troupe, but never as a performer.

13 Olga was fluent in German and English, as well as French, which she probably learned on her travels and perfected in Brussels (she spoke French to her grandchildren).

The Cirque Fernando

1 Boston and New York 1991, p. 39.

2 Gladiateur II, 'Cirque Fernando', *L'Orchestre*, 1 October 1878, n.p.

3 Rivière 1935, pp. 104–5.

4 Another drawing of her (whereabouts unknown) is recorded in the Institut National d'Histoire de l'Art, Fonds Paul-André Lemoisne, Archives 69, carton no. 28. The author deeply thanks Laurie Fierstein for sharing this information.

5 Original broadcast: https://fresques.ina.fr/en-scenes/fiche-media/Scenes00531/demolition-du-cirque-medrano.html (accessed 13 February 2024).

Watching, Drawing, Posing Miss La La

1 See Robbins, 'Paris, 1879: Degas and Miss La La' in the present volume, p. 24. With the exception of Degas's notebook sketches, the majority of these studies were no doubt made in his studio on rue Fontaine. See, for comparison, Degas's preparatory drawings for his portraits – done very soon after – of Edmond Duranty (one of which is inscribed '*chez Duranty 25 mars 1879*'), or Diego Martelli (a sheet of similar size, inscribed '*chez Martelli/3 avril 79/Degas*; Edinburgh 1979, p. 53). The fact that no location is mentioned on the dated Miss La La drawings implies that they were done in the artist's own studio.

2 In notebook 23, two drawings show the figure (f. 18, her legs, and 21, a compositional sketch), while seven are architectural notations (f. 30, 36, 37, 38, 45, 48, 70).

3 A pencil drawing on the reverse shows (cropped) the top of a table with, on it, a pair of binoculars, a glass, a plate, a knife and a spoon, as well as what looks like a jug.

4 Letter from Paul Paulin to François Thiébault-Sisson, 2 March 1918, partly cited in Marie-Claire and Daniel Brukarz, *Librairie Monogramme, Catalogue XIII*, Paris n.d., no. 16.

5 In his copy of Paul Jamot's monograph on Degas (Jamot 1924, kept in the Fondation Custodia, Paris), Walter Sickert, who had seen the painting in Degas's studio on rue Pigalle, wrote that the artist told him 'that he had been unable to solve the problem of perspective and had employed a professional for the drawing of the architecture of the ceiling'. In another copy of the book (kept in the Courtauld Institute of Art, London), Sickert wrote: 'He told us in 1885 that he had the perspective on the canvas done by a professional.' See Anna Gruetzner Robins, 'In his Own Words. Walter Sickert's Writings on Degas', in Brown 2017 A, p. 245 and note 5.

6 London 2004, pp. 88–9.

7 The author is grateful to the National Gallery Conservation and Scientific teams for sharing their observations.

8 The first page of this notebook, now kept in the Morgan Library & Museum, bears the following inscription, written by Ludovic Halévy: 'All the sketches in this album/were made at my home by Degas/Years 1880 and following'.

9 Huysmans 1883, pp. 85–123, quoted in Berson 1996, vol. I, pp. 285–93.

Degas and 'the Black World'

1 The second painting is *A Cotton Office in New Orleans*, 1873, oil on canvas, 73 × 92 cm, Musée des Beaux-Arts de Pau, France.

2 Letter to James Tissot, 18 February 1873, in Guérin 1947, p. 31.

3 Letter to Lorenz Frølich, 27 November 1872, in ibid., p. 21.

4 Guérin 1947, p. 31.

Miss La La in Britain

1 On this latter exhibition, key to the reception of modern French art in the UK, see Anne Robbins, 'Durand-Ruel's Conquest of London', in London 2015, pp. 186–93.

2 On the early history of the painting through 1920, see Riopelle, '*Miss La La* in Toronto' in the present volume, pp. 60–9.

3 On Courtauld and his Fund, see Anne Robbins, 'Courtauld and the National Gallery: "An assault on a big scale"', in London 2018, pp. 18–35, and revised and expanded in Paris 2019 B, pp. 28–41.

4 On that fruitful relationship, see London 2006.

5 Rothenstein 1947, plate 59.

6 See Walter Sickert, 'Memories of Degas', in Robins 2011, pp. 67–94.

BIBLIOGRAPHY

Barbey d'Aurevilly 1881
J. Barbey d'Aurevilly, 'Le Cirque' [20 June 1881], in *Théâtre contemporain. Dernière série, 1881–1883*, Paris 1896, pp. 23–33

Basch 2002
S. Basch (ed.), *Romans de cirque*, Paris 2002

Basel 2021
J. Helfenstein and C. Duvivier, *Camille Pissarro: The Studio of Modernism*, exh. cat., Kunstmuseum Basel 2021

Bayer 1998
T.M. Bayer, 'Degas and the English Connection 1872–1876', *Athanor*, 16 (1998), pp. 31–8

Berghaus 1865
H.K.W. Berghaus, *Landbuch des Herzogthums Pommern und des Fürstenthums Rügen*, vol. II, Berlin 1865

Berhaut 1978
M. Berhaut, *Caillebotte, sa vie et son oeuvre*, Paris 1978

Berson 1996
R. Berson, *The New Painting: Impressionism 1874–1886*, 2 vols, San Francisco 1996

Bonnet 2013
G. Bonnet, 'La pantomime fin de siècle, caprice moderne', in A. Vaillant and R. de Villeneuve (eds), *Le rire moderne*, Nanterre 2013, pp. 453–66

Boston and New York 1991
B. Stern Shapiro et al., *Pleasures of Paris: Daumier to Picasso*, exh. cat., Museum of Fine Arts, Boston, and Metropolitan Museum of Art, New York 1991

Boston and Paris 2012
G.T.M. Shackleford and X. Rey (eds), *Degas and the Nude*, exh. cat., Museum of Fine Arts, Boston, and Musée d'Orsay, Paris 2012

Branagan 1807
T. Branagan, *The Penitential Tyrant; or, Slave Trader Reformed*, New York 1807

Brockhouse 2007
R. Brockhouse, *The Royal Alexandra Theatre: A Celebration of 100 Years*, with a photo essay by E. Burtynsky, Toronto 2007

Brown 2007
M.R. Brown, '"Miss La La's" Teeth: Reflections on Degas and "Race"', *The Art Bulletin*, 89, no. 4 (2007), pp. 738–65

Brown 2017 A
K. Brown (ed.), *Perspectives on Degas*, London and New York 2017

Brown 2017 B
M.R. Brown, '"Miss La La's" Teeth: Further Reflections on Degas and "Race"', in K. Brown (ed.), *Perspectives on Degas*, London and New York 2017, pp. 94–132

Brown 2023
K. Brown (ed.), *Dialogues with Degas: Influence and Antagonism in Contemporary Art*, London 2023

Carter 2012
K.L. Carter, 'Joris-Karl Huysmans, A *Dénicheur* of Jules Chéret's Posters', *Nineteenth-Century French Studies*, 41, no. 1–2 (2012), pp. 122–41

Cavailhon 1878
E. Cavailhon, 'Sept Journées au Cirque Fernando', *L'Orchestre*, 2–9 December 1878, n.p.

Charlier 2012
M.A. Charlier, 'L'œuvre au sable (*Les Frères Zemganno*, Edmond de Goncourt)', *Autour de Vallès: revue de lectures et d'études vallésiennes*, no. 42 (2012), pp. 113–23

Cocteau 1926
J. Cocteau, 'Le Numéro Barbette', *La Nouvelle Revue Française*, no. 154 (1926), pp. 33–8

Collins 1985
B.R. Collins, 'The Poster as Art: Jules Chéret and the Struggle for the Equality of the Arts in Late Nineteenth-Century France', *Design Issues*, 2, no. 1 (1985), pp. 41–50

Coquiot 1924
G. Coquiot, *Degas*, Paris 1924

Corbin 1995
A. Corbin, *L'avènement des loisirs, 1850–1960*, Paris 1995

Cosdon 2009
M. Cosdon, *The Hanlon Brothers: From Daredevil Acrobatics to Spectacle Pantomime, 1833–1931*, Carbondale, IL 2009

Cosdon 2014
M. Cosdon, 'A Chronological Outline of the Hanlon Brothers, 1833–1931': http://siupress.siu.edu/sites/default/files/pdf/Chronological%20Outline%20of%20Hanlon%20Brothers%203-12-14.pdf (accessed 16 February 2024)

Coutelet 2017
N. Coutelet, 'Femmes herculéennes au music-hall: déconstruction d'un cliché', *Horizons/Théâtre, Genre et arts vivants. Seconde partie: Pour une histoire du genre et des arts vivants*, no. 10–11 (2017), pp. 260–79

Degas, Reff (ed.) 2020
E. Degas, *The Letters of Edgar Degas*, ed. T. Reff, New York 2020

Desbonnet 1910
E. Desbonnet, 'Acrobates et jeux de cirque', *La Culture physique*, 15 March 1910, pp. 173–5; 'Miss Olga et Kaïra', p. 174

Desnoyers 1836
L. Desnoyers, *Les aventures de Jean-Paul Choppart*, Paris 1836

Drąg 2021
S. Drąg, 'Herstoria eksperymentalna: Miss La La', *Panoptikum*, no. 25 (2021), pp.117–34

Echte and Feilchenfeldt 2011
B. Echte and W. Feilchenfeldt (eds), *Kunstsalon Paul Cassirer. Die Ausstellungen 1901–1905, "Man steht da und staunt"*, Wädenswil 2011

Edinburgh 1979
R. Pickvance, *Degas 1879: Paintings, pastels, drawings, prints and sculpture from around 100 years ago in the context of his earlier and later works*, exh. cat., National Galleries of Scotland, Edinburgh 1979

Eiselen 1861
E.W.B. Eiselen (ed.), *Abbildungen von Turn-Übungen*, with illustrations of gymnastic exercises by H. Robolsky and A. Töppe, Berlin 1861

Escudier 1875
G. Escudier, *Les saltimbanques: leur vie, leurs mœurs*, Paris 1875

Euler 1896
C. Euler (ed.), *Encyklopädisches Handbuch des gesamten Turnwesens und der verwandten Gebiete*, vol. 3, Vienna and Leipzig 1896

Fei 2017
E. Fei, *As Above, so Between: Configuring Miss Lala as a Mixed Race Subject*, PhD dissertation, College of Liberal Arts & Social Sciences Theses and Dissertations 2017

Fénéon 1920
F.F. [Félix Fénéon], 'Souvenirs sur Manet', *Bulletin de la vie artistique*, no. 22 (1920), pp. 606–11

Flint 1984
K. Flint (ed.), *Impressionists in England: The Critical Reception*, Abingdon 1984

Foa 2020
M. Foa, 'In Transit: Edgar Degas and the Matter of Cotton, between New World and Old', *The Art Bulletin*, 102, no. 3 (2020), pp. 54–76

Forrest 2020
J. Forrest, *Decadent Aesthetics and the Acrobat in Fin-de-siècle France*, London 2020

Goncourt 1851–95
E. and J. de Goncourt, *Journal des Goncourt. Mémoires de la vie littéraire, 1851–95* (online: https://fr.wikisource.org/wiki/Journal_des_Goncourt; accessed 16 February 2024)

Goncourt 1879
E. de Goncourt, *Les Frères Zemganno*, Paris 1879

Grigsby 2002
D.G. Grigsby, *Extremities: Painting Empire in Post-Revolutionary France*, New Haven, CT 2002

Grigsby 2022
D.G. Grigsby, *Creole: Portraits of France's Foreign Relations During the Long Nineteenth Century*, University Park, PA 2022

Guérin 1947
M. Guérin (ed.), *Edgar Germain Hilaire Degas: Letters*, trans. M. Kay, Oxford 1947

Hanlon Lees 1879
Hanlon Lees frères, *Mémoires et pantomimes des frères Hanlon Lees*, preface by T. de Banville, Paris 1879

Haxell 2000
N.A. Haxell, '"Ces Dames du Cirque": A Taxonomy of Male Desire in Nineteenth-Century French Literature and Art', *MLN*, 115, no. 4 (2000), pp. 783–800

Huysmans 1880
J.-K. Huysmans, *Croquis parisiens*, Paris 1880

Huysmans 1883
J.-K. Huysmans, *L'art moderne*, Paris 1883

Huysmans 1884 (2009)
J.-K. Huysmans, *Against Nature [A Rebours]*, ed. N. White, trans. M. Mauldon, Oxford 2009

Huysmans (1928–34)
J.-K. Huysmans, *Œuvres complètes de J.-K. Huysmans*, 18 vols, Paris 1928–34

Jamot 1924
P. Jamot, *Degas*, Paris 1924

Jando 2018
D. Jando, 'From Fernando to Medrano: A Parisian Circus Epic', *Bandwagon: The Journal of the Circus Historical Society*, 62, no. 2 (2018), pp. 6–31

Janis 1967
E.P. Janis, 'The Role of the Monotype in the Working Method of Degas – I', *The Burlington Magazine*, 109, no. 766 (1967), pp. 20–9

Jones 1984
L.E. Jones, *Sad Clowns and Pale Pierrots: Literature and the Popular Comic Arts in 19th-Century France*, Lexington, KY 1984

Keil 1863
E. Keil (ed.), *Statistisches Jahrbuch der Turnvereine Deutschlands*, vol. I, Leipzig 1863

Lafond 1918
P. Lafond, *Degas*, vol. 2, Paris 1918

Le Men 1991
S. Le Men, 'French Circus Posters', *Print Quarterly*, 8, no. 4 (1991), pp. 363–87

Le Men 1994
S. Le Men, *Seurat et Chéret: le peintre, le cirque et l'affiche*, Paris 1994

Lemoisne 1946–9
Paul-André Lemoisne, *Degas et son oeuvre*, Paris 1946–9, vol. II

Li Bassi 2015
M. Li Bassi, 'Reflections of Mallarmé: A Comparative Study of Manet's *A Bar at the Folies-Bergère*', in R. Neginsky and D. Cibelli (eds), *Light and Obscurity in Symbolism*, Cambridge 2015, pp. 252–69

London 2004
D. Bomford et al., *Art in the Making: Degas*, exh. cat., The National Gallery, London 2004

London 2006
A.G. Robins and R. Thomson, *Degas, Sickert and Toulouse-Lautrec: London and Paris 1870–1910*, exh. cat., Tate, London 2006

London 2015
S. Patry (ed.), *Inventing Impressionism: Paul Durand-Ruel and the Modern Art Market*, exh. cat., The National Gallery, London 2015

London 2018
A. Robbins (ed.), *Courtauld Impressionists: from Manet to Cézanne*, exh. cat., The National Gallery, London 2018

Loyrette 1991
H. Loyrette, *Degas*, Paris 1991

Mallarmé (1965)
S. Mallarmé, *Correspondance*, vol. II, 1871–85, ed. H. Mondor and L.J. Austin, Paris 1965

Manchester and Cambridge 1987
R. Thomson, *The Private Degas*, exh. cat., Whitworth Art Gallery, Manchester, and Fitzwilliam Museum, Cambridge 1987

McMullen 1984
R. McMullen, *Degas: His Life, Times and Work*, Boston 1984

Méndez-Méndez and Cueto 2003
S. Méndez-Méndez and G.A. Cueto, *Notable Caribbeans and Caribbean Americans: A Biographical Dictionary*, Westport, CT 2003

Monaco 2002
A. Frère et al., *Jours de cirque*, exh. cat., Grimaldi Forum, Monaco 2002

Morrison 2021
A. Morrison, 'A forgotten painter at the Impressionist exhibitions: "Jacques François" or the Marquise de Rambures (1844–1924)', *The Burlington Magazine*, 163, no. 1422 (2021), pp. 832–5

Morrow 1899
W.C. Morrow, *Bohemian Paris of To-day*, Philadelphia, PA 1899

Namur 2002
S. Le Men, *Jules Chéret, le cirque et l'art forain*, exh. cat., Musée Félicien Rops, Namur 2002

New York 1997
A. Dumas et al., *The Private Collection of Edgar Degas*, exh. cat., Metropolitan Museum of Art, New York 1997

New York 2013
L. Wolk-Simon (ed.), *Degas, Miss La La, and the Cirque Fernando*, exh. cat., Morgan Library & Museum, New York 2013

New York 2016
J. Hauptman (ed.), *Degas: A Strange New Beauty*, exh. cat., Museum of Modern Art, New York 2016

New York 2017
R. Thomson (ed.), *Seurat's Circus Sideshow*, exh. cat., Metropolitan Museum of Art, New York 2017

New York 2018
D. Murrell (ed.), *Posing Modernity: The Black Model from Manet and Matisse to Today*, exh. cat., Wallach Art Gallery, New York 2018

Paris 2019 A
Le modèle noir de Géricault à Matisse, exh. cat., Musée d'Orsay, Paris 2019

Paris 2019 B
K. Serres (ed.), *The Courtauld Collection: A Vision for Impressionism*, exh. cat., Fondation Louis Vuitton, Paris 2019

Paris, Ottawa and New York 1988–9
J. Sutherland Boggs (ed.), *Degas*, exh. cat., Galeries nationales du Grand Palais, Paris, National Gallery of Canada, Ottawa, and Metropolitan Museum of Art, New York 1988–9

Paris and Ottawa 2004
J. Clair (ed.), *La Grande Parade. Portrait de l'artiste en clown*, exh. cat., Galeries nationales du Grand Palais, Paris, and Musée des beaux-arts du Canada, Ottawa 2004

Paris and Washington 2019–20
H. Loyrette et al., *Degas at the Opéra*, exh. cat., Musée d'Orsay, Paris, and National Gallery of Art, Washington, DC 2019–20

Paris and Washington 2024–5
Paris 1874. Inventer l'impressionnisme, exh. cat., Musée d'Orsay, Paris, and National Gallery of Washington, Washington, DC 2024–5

Perruchot 1964
H. Perruchot, *La Vie de Renoir*, Paris 1964

Reading 2007
J. DeVonyar and R. Kendall, *Degas and the Art of Japan*, exh. cat., Reading Public Museum, Reading, PA 2007

Reff 1976 A
T. Reff, *The Notebooks of Edgar Degas*, 2 vols, Oxford 1976

Reff 1976 B
T. Reff, *Degas: The Artist's Mind*, New York 1976

Ritter 1989
N. Ritter, 'Art and Androgyny: The Aerialist', *Studies in 20th Century Literature*, 13, no. 2 (1989), pp. 173–93

Rivière 1935
G. Rivière, *Monsieur Degas, bourgeois de Paris*, Paris 1935

Robins 2011
A.G. Robins (ed.), *Degas: the Painter of Modern Life. Memories of Degas by George Moore and Walter Sickert*, London 2011

Ross 1982
N. Ross, *Manet's Bar at the Folies-Bergère and the Myths of Popular Illustration*, Ann Arbor, MI 1982

Rothenstein 1947
J. Rothenstein, *One Hundred Modern Foreign Pictures in the Tate Gallery*, London 1947

Rübezahl 1869
Rübezahl: Der Schlesischen Provinzialblätter, Breslau 1869

Rutter 1933
F. Rutter, *Art in My Time*, London 1933

Smalls 2003
J. Smalls, '"Race" As Spectacle in Late-Nineteenth-Century French Art and Popular Culture', *French Historical Studies*, 26, no. 2 (2003), pp. 351–82

Spiess 1842
A. Spiess, *Das Turnen in den Hangübungen für beide Geschlechter*, Basel 1842

Starobinski 1970
J. Starobinski, *Portrait de l'artiste en saltimbanque*, Paris 1970

Tait 2005
P. Tait, *Circus Bodies: Cultural Identity in Aerial Performance*, New York 2005

Teneriello 2015
S. Teneriello, 'Behind the Scenes: Art Work and the Laboring Body in the Dance Images of Degas', *Dance Chronicle*, 38, no. 1 (2015), pp. 27–54

Toulmin 2018
V. Toulmin, 'Black Circus Performers in Victorian Britain', *Early Popular Visual Culture*, 16, no. 3 (2018), pp. 267–89

Ward 2021
S. Ward, *Artistes of Colour: Ethnic Diversity and Representation in the Victorian Circus*, Philadelphia, PA 2021

Washington and San Francisco 1986
C.S. Moffett (ed.), *The New Painting: Impressionism 1874–1886*, exh. cat., National Gallery of Art, Washington, DC, and Fine Arts Museums of San Francisco 1986

Zola 1881
E. Zola, *Le naturalisme au théâtre*, Paris 1881

ACKNOWLEDGEMENTS

Discover Degas & Miss La La was initiated in 2020 during my time as curator at the National Gallery. My deepest gratitude goes to Gabriele Finaldi, Director, and Christopher Riopelle, Curator of Post-1800 Paintings, who supported the project from the outset and entrusted me to continue curating it for the Gallery after my departure. I am equally grateful to Christophe Leribault, former President of the Musées d'Orsay and de l'Orangerie, as well as to Sylvie Patry and Paul Perrin, former and present Directors of Collections and Heads of Curatorial at the Musée d'Orsay, for allowing me to bring it to fruition from across the Channel. At the National Gallery, the exhibition has crucially benefitted from the input, research and ideas of Chiara Di Stefano, who, as its co-curator, contributed to the project in invaluable ways. I am also thankful to Sterre Overmars for providing vital help in the last months of its making.

The exhibition owes a great debt to Laurie Fierstein, who generously shared with us her unparalleled knowledge of Miss La La's (Anna Albertine Olga Brown's) life and career. We thank her deeply for her benevolence and collegiality. We are also profoundly indebted to the extensive scholarship of Denise Murrell and Isolde Pludermacher – showcased in the transformative *Posing Modernity/Le modèle noir* exhibitions – as well as to the fundamental research of Darcy Grimaldo Grigsby and her thought-provoking work on 'Creole Degas'. It is an honour to have them, in addition to Christopher Riopelle, as contributors to this catalogue.

This exhibition has been made possible by the generosity of our lenders. We are grateful to the following institutions: The Art Institute of Chicago; The Barber Institute of Fine Arts, Birmingham; Bibliothèque de l'Arsenal, Bibliothèque-musée de l'Opéra, Paris; Bibliothèque de l'Institut national d'histoire de l'art, Paris; Bibliothèque nationale de France, Département des Estampes et de la photographie, Paris; The British Library, London; Musée Carnavalet – Histoire de Paris; Detroit Institute of Arts; The Fitzwilliam Museum, Cambridge; The J. Paul Getty Museum, Los Angeles; Hastings Museum & Art Gallery; The Morgan Library & Museum, New York; Mucem, Marseille; Nationalmuseum, Stockholm; Galerie La Nouvelle Athènes, Paris; Ordrupgaard, Copenhagen; Royal Academy of Arts, London; Le Signe, Centre National du Graphisme, Chaumont; UK Government Art Collection, London; and Zimmerli Art Museum, New Brunswick. For enriching the exhibition with pieces from their personal collections, we are grateful to Megan and Joseph Cook; Dylan and Emilee Ferguson; David Paul Schulingkamp; the Van Loo family; and the private lenders who wish to remain anonymous. We are especially indebted to the descendants of Anna Albertine Olga Brown, who entrusted us with the previously unseen, never-before-exhibited personal photographs of their great-grandmother. We express our deepest gratitude to them.

For sharing their advice and expertise, we thank Sylvie Aubenas, Giovanna Bertazzoni, Caroline Campbell, Caroline Corbeau-Parsons, Frédéric Denys, Damien Dumarquez, Flavie Durand-Ruel, Paul-Louis Durand-Ruel, Thomas Galifot, Gloria Groom, Lynne Harrison, Sarah Herring, Teresa Krasny, Helen Loveday, Sandrine Maillet, Véronique Meunier, Carl-Johan Olsson, Sylvie Patry, Helen Peden, Isolde Pludermacher, Clémence Raynaud, Natalia Sidlina, Valérie Sueur, Vanessa Toulmin, Bénédicte Trémolières, Letizia Treves, Noëmie Vermoesen, Robert Wenley and Emily Whittle. Our debt of gratitude is not least to Henri Loyrette, who generously shared his phenomenal knowledge.

At the National Gallery I wish to thank Julie Firth, Jane Knowles, Eleanor Richards, Christine Riding and Per Rumberg. My gratitude also goes to Robyn Earl, Sunnifa Hope, Susan Thompson and Réka Vajda for their superb management of the exhibition, and to Sophie Ballinger, George Bird and Chris Oberon for their stunning exhibition design. Marenka Thompson-Odlum produced a remarkable interpretation brief and her input into this publication has been priceless. This catalogue has been masterfully overseen by Diana Adell – whose outstanding work I would like to single out – and has benefitted from the attentive care of Suzanne Bosman, Davina Cheung, Laura Lappin, Jenny Wilson and Sandra Zellmer. My understanding of *Miss La La at the Cirque Fernando* has been deepened by looking at the painting in the Conservation and Scientific Departments with Larry Keith, Hayley Tomlinson, Marika Spring, Rachel Billinge and Joanna Russell. I am grateful to them for their time and expertise.

Finally my thanks go to Luc, Edgar and Gabriel Robbins. This book is dedicated to my late father, Jean-Pierre Josse.

Anne Robbins

PHOTOGRAPHIC CREDITS

Amsterdam
© Rijksmuseum, Amsterdam: p. 6.

Birmingham
© The Henry Barber Trust, The Barber Institute of Fine Arts, University of Birmingham: cats 36, 38.

Boston, Massachusetts
Museum of Fine Arts, Boston, Massachusetts: © akg-images: fig. 27.

Cambridge
© Fitzwilliam Museum, Cambridge: cat. 47.

Cambridge, Massachusetts
© President and Fellows of Harvard College, Cambridge, Massachusetts: figs 19, 20, 28.

Castello
Museo Civico, Castello © Mondadori Portfolio/Bridgeman Images: fig. 21.

Chaumont
© Chaumont, Collection de la Ville de Chaumont/Le Signe, Centre national du graphisme: cats 8, 14.

Chicago, Illinois
© The Art Institute of Chicago: cat. 28.

Copenhagen
Ordrupgaard, Copenhagen © Ordrupgaard, Copenhagen/ Photo: Anders Sune Berg: fig. 18; cat. 42.

Detroit, Michigan
© The Detroit Institute of Arts, Detroit, Michigan: cat. 34.

Edinburgh
Scottish National Gallery © National Galleries of Scotland/ Bridgeman Images: fig. 13.

Grenoble
© DACS 2024/photo Ville de Grenoble/Musée de Grenoble– J.L. Lacroix: fig. 23.

Hastings
© Hastings Museum & Art Gallery, Hastings Borough Council: cat. 46.

Kraków
© Collection The Jagiellonian Library, Kraków: fig. 6.

London
© By Permission of The British Library, London: cat. 9.
© The Trustees of the British Museum: fig. 26.
© Francis Reiss/Picture Post/ Getty Images: fig. 47.
© The National Gallery, London: figs 2, 22, 41; cat. 40.
© Royal Academy of Arts, London/estate of Dame Laura Knight: cat. 48.
© Tate: fig. 9.
UK Government Art Collection © Estate of Duncan Grant. All rights reserved, DACS 2024/ image: Crown copyright: UK Government Art Collection: cat. 49.

Los Angeles, California
Digital image courtesy of the Getty's Open Content Program: cat. 32.

Louisville, Kentucky
© The Speed Art Museum, Louisville, Kentucky: fig. 8.

Madrid
© Biblioteca Nacional, Madrid: cat. 13.

Marseille
© Mucem/C.M: cats 3, 23, 24.

Montauban
Musée Ingres Bourdelle, Montauban © Bridgeman Images: fig. 35.

New Orleans
© Courtesy of the Louisiana State Museum, New Orleans: fig. 17.
New Orleans Museum of Art © Scala/HIP: fig. 33.

New York
© The Metropolitan Museum of Art, New York: figs 12, 34, 38.
© The Morgan Library & Museum, New York: cat. 39.

Paris
© Bibliothèque Nationale de France, Paris: figs 11, 29, 31, 36, 37; cats 4, 6, 7, 12, 21, 22, 29, 31, 41.
Centre Georges Pompidou, Paris, Musée national d'art moderne/Centre de création industrielle © Man Ray 2015 Trust/DACS, London 2024/

photo Centre Pompidou, MNAM-CCI, Dist. RMN-Grand Palais: fig. 30.
Archives Durand-Ruel © Durand-Ruel & Cie: cat. 35.
© Galerie La Nouvelle Athènes, Paris: cat. 30.
© Gamma-Rapho: p. 135.
Bibliothèque de l'Institut National d'Histoire de l'Art, collections Jacques Doucet © Bibliothèque numérique de l'INHA: cat. 27.
Musée Carnavalet, Histoire de Paris © Mairie de Paris, Photothèque des Musées de la ville de Paris: figs 4, 5; cats 10, 11.
Musée d'Orsay, Paris © RMN-Grand Palais (musée d'Orsay)/ Hervé Lewandowski: figs 16, 40; © Musée d'Orsay, Dist. RMN-Grand Palais/Patrice Schmidt: fig. 42.
Musée d'Orsay, Paris © Glenn Ligon; courtesy of the artist, Hauser & Wirth, New York, Regen Projects, Los Angeles, Thomas Dane Gallery, London, and Galerie Chantal Crousel, Paris: fig. 1.

Philadelphia, Pennsylvania
© Philadelphia Museum of Art, Pennsylvania: fig. 25.

Private collection
Private collections © Photo courtesy of the owner: figs 10, 39, 43; cats 25, 26, 33, 37, 43, 45.
© Artmedia/Alamy Stock Photo: fig. 14.

© Laurie Fierstein. Photo: Sander de Wilde: cats 1, 5, 15, 16, 17, 18, 19, 20.
© Historic Images/Alamy Stock Photo: fig. 15.
© Photo courtesy of the Matthiesen Gallery, London: fig. 3.
© Photo Witt Library: fig. 7.
Lynette Yiadom-Boakye © Photo courtesy the artist, Corvi-Mora, London, and Jack Shainman Gallery, New York: fig. 24.

Rutgers
Collection Zimmerli Art Museum at Rutgers University © Collection Zimmerli Art Museum at Rutgers University/ Photo Peter Jacobs: cat. 2.

Stockholm
Nationalmuseum, Stockholm/ Photo: Erik Cornelius, Nationalmuseum: cat. 44.

Toronto
Postmedia © Postmedia/ photo Provincial Archives of Saskatchewan: fig. 46.
Royal Alexandra Theatre, Toronto © Mirvish Productions: fig. 45.
© courtesy Toronto Public Library: fig. 44.

Wintherthur
Oskar Reinhart Collection 'am Römerholz', Winterthur © akg-images: fig. 32.

LIST OF LENDERS

Birmingham
The Henry Barber Trust, the Barber Institute of Fine Arts, University of Birmingham

Cambridge
The Syndics of the Fitzwilliam Museum, University of Cambridge

Chaumont
Le Signe, Centre National du Graphisme, Chaumont

Chicago, Illinois
The Art Institute of Chicago

Copenhagen
Ordrupgaard

Detroit, Michigan
Detroit Institute of Arts

Hastings
Hastings Museum & Art Gallery, Hastings Borough Council

London
The British Library
Megan and Joseph Cook
Royal Academy of Arts
UK Government Art Collection

Los Angeles, California
The J. Paul Getty Museum

Marseille
MuCEM

New Brunswick
Zimmerli Art Museum at Rutgers University

New Orleans, Louisiana
David Paul Schulingkamp

New York
The Morgan Library & Museum

Paris
Bibliothèque de l'Institut national d'histoire de l'art, collections Jacques Doucet
Bibliothèque nationale de France, Département des Estampes et de la photographie
Bibliothèque nationale de France, Bibliothèque de l'Arsenal
Bibliothèque nationale de France, Bibliothèque-musée de l'Opéra
Galerie La Nouvelle Athènes
Musée Carnavalet – Histoire de Paris

Private collections
Belfast
Brussels
London
New York
Paris
Rixensart

Salt Lake City, Utah
Dylan and Emilee Ferguson

Stockholm
Nationalmuseum

And all the private collectors who wish to remain anonymous.